Hinter der Vierten Wand
Fiktive Leben – Gelebte Fiktionen

Behind the Fourth Wall
Fictitious Lives – Lived Fictions

Herausgegeben von | Edited by Ilse Lafer
Verlegt von | Published by Sabine Folie
für | for Generali Foundation

Generali Foundation, Wien

Verlag für moderne Kunst Nürnberg

Inhalt
Contents

Werke | Works

Appendix

Vorwort

Es wäre Euphemismus, wenn wir nicht feststellten, wie sehr die Allgegenwärtigkeit medialer Bilder in Film, Fernsehen und Internet das Erleben, die Träume und Vorstellungen der Menschen prägen, beeinflussen und manipulieren, so sehr, dass es zunehmend schwieriger wird, den Grad von Eigen- und Fremdbestimmung in einer globalisierten, durchorganisierten und von virtuellem Kapital dominierten Welt richtig einzuschätzen.

Dem Versuch, in dieser Situation Reflexion und Orientierung zu ermöglichen, ist das aktuelle Projekt der Generali Foundation gewidmet. Dabei nehmen Ausstellung und Publikation die Fährte künstlerischer Positionen auf, die mittels Film, Fotografie und Video das Trügerische in unserer Wahrnehmung von Wirklichkeit untersuchen.

Die Generali Foundation hat seit ihrer Gründung in ihrer Ausstellungs- und Sammlungstätigkeit die künstlerische Auseinandersetzung mit den unsere Kultur bestimmenden Medien und den Folgen für das moderne Subjekt kontinuierlich untersucht und vorangetrieben.

So werden in der vorliegenden Publikation zur Ausstellung *Hinter der Vierten Wand. Fiktive Leben – Gelebte Fiktionen* und in der Ausstellung selbst Werke der Sammlung mit aktuellen internationalen Positionen und zwei als Auftragswerke entwickelten Performances in Beziehung gesetzt.

Mit dem Versuch, abseits von Klischees und abgestumpfter Wahrnehmung einen differenzierten Blick auf die Realität – oder das, was wir als solche wahrnehmen, – und deren Trugbilder zu werfen, bleibt die Generali Foundation ihrem Anliegen treu, einen kritischen Beitrag zur Standortbestimmung des gegenwärtigen Begriffs von Wirklichkeit und Schein zu leisten und den Grenzbereich dazwischen auszuloten.

Meine besondere Anerkennung gilt Sabine Folie für die interessante Programmierung der Generali Foundation, die das Thema des Theatralen und Performativen zum Leitmotiv dieses Jahres gemacht hat, was in den Einzelschauen *Danica Dakić. Role-Taking, Role-Making* und *ANA TORFS. ALBUM / TRACKS B* und besonders in der derzeitigen, von Ilse Lafer kuratierten Ausstellung in anschaulicher Weise zum Ausdruck kommt. Ihr und dem gesamten Team möchte ich meinen Dank für die Umsetzung dieser zeitgemäßen Thematik aussprechen, sowie allen, die dieses Projekt unterstützt haben.

Dietrich Karner
Präsident

Preface

It would be euphemistic not to point out the degree to which the omni-presence of media images in film, television, and the Internet shapes, influences, and manipulates people's experiences, dreams, and imagina-tions, making it increasingly difficult to correctly assess relative levels of autonomy and heteronomy in a world that is globalized, thoroughly organized, and dominated by virtual capital.

The Generali Foundation's current exhibition project is an attempt to facilitate reflection and orientation, focusing in the show and its catalogue on artistic positions that use film, photography, and video to examine the deceptive dimension of the way we perceive reality.

From its establishment, the Generali Foundation has, in its exhibitions and collecting activities, continually explored and fostered artistic engage-ment with the media that shape our culture and the impact of these media on the modern subject.

In the exhibition catalogue for *Behind the Fourth Wall. Fictitious Lives – Lived Fictions* and in the show itself, works from the collection are related to contemporary international positions and two specially commis-sioned performances.

With this attempt to go beyond clichés and blunted perceptions and take a differentiated look at reality—or what we take for reality—and its illusions, the Generali Foundation remains true to its aim of making a critical contribution to the mapping of current concepts of reality and illusion and all that lies between.

I would like to extend a special compliment to Sabine Folie for her programming of the Generali Foundation, which focuses this year on the leitmotiv of theatricality and performativity, as seen in the solo shows *Danica Dakić. Role-Taking, Role-Making* and *ANA TORFS. ALBUM/ TRACKS B,* and particularly in the current exhibition curated by Ilse Lafer. To her and her entire team I would like to express my thanks for their handling of this topical subject matter, as well as to all those who supported this project.

Dietrich Karner
President

Zum Geleit

Das gegenwärtige Wiederaufleben des Diskurses über den Topos der „Vierten Wand", eines Begriffs, mit dem Denis Diderot die Nahtstelle zwischen dem Spiel auf der Bühne und der Realität des Publikums markieren wollte, um damit gleichzeitig ein Instrument der Distanzierung und in der Folge des „Gewahrwerdens" einzuführen, ist nicht überraschend.

Der neuralgische Punkt, der damit benannt werden sollte, nämlich, dass die Welt der Dinge keine gesicherte sei, in der alle für immer ihre zugeschriebenen Rollen einnehmen würden, sondern vielmehr ein Parkett für mögliche Entwürfe des Selbst und mögliche Erscheinungen, wurde in den Spiegelreflexionen der Romantik genauso aktiviert wie in den Visionen der Moderne als beschleunigter Maschine, in denen der Mensch die Übersicht verliert und sich die Welt aus Fragmenten zusammenmontiert: Walter Benjamin, Charles Baudelaire, Georg Simmel und Robert Musil sind hier als Denker anzuführen. Nicht zu vergessen die Errungenschaften von Film und Fotografie und deren Möglichkeiten, Welten durch den Einsatz von Raum und Zeit zu multiplizieren und damit die durch die Postmoderne erneut gestellte Frage der Repräsentation vorzubereiten. Die Postmoderne erkannte die Folgen einer umfassenden Medialisierung und begann die Tropen der vieldeutigen Allegorie und des sozialen Blicks sowie Methoden des Innehaltens, der Absorption, der Montage und der Wiederholung wieder aufzunehmen, um sich einerseits dem „Fluss der Bilder" zu entziehen und andererseits die Prozesshaftigkeit von Wahrnehmung in den Vordergrund zu rücken. Das heißt, den semantischen Verunklärungsprozess von Wahrnehmung und ihren Bedingungen zu affirmieren, anstatt zu versuchen, diese wie bei Diderot auf ein allgemein verständliches *Tableau* zurückzuführen, das, wenn auch Fragment, als durchaus „repräsentativ" gewertet werden sollte. Dieser strukturalistische Ansatz förderte eine analytische Bestandsaufnahme der Verhältnisse, mit deren kontinuierlich wachsender Komplexität auch die Gefahr einer Unübersichtlichkeit zunahm, die das Subjekt in eine passive Rolle zu drängen drohte, in der es von eben jenen Verhältnissen überwältigt würde, und die daher zusehends jeglichen emanzipatorischen Anspruch eines politisch handelnden Subjekts gefährdete: „Dass unser Leben ein Patchwork zusammenhangloser Zustände ist, ist keineswegs ‚natürlich', sondern ein Ergebnis jener intensiven und tiefgehenden Umformung der menschlichen Subjektivität, die in der westlichen Welt in den letzten hundertfünfzig Jahren stattgefunden hat. Es ist daher auch nicht von ungefähr, wenn jetzt, am Ende des zwanzigsten Jahrhunderts, eine gewaltige soziale Krise der subjektiven Desintegration unter anderem metaphorisch als Versagen der ‚Aufmerksamkeit' diagnostiziert wird", konstatiert Jonathan Crary.

Hier wurden und werden beispielsweise von Filmemachern wie Godard, Straub-Huillet oder Farocki Strategien eingesetzt, die diesen Prozess der Überwältigung nicht verschleiern, sondern ihn sezieren, reduzieren oder überzeichnen, um erneut „Sichtbarkeit" oder „Aufmerksamkeit" zu gewährleisten. In dieser Tradition finden sich auch viele zeitgenössische KünstlerInnen, die Formen des Theatralen, Theatralischen und Performativen im Alltag erproben, der Ununterscheidbarkeit von Realem und Fiktivem ebenso nachspüren wie der Strategie der Medien und des Internets, zusehends die Grenzen von Alltag, Berichterstattung, Dokumentarischem und Fiktionalem in einer Weise durchlässig werden zu lassen, geradezu zu perforieren, sodass gefährliche Zonen entstehen, in denen die Grenze zwischen harmlosen und extremen Fiktionalisierungen realer Verbrechen immer müheloser überschritten werden kann. So droht Wirklichkeit scheinhaft zu werden und das Scheinbare real.

Beliebtes Untersuchungsinstrument wird in der künstlerischen Produktion die Videoinstallation, weil in ihr, abgesehen von den Techniken der Überblendung, der Montage, der Collage et cetera, auch räumlich Illusion aufgebaut oder zerstört werden kann. Hier erscheint das Theater sprichwörtlich bürgerlich und antiquiert, vermag es doch letztlich schwer die Distanz zwischen Publikum und Bühne aufzuheben, auch wenn noch so viele Videoprojektionen zu Hilfe genommen werden, um andere Schauplätze oder das Innenleben der Protagonisten auf die Bühne zu holen und damit je nach Einsatz Gefahr zu laufen, das, was Brecht als Verfremdungseffekt eingeführt hat, gänzlich abzuschaffen. Die Videoinstallation hat es insofern leichter, als das Publikum sich in das Geschehen buchstäblich hineinstellen kann, um im komplexen Perspektivenwechsel und in zahlreichen Brüchen Zeuge der Zerstörung von Illusion zu werden. Der Reality-Check führt gleichermaßen die Instabilität des Realen vor.

Vielleicht war die simple Opposition von betrachtendem Auge und Geschehen auf der Bühne zwar bürgerliches Theater, aber sie bezeichnete einen überschaubaren Modus der Betrachtung: Man konnte dem Auge gleichsam trauen, was in der Folge immer schwieriger wurde und sich in den technisch und räumlich komplexen Arbeiten der KünstlerInnen widerspiegelt.

Was derzeit in der künstlerischen Produktion stattfindet, wäre, so könnte man behaupten – ganz im Sinn von Diderot – eine Art Rekuperation der semantischen Unmittelbarkeit der Erscheinungen, die sich qua poetischer Kraft gleichsam als Punkte „entscheidender Augenblicke" affektiver Bilder und gespannter Absorption mitteilen, die berühren, erkennen lassen und daher transformieren, eventuell auch ohne die Übersetzungsleistung der Sprache.

Diese Ausstellung nimmt sich vor allem der Medien Film und Video an, in denen die angesprochenen Fragen besonders sinnfällig zum Ausdruck kommen; die konzeptuelle Fotografie der 1960er und 1970er Jahre hat hier

große Vorarbeit geleistet: sie wird Gegenstand eines eigenen Ausstellungsprojekts sein.

Den KünstlerInnen Harun Farocki, Omer Fast, Andrea Geyer, Aernout Mik, Frédéric Moser & Philippe Schwinger, Wendelien van Oldenborgh, Judy Radul, Allan Sekula und Ian Wallace möchte ich meinen Dank für ihr Engagement und ihre Kooperationsbereitschaft bei der Vorbereitung der Ausstellung sowie das Zurverfügungstellen ihrer hervorragenden Arbeiten aussprechen. Besonderer Dank gebührt den beiden Performern Michael Fliri und Marcello Maloberti, die speziell für diese Ausstellung zwei ortsspezifische Performances entwickelt haben, die auch in der Ausstellung dokumentiert sind.

Danken möchte ich zudem den Leihgebern und Galeristen für ihr Entgegenkommen und die Unterstützung bei der Recherche sowie den Sponsoren Mondriaan Foundation, Pro Helvetia und dem Canada Council for the Arts, die wesentlich daran beteiligt sind, dass diese Ausstellung zustande kommen konnte.

Ich danke auch den Autorinnen und Autoren für ihre substanziellen Beiträge zu diesem Katalog sowie der Grafikerin für die Gestaltung dieser gelungenen Publikation.

Vor allem möchte ich Ilse Lafer für die ideenreiche Umsetzung eines sehr ambitionierten Konzepts danken, das sie mit der ihr eigenen Ernsthaftigkeit und Leidenschaft entwickelt hat. Ich danke auch allen aus dem Team der Generali Foundation, die zum Gelingen dieses Projekts beigetragen haben, besonders Katharina Menches, Georgia Holz, Barbara Mahlknecht, Thomas Ehringer und Dietmar Ebenhofer.

Sabine Folie
Direktorin Generali Foundation

Foreword

The current revival of the discourse on the topos of the "Fourth Wall,"
a concept introduced by Denis Diderot to mark the line between the action
on stage and the reality of the audience, as an instrument of distancing
and thus of heightened awareness, comes as no surprise. The key point
under discussion here—the fact that the material world is not a secure place
where everyone can go on playing their assigned roles forever, but an arena
for the development of possible identities and appearances—was articulated
in Romantic motifs of mirroring and in visions of modernity as an acceler-
ated machine in which the human individual no longer has an overall
picture of the world, piecing it together out of fragments instead. Thinkers
who have focused on this include Walter Benjamin, Charles Baudelaire,
Georg Simmel, and Robert Musil. Not forgetting the achievements of film
and photography and their ability to multiply worlds through the use of
space and time, paving the way for postmodernism's renewed interest
in questions of representation. Postmodern thinkers have recognized the
consequences of widespread mediatisation, prompting a return to the
tropes of ambiguous allegory and a social viewpoint, as well as to methods
of pausing, absorption, montage, and repetition, on the one hand as a way
of escaping the "flow of images" and, on the other, to focus attention on
the processual character of perception. This means embracing the increas-
ing semantic complexity of perception and its conditions, rather than
attempting, as in the case of Diderot, to reduce it to a generally understand-
able *tableau* which, although a fragment, was meant to be seen as "repre-
sentative." Such a structuralist approach fostered an analytical appraisal of
prevailing conditions whose increasing complexity threatened the subject
with a loss of overview that could force it into a passive role, where it would
be overwhelmed by these conditions, thus jeopardizing any emancipatory
claim of a politically active subject: "That our lives are so thoroughly a
patchwork of such disconnected states is not a 'natural' condition," writes
Jonathan Crary, "but rather the product of a dense and powerful remaking
of human subjectivity in the West over the last 150 years. Nor is it insigni-
ficant now at the end of the twentieth century that one of the ways an
immense social crisis of subjective dis-integration is metaphorically
diagnosed is as a deficiency of 'attention'."

Filmmakers like Godard, Straub-Huillet, and Farocki, for example, employ
strategies which, instead of masking this process of overwhelming, dissect,
reduce, or exaggerate it as a way of reestablishing "visibility" or "attention."
This tradition also includes many contemporary artists who experiment
with forms of drama, theatricality, and performance in everyday life, explor-
ing the indistinguishability of the real and the fictional and the way the

media and the internet are increasingly blurring, even perforating, the boundaries between everyday life, reporting, documentary, and fiction in a way that creates dangerous zones where crossing the line between harmless and extreme fictionalizations of real crimes becomes more and more easy. As a result, reality is in danger of becoming illusory, and the illusory real.

One much-used tool for such inquiries in art is the video installation because, apart from techniques like the cross-dissolve, montage, collage, etc., illusion can be created and destroyed here in three-dimensional space. By comparison, theater really does appear bourgeois and antiquated, unable as it is to overcome the distance between the audience and the stage—however many video projections may be used to bring onto the stage other locations or the inner life of the characters, in some cases running the risk of suppressing any Brechtian alienation effect. Video installation has less of a problem, since the audience can literally insert itself into the center of the action, where complex changes of perspective and numerous ruptures allow it to actually experience the breaking down of illusion first hand—a reality check that demonstrates the instability of the real.

The simple opposition of observing eye and action on stage may have been truly bourgeois theater, but at least it defined a manageable mode of observation: one could believe one's eyes, so to speak, which subsequently became increasingly difficult, as reflected in the technical and spatial complexity of artists' works.

What is happening in artistic production today could be characterized, in Diderot's spirit, as a kind of reclaiming of the semantic immediacy of appearances which communicate themselves through their poetic force as "decisive moments" of affective images and intense, concentrated absorption, which are moving, which produce insight and hence transformation, sometimes even without the mediation of language.

This exhibition primarily features the media of film and video, where the issues in question find especially clear expression. The conceptual photography of the 1960s and 1970s played a key pioneering role here, and it will be the subject of a separate exhibition.

I would like to thank the artists Harun Farocki, Omer Fast, Andrea Geyer, Aernout Mik, Frédéric Moser & Philippe Schwinger, Wendelien van Oldenborgh, Judy Radul, Allan Sekula, and Ian Wallace for their commitment and cooperation in preparing the exhibition and for putting their outstanding works at our disposal. Special thanks are due to Michael Fliri and Marcello Maloberti, who developed two site-specific performances especially for the exhibition, which are also documented in the show.

I would also like to thank the gallerists and private lenders for their helpfulness and support with research, as well as the sponsoring institutions—the Mondriaan Foundation, Pro Helvetia, and The Canada

Council for the Arts—whose vital contribution helped to make this exhibition possible.

My thanks also go to the authors for their substantial essays and to the graphic designer for her great work on this publication.

Above all, I would like to thank Ilse Lafer for her resourceful realization of a highly ambitious concept that she developed with characteristic diligence and passion. Thanks also to everyone at the Generali Foundation who contributed to the success of this project, especially Katharina Menches, Georgia Holz, Barbara Mahlknecht, Thomas Ehringer, and Dietmar Ebenhofer.

Sabine Folie
Director, Generali Foundation

Ilse Lafer
Hinter der Vierten Wand

Einführung

Prolog

Man denke also, sowohl während des Schreibens als während des
Spielens an den Zuschauer ebensowenig, als ob gar keiner da wäre.
Man stelle sich an dem äußersten Rande der Bühne eine große Mauer
vor, durch die das Parterre abgesondert wird. Man spiele, als ob der
Vorhang nicht aufgezogen würde.
—Denis Diderot [1]

Auf diesem Paradoxon beruht Denis Diderots Konzept der „Vierten Wand".
Im Theater des 18. Jahrhunderts bezeichnet sie die Grenze zwischen insze-
nierter und realer Welt und ist zugleich Mittlerin zwischen Bühne und Zu-
schauerraum. Sie ist die Schwelle, an der zwei Räume verklammert sind, an
der sich die Differenz zwischen Fiktion und Realität manifestiert. Mit der
Vierten Wand führt Diderot jene Zäsur ein, die bis heute das räumliche
Dispositiv des Theaters (Kinos) bestimmt: Die Bühne wird zu einem auto-
nomen Aktionsraum, aus dem die BetrachterInnen, zumindest imaginär,
ausgeschlossen sind. Auf Basis dieser Trennung entwirft er ein Konzept der
affektiven und kognitiven Wahrnehmung, das Subjekt und Objekt, Aktivität
und Passivität, Distanz und Intensität, Eigen- und Fremdbeobachtung auf
neuartige Weise miteinander verschränkt. Diese stellen mit Doris Kolesch

„keine binären oder gar essentialisierbaren Oppositionen dar, sondern dynamische Prozesse im performativen Darstellungs- und Wahrnehmungsprozess"[2]. Diderots – nicht systematisiertes – Konzept der Vierten Wand reicht weit über die Theaterbühne hinaus und schlägt sich in seinen theoretischen Schriften, Briefen und Romanen nieder.

Während er in den Texten ein „metareflexives Zusammenspiel von Drama, Dialog, Kommentar und Briefwechseln inszeniert", in denen er beispielsweise als erster und zweiter Redner, Autor und Erzähler gleichzeitig auftritt und sich zuweilen mit einem fiktiven Leser unterhält, entwirft er „für das Geschehen auf der Bühne eine Konstellation der wechselseitigen Beobachtung der Figuren", stellt die Vierte Wand gleichsam in das szenische Geschehen selbst, wie Susanne Knaller in ihrem Textbeitrag ausführt[3]. Alle noch so verwirrenden ineinandergefalteten Inszenierungen finden an der Grenze zwischen Realität und Fiktion statt, immer werden Momente von Wirklichkeit in die Fiktion hereingeholt, gleichsam über die Vierte Wand in sie hineingespiegelt, ohne jedoch die Unterscheidbarkeit zwischen Vorstellungswelt und Realität aufzugeben.

Die gesamte Ästhetik Diderots beruht bekanntlich auf der Gleichsetzung der Theaterbühne mit dem gemalten Bild: Das perfekte Stück ist eine Abfolge von Bildern, das heißt eine Galerie, eine Ausstellung: Die Bühne bietet dem Zuschauer „ebenso viele wirkliche Bilder, wie es in der Handlung für den Maler günstige Momente gibt".[4]

1 Denis Diderot, „Von der dramatischen Dichtkunst", in: *Ästhetische Schriften*, Bd. 1,
 Berlin/Weimar: Aufbau-Verlag, 1967, S. 284.
2 Doris Kolesch, „Bestürmte Bühnen. Diderots erotische Verflechtung von Gefühl und Reflexion", in: dies., *Theater der Emotionen*, Frankfurt am Main: Campus Verlag, 2009, S. 238.
3 Vgl. Susanne Knaller, S. 51 in diesem Katalog.
4 Roland Barthes, „Diderot, Brecht, Eisenstein", S. 32 in diesem Katalog.
5 Elisabeth Cowie, „Dokumentarische Kunst: das Reale begehren, der Wirklichkeit
 eine Stimme geben", in: *Auf den Spuren des Realen. Kunst und Dokumentarismus*,
 Hg. Karin Gludovatz, Wien: Museum Moderner Kunst, 2003, S. 24.
6 Vlg. Roland Barthes, „Diderot, Brecht, Eisenstein", S. 34 in diesem Katalog.
7 Günther Heeg, „Bilder-Theater: Zur Intermedialität der Schwesterkünste Theater
 und Malerei bei Diderot", in: *Crossing Media: Theater – Film – Fotografie – Neue Medien*,
 Hg. Christopher Balme, Markus Moninger, München: epodium Verlag, 2003, S. 87.
8 Vgl. Samuel Weber, „‚Mittelbarkeit' und ‚Exponierung' – Zu Walter Benjamins Auffassung
 des ‚Mediums'", in: *Thewis Zeitschrift der Gesellschaft für Theaterwissenschaft*,
 Jänner 2004. http://www.thewis.de/?q=node/35 (12.5.2010)
9 Roland Barthes, „Kommentar (Vorwort zu Brechts *Mutter Courage und ihre Kinder*
 mit Photographien von Pic)", in: ders., *Ich habe das Theater immer sehr geliebt, und
 dennoch gehe ich fast nie mehr hin, Schriften zum Theater*, Hg. Jean-Loup Rivière,
 Berlin: Alexander Verlag, 2001, S. 244.
10 Vgl. Juliane Rebentisch, „Der Auftritt des minimalistischen Objekts, die Performanz
 des Betrachters und die ethisch-ästhetischen Folgen", in: *Performativität und Praxis*,
 Hg. Jens Kertscher und Dieter Mersch, München: Wilhelm Fink Verlag, 2003,
 S. 113–139. Der Aufsatz richtet sich gegen die von Fried postulierte Unterscheidung
 und kommt zu dem Schluss: „Es gibt, so ließe sich innerhalb seines Vokabulars gegen
 Fried einwenden, keine nicht-theatralische Kunst." (S. 139)

„Man spiele, als ob der Vorhang nicht aufgezogen würde": Der so gedachte (geschlossene) Bühnenraum ist Bedingung für Diderots „Theater der Bilder", dessen zentrales Movens die mimetische Nachstellung des *vrai de nature* (des Naturwahren) ist. Die Rolle, die er dem lebenden Bild zuerkennt, ist die einer Irritation, welche über Affekt und kontemplative Versenkung die Wahrnehmung und Selbstgewissheit der BetrachterInnen „erschüttern", auch verändern sollte. Es geht ihm um die ästhetische Erfahrung von „Wirklichkeit", die nur als „vermittelte" vorstellbar sei und sich immer erst durch ihre Repräsentation im Erinnern konstituiere. Vergleichbar mit Lessings „prägnantem Augenblick" kommt im Tableau das „Verständnis einer Bewegung im Stillstand zum Tragen"[5], ein Effekt, welcher der dramatischen Handlung, dem *vrai de nature* zuwiderläuft. Damit gibt es seine Künstlichkeit preis und wird zum Zitat im Handlungsablauf oder zur „sichtbaren" Vierten Wand.

Mit seinem Aufsatz „Diderot, Eisenstein, Brecht" gelingt Roland Barthes eine bemerkenswerte vergleichende Studie: Neben dem Theater Diderots seien auch die epischen Szenen Brechts oder der Eisenstein'sche Film eine Abfolge von Bildern, deren Essenz in der Inszenierung des „prägnanten Augenblicks" liege. Was Barthes den drei genannten Autoren als Gemeinsames unterstellt, ist die Suche nach jenem „sorgfältig" gewählten „totalen" Augenblick, aus dem sich „die Gegenwart, die Vergangenheit und die Zukunft herauslesen lassen", in dem alles Abwesende anwesend erscheint.[6] Die spezifischen Verfahren, die dafür eingesetzt werden, korrelieren mit Diderots Theorie des Tableaus, welche Günther Heeg zufolge von Sergei Eisenstein in seiner „Montage der Attraktionen", vor allem aber von Bertolt Brecht mit dem Begriff des sozialen „Gestus" aufgegriffen wird.[7] Das Prinzip der Unterbrechung oder der Zitierbarkeit des Gestus, das der Ästhetik des Tableaus zugrunde liegt, erkennt auch Walter Benjamin im epischen Theater Brechts. Im Gegensatz zu Diderot gehe es im Brecht'schen Bild nicht darum, „etwas Innerliches, Unsichtbares nach Außen zu befördern, um es sichtbar werden zu lassen, [...] entscheidend ist das Äußerliche, Räumliche, Rationale".[8]

> Das Brecht'sche Bild ist beinahe ein lebendes Bild; wie die narrative Malerei präsentiert es eine Geste, die in der Schwebe verharrt und virtuell im fragilsten und intensivsten Moment ihrer Bedeutung verewigt wird. [...] daher sein Realismus, ist doch der Realismus immer nur eine Erkenntnis des Realen.[9]

Brechts „prägnanter Augenblick" steht unter einem völlig anderen Vorzeichen: Sein episches Theater und Diderots „Theater der Bilder" könnten unterschiedlicher nicht sein, wenn man Michael Frieds Gegenüberstellung von „Absorption" (Diderot/Illusionstheater) und „Theatralität" (Brecht/ episches Theater) folgt[10]. Doch ist beiden gemein, dass ihre Verfahren der

Distanzierung eine Neuordnung des Verhältnisses von Bühne/Illusion und ZuschauerIn/Realität ansteuern, um einen vielschichtigen Prozess der Reflexion und Selbstreflexion auszulösen, der dem Einzelnen die eigene Geschichte hervorzubringen[11] oder seine Urteilskraft zu schärfen erlaubt. Entwickelt werden soll eine „Spielweise, die den beobachtenden Geist frei und beweglich erhält. Er muß sozusagen laufend fiktive Montagen an unserem Bau vornehmen können"[12], sagt Brecht. Für ihn werden die ZuschauerInnen zu aktiven KoautorInnen und dürfen (im Gegensatz zu Diderot) keinesfalls „hypnotisiert" werden. Auf dieser Grundlage entwickelt Brecht komplexe Strategien, die, unter dem Begriff des V-Effekts zusammengefasst, „die Verfremdung des Blicks besorgen, Distanzen aufbauen und die Kontrolle der Illusion ermöglichen".[13] Vergleichbar dem Konzept der Vierten Wand kommt der V-Effekt vorrangig in der Arbeit mit den SchauspielerInnen zur Anwendung: Beide, Brecht und Diderot, fordern die Distanz des Schauspielers/der Schauspielerin von seiner/ihrer Rolle. Während Diderot die äußere und innere Distanz der AkteurInnen verlangte, um ein illusionäres Erleben von „Wahrheit" durch die gezielte Nachstellung der Natur zu erreichen[14], wird bei Brecht die Differenz zwischen SchauspielerIn und Figur zur produktiven Reibungsfläche im Gestus des Vorzeigens.

Vor der Folie eines veränderten Realitäts-, aber auch Theaterbegriffs verfolgt Brecht mit der Verfremdung ein ähnliches Ziel wie Diderot mit dem Konzept der Vierten Wand: In ihrer Vorstellung wird die Bühne zu einem distanzierenden Spiegel, welche dem Auge das wahre/falsche Wesen der Welt enthüllt. Wenn Brecht im Theater den Zeitfluss immer wieder unterbricht und die Zeit als Medium sichtbar macht, stellt er, im Gegensatz

11 Vgl. Doris Kolesch und Annette Jael Lehmann, „Zwischen Szene und Schauraum –
 Bildinszenierungen als Orte performativer Wirklichkeitskonstitution", in: *Performanz.
 Zwischen Sprachphilosophie und Kulturwissenschaften*, Hg. Uwe Wirth, Frankfurt
 am Main: Suhrkamp, 2002, S. 353.
12 Bertolt Brecht, „Schriften zum Theater 2", in: *Gesammelte Werke*, Bd. 16, Frankfurt
 am Main: Suhrkamp, 1999, S. 680.
13 Heiner Goebbels, „Von der Unabhängigkeit der Mittel", in: *Brecht frißt Brecht.
 Neues Episches Theater im 21. Jahrhundert*, Hg. Frank-M. Raddatz, Berlin:
 Henschel Verlag, 2007, S. 105.
14 Vgl. Isabella von Treskow, *Französische Aufklärung und sozialistische Wirklichkeit.
 Denis Diderots* Jacques le fataliste *als Modell für Volker Brauns* Hinze-Kunze-Roman
 (Diss. Universität Heidelberg 1995), Würzburg: Königshausen & Neumann, 1996,
 S. 41–42.
15 Walter Benjamin, „Über den Begriff der Geschichte", in: *Gesammelte Schriften*,
 Band 1–2, Frankfurt am Main: Suhrkamp, 1980, S. 695.
16 Vgl. Hito Steyerl, *Die Farbe der Wahrheit. Dokumentarismen im Kunstfeld*, Wien:
 Turia + Kant, 2008, S. 93.
17 Tom Holert, „Die Erscheinung des Dokumentarischen", in: *Auf den Spuren des Realen.
 Kunst und Dokumentarismus*, Hg. Karin Gludovatz, Wien: Museum Moderner Kunst,
 2003, S. 52.
18 Ruth Sonderegger, „Nichts als die reine Wahrheit? Ein Versuch die Aktualität des
 Dokumentarischen mit den materialistischen Wahrheitstheorien Benjamins und Adornos
 zu verstehen", in: *Auf den Spuren des Realen*, S. 65.
19 Steyerl, *Die Farbe der Wahrheit*, S. 93.

zu Diderot, die Illusion von Realität als sinnvoll zusammenhängendes Ganzes in Frage. Der „prägnante Augenblick" (Laokoon) steht nicht mehr im Zeichen eines repräsentativen Ganzen (Diderot), sondern wird zum Bild einer „aufblitzenden Wahrheit" in der Zeit. Oder im Anschluss an Walter Benjamin: „Das wahre Bild der Vergangenheit *huscht* vorbei. Nur als Bild, das auf Nimmerwiedersehen im Augenblick seiner Erkennbarkeit eben aufblitzt, ist die Vergangenheit festzuhalten."[15]

Mit Charles Baudelaire und Walter Benjamin nennt Christian Schulte in seinem Beitrag zwei Positionen, die den „fundamentalen Erfahrungs-wandel, der sich im Zeitalter industrieller Massenproduktion vollzog", den Prozess der Fragmentierung und Entfremdung, bereits in der ersten Hälfte des 19. Jahrhunderts vorbereitet sahen. Mit Dziga Vertovs trium-phalem Ausruf „Es lebe das Leben, wie es ist!"[16] war Anfang des 20. Jahr-hunderts der Glaube geboren, dass die Kameralinse jedes Detail der Welt objektiv einfangen und die Wirklichkeit wiedergeben könne, wie sie eben ist. Die mit dem filmischen oder fotografischen Bild erzeugte Objektivität „bestimmte fortan die Begriffe von Wahrheit und Wahrhaftigkeit, von visueller Zeugenschaft und Evidenz".[17]

Spätestens seit der Ära der Strukturalisten und Poststrukturalisten steht fest: „Es gibt keine Wahrheit. Es gibt keine Wirklichkeit. Nur ihre zufällig entstandenen und intransparenten Konstruktionen."[18] Dass die „Gemachtheit" von Welt oder die Konstruktion immer neuer Realitäts- und Lebensentwürfe nicht rein zufällig ist, sondern unser Zusammenleben organisiert, steuert und manipuliert, hat vermutlich Alain Badious „Passion des Realen" auf den Plan gerufen, der das Verlangen nach „Wirklichkeit" als zentrale Eigenschaft für das 20. Jahrhundert identifiziert: „Das Reale ist nie real genug, um nicht doch als Schein verdächtig werden zu können."[19] Wenn die Welt ein undurchdringliches Gewebe von Fiktion und Realität geworden ist, ein Effekt sich ständig wandelnder medialer Oberflächen, ist der Wunsch nach Orientierung aktueller denn je. Nun ist die Kehrseite der Auffassung, dass die Wirklichkeit hinter ihrer Repräsentation verschwun-den sei, zugleich Botschaft und legitime Forderung, „hinter" die Kulissen zu schauen, gegebenenfalls selbst Bühnen zu schaffen, das Fiktionale am Realen aufzuführen. Wie wird „Wahrheit" an der Schnittstelle zwischen Realität und Illusion, zwischen unserem alltäglichen „unvermittelten" Sein und den virtuellen Welten erfahrbar? Oder anders: Kann mit dem Rück-griff auf Diderots Vierte Wand als historisches Modell gefinkelter Fiktions-durchbrechungen oder Brechts Verfremdungseffekt eine Bühne entstehen, die ein „neues Sehen" oder die kritische Beschreibung unserer Lebenswelt ermöglicht?

Ausstellung

Die Fiktion ist nicht die Erschaffung einer imaginären Welt, die der
wirklichen Welt entgegengesetzt ist. Sie ist die Arbeit, die *Dissense*
vollzieht, die die Modi der sinnlichen Präsentation und die Formen
der Aussage verändert, indem sie die Rahmen, die Maßstäbe oder
Rhythmen ändert, indem sie neue Verhältnisse zwischen der Erschei-
nung und der Wirklichkeit, dem Einzelnen und dem Allgemeinen,
dem Sichtbaren und seiner Bedeutung herstellt. Diese Arbeit verändert
die Koordination des Darstellbaren. Sie verändert unsere Wahrneh-
mung der sinnlichen Ereignisse [...].[20]

Die KünstlerInnen der Ausstellung zielen darauf ab, die Wirklichkeit
in ihrer Vielschichtigkeit *under construction* zu zeigen. Sie nehmen dazu
(mikro)politische Gemeinschaften unter die Lupe, verwandeln gewöhn-
liche Orte in theatralische Schauplätze, sezieren deren Strukturen mit
Rhetoriken des Theaters und des Films. Auf jeweils spezifische Art und
Weise sprengen sie den „Rahmen und die Maßstäbe dessen, was sichtbar
und aussprechbar ist"[21], schauen über die Ränder oder hinter das Dar-
zustellende hinaus, schaffen Zwischenräume oder Bezüge, wo vorher
keine waren. Die KünstlerInnen setzen in fotografischen Bildern, Dia-
und Videoprojektionen, multiperspektivischen Videoinstallationen sowie
Liveperformances und performativen Installationen Stilmittel ein, die
Diderots Vierter Wand und Bertolt Brechts V-Effekt nahekommen. Dabei
entstehen zumeist kleine oder auch größere Bühnen, in denen der Blick
der BetrachterInnen irritiert oder auf sich selbst zurückgeworfen wird:
sei es durch subtile oder verwirrende Beobachterbeziehungen (Judy
Radul), das Zerstreuen des Blicks durch Zwei- oder Mehrfachprojektionen
(Aernout Mik, Omer Fast, Wendelien van Oldenborgh), Überblendungen
und Verlangsamung der Bilder (Wendelien van Oldenborgh), Verfrem-
dung der Sprache, der Text- oder Bildebene (Andrea Geyer, Omer Fast,
Ian Wallace), das gezielte Sichtbarmachen technischer Hilfsmittel (Harun
Farocki, Michael Fliri) oder die Erzeugung von Distanz durch performative
oder theatrale Elemente (Frédéric Moser & Philippe Schwinger). Was
die einzelnen Werke zusammenhält, ist die Frage, wie Realität in Bildern,
Aussagen und Zeichen vermittelt, wahrgenommen wird. Ausgelotet wird
die Frage nach dem Verhältnis zwischen Unmittelbarkeit und Mittelbar-
keit, Affekt und Distanz, Passivität und Aktivität, wobei die Vierte Wand

20 Jacques Rancière, *Der emanzipierte Zuschauer*, Wien: Passagen Verlag, 2008, S. 79.
21 Ebd.
22 Michel Foucault, „Der Panoptismus", in: *Überwachen und Strafen. Die Geburt des
 Gefängnisses*, Frankfurt am Main: Suhrkamp, 1994, S. 279–292.
23 Vgl. Katharina Menches, S. 102–109 in diesem Katalog.

als Metapher zum eigentlichen Dreh- und Angelpunkt für die Wieder-
gewinnung eines reflektierten Standpunkts wird, in dem sich subtil die
fragwürdige Unterscheidung zwischen Sein und Schein manifestiert.

Die Frage nach der „Wahrheit", dem Verhältnis der „Realität" zu ihrem
(Ab-)Bild führt Judy Radul zu ihren Wurzeln zurück, wenn sie den Inter-
nationalen Gerichtshof in Den Haag in den Ausstellungsraum verlegt. Hier
findet das vierstündige Reenactment einiger Gerichtsverfahren (u. a. gegen
Slobodan Milošević oder den liberianischen Präsidenten Charles Taylor)
statt, in welchem die Frage nach der Darstellbarkeit und Inszenierung von
„Wahrheit" ins Blickfeld rückt. Raduls Mise en Scène orientiert sich an
der Organisation und Inszenierung der aufzeichnenden Apparaturen:
In ihrem Schauspiel des kontrollierten Blicks führt das Kameraauge Regie,
mit dem sie eine Performance ineinander verschachtelter Beobachter-
situationen inszeniert. *World Rehearsal Court* ist ein Spektakel des Be-
obachtens und Beobachtetwerdens, in dem wir sehend unserem eigenen
Sehen begegnen. Es gibt der Arbeit einen doppelten Boden, wenn Radul
ihr Nachdenken über die Politik des Ausschnitts im Gerichtssaal entfaltet:
Wie die Bühne Diderots ist er ein von der Außenwelt abgetrennter Ort,
an dem die immer gleiche Kulisse, die Kostüme und eingeschliffenen
Rollen, die Sprache und die Art des Sprechens Wahrheit suggerieren.
Hier teilen sich die Ästhetik des Authentischen und die des kontrollierten
Ausschnitts, der mit Barthes „seine ganze unbenannte Umgebung ins
Nichts verweist und all das ins Wesen, ins Licht, ins Blickfeld rückt, was
er in sein Feld aufnimmt", einen gemeinsamen Raum der Sichtbarkeit,
in dem die „panoptische Spielart der Macht"[22] offen zutage tritt. Dies wird
umso deutlicher, wenn Judy Radul *World Rehearsal Court* als abgeschlosse-
nen Raum samt Umgebung konzipiert: in der Mitte die Bühne als „reiner
Ausschnitt mit sauberen Rändern", links und rechts davon jene Räume, die
für gewöhnlich außerhalb unseres Blickfelds liegen, sehen und gesehen
werden – Livekameras, gekoppelt an Monitore, reproduzieren unentwegt
unsere Bewegung im Raum. Wir treffen auch auf die vermeintlichen Be-
weisstücke – Requisiten und Fundstücke aller Art –, deren kausaler Zusam-
menhang jedoch rätselhaft bleibt.

 Ein Bild als „reinen Ausschnitt mit sauberen Rändern" liefert Aernout
Mik in *Convergencies* nicht, denn dieses franst an den Rändern in eine Un-
bestimmtheit von Raum und Zeit aus. Wie in Harun Farockis *Immersion*[23],
einer Arbeit, in der die Wirkung virtueller Welten getestet wird, geht es um
den kritischen Blick auf die Sogwirkung der visuellen Reize des medialen
Bildes. Auf zwei über Eck montierte panoramenhafte Bildtafeln, die das
Genre des Historienbildes aufnehmen, wird unentwegt Found-Footage-
Material internationaler Nachrichtensender projiziert. Trainingssituatio-
nen für den Erstfall – Menschenmassen, dazwischen Uniformierte, Poli-
zei und Militär – suggerieren ein stetes Getriebensein der Bilder, welches

paradoxerweise in ein Auf-der-Stelle-Treten mündet. Das ohne narrative
Spitzen und erklärende Kommentare montierte Material lässt die Betrach-
terInnen in einem desorientierenden Schwebezustand zurück: Die Vierte
Wand, vor der sie stehen, könnte nicht buchstäblicher als im Ausstellen der
von den Worten getrennten Bilder sichtbar werden. Was wir sehen, sind
„zu viele Körper ohne Namen, zu viele Körper, die nicht in der Lage sind,
uns den Blick, den wir ihnen widmen, zu erwidern, zu viele Körper, die
Gegenstand einer Rede sind, ohne selbst die Rede ergreifen zu können".[24]

Das Getriebensein der Bilder kann auch das der aus einem israelischen
Panzer abgefeuerten Worte sein. In *A Tank Translated* interviewt Omer Fast
vier junge Männer auf Hebräisch und positioniert sie entsprechend ihrer
Rangordnung im Panzer – Kommandant, Schütze, Ladeschütze, Fahrer –
auf vier Monitoren und unterschiedlich hohen Sockeln. Während Fast auf
der Bildebene den Charakter vermeintlicher Inszenierung von Authen-
tizität forciert – vier Köpfe in Frontalansicht vor neutralem Hintergrund –,
greift er in die Sinnstruktur der Untertitel ein, manipuliert Satz für Satz,
verändert die Syntax, bis die einzelnen Wörter in neuen Zusammenhängen
mit kaum entschlüsselbarem Inhalt zusammengeführt werden. Im Aus-
löschen, Ersetzen oder Vertauschen der Wörter verbildlicht er den Prozess
des Erinnerns oder Rekonstruierens von Geschichte, der weder geradlinig
noch objektiv ist. Erst die offensichtliche Manipulation macht jenen
Raum „hinter" dem vordergründig Authentischen sichtbar, zeigt anhand
von Augenzeugenberichten, wie ein Bild von Wirklichkeit aufbereitet, aber
auch zugerichtet wird, sei es auf medialer Ebene oder auf der Ebene des
Erinnerns – eine Demontage vertrauter Gewissheiten.

Godville ist ein seltsamer Ort, *Godville* ist permanentes Reenactment,
Museum, alltägliche Lebenswelt. Die Geschichten von *Godville* sind so real
wie inszeniert, in *Godville* fallen die Fiktion des 18. und die Realität des
21. Jahrhunderts ineinander – regiert in *Godville* am Ende Gott? Dieser
Eindruck mag entstehen, wenn man den Schluss der 50-minütigen Video-
doppelprojektion von Omer Fast sieht: Einer der Protagonisten aus dem
Living-History-Museum in Williamsburg in West Virginia wiederholt die
Worte „Gott ist …" und vervollständigt den Satz mit überraschenden
Attributen: elektrisches Licht, ein Transformator, ein Ökonom, usw.[25] Das
Gegenwärtige und Historische, ineinander verwoben und an die Grenze
des Absurden geführt, werden in *Godville* auf ganz besondere Weise ver-
arbeitet: Drei BewohnerInnen in ihren historischen Kostümen hat Omer

24 Rancière, *Der emanzipierte Zuschauer*, S. 114.
25 Vgl. Steyerl, *Die Farbe der Wahrheit*, S. 68.
26 Persönliche Mitteilung der Künstlerin an Parveen Adams, vgl. Parveen Adams,
 „Kunst und die Zeit der Wiederholung", in: *Exil des Imaginären. Politik, Ästhetik, Liebe*,
 Wien: Generali Foundation; Köln: Verlag Walther König, 2007, S. 73.

Fast zu ihrem Alltag in der Gegenwart und ihren historischen Rollen befragt und dann das Rohmaterial zu einem nahtlosen Redeschwall montiert. Die durchgängige Erzählung spießt sich jedoch an den offensichtlichen Jumpcuts der Bildebene – eine Irritation, die mit der Projektionsrückseite eine Akzentuierung erhält: Stille, mit einer einfachen Kamera aufgezeichnete Impressionen der Stadt, Architekturen, Außen- und Innenräume. Mit dieser Inszenierung negierter Historizität und Individualität hebelt Fast die unverrückbaren Vorstellungen von Vergangenheit und Gegenwart aus, ordnet das Material, ob Rollenspiel oder reales Leben, Potemkin'sches Dorf oder Lebenswelt, nach neuen Beziehungen, ohne dabei seine eigene Rolle als potenzieller (Um)gestalter zu verbergen. Hinter der heillosen Verschränkung von Unabhängigkeitskrieg, Terror, Sklaverei, Nahostkonflikt und religiösem Fanatismus lauert eine „andere" Wahrnehmung von Realität: die ewige Wiederkehr des Gleichen, wie sie dem Reenactment eben innewohnt.

Eine Umschrift historischer Ereignisse, die das Verhältnis zwischen Zeitlichkeit und Kausalität außer Kraft setzt, gelingt auch Andrea Geyer mit *Reference Over Time*. Stottern und Versagen, verbunden mit sichtlich körperlichem Unbehagen, versinnbildlichen die prekäre Situation der Staatenlosigkeit, wenn die Künstlerin als unmittelbare Reaktion auf einen Gesetzesentwurf der Ära Bush – den sogenannten USA PATRIOT Act II, in dem der Staat unter anderem das Recht erhalten sollte, legale ImmigrantInnen zu deportieren – eine Schauspielerin Bertolt Brechts *Flüchtlingsgespräche* performen lässt.

Ein Monitor auf einem Tisch, davor ein Sessel: Eine Frau erscheint am Bildschirm, sie setzt sich, starrt uns an, beginnt zu sprechen – so als verstünde sie die Worte nicht –, hält inne, erhebt sich, will gehen, tritt aus dem Bild, kehrt zurück, setzt sich wieder, spricht weiter, bricht ab ... Geyer sucht „einen Weg, einen Körper für das Sprechen zu situieren" oder eine Position, „von der aus man sprechen kann",[26] und weist dem Betrachter/ der Betrachterin einen Platz am Tisch gegenüber dem Monitor zu. Damit nimmt sie Bezug auf die Protagonisten von Brechts *Flüchtlingsgesprächen*, den Physiker Ziffel und den Metallarbeiter Kaller, die in einem Bahnhofsrestaurant in Helsinki „über Pässe, über die Ebenbürtigkeit von Bier und Zigarre, über die Ordnungsliebe" im totalitären Regime des Dritten Reiches diskutieren.

Eine weitere, vielleicht zufällige, historische Referenz erhält die Arbeit durch die zu Beginn über den Bildschirm laufende Textzeile: „I dipped into Diderot's JACQUES THE FATALIST when a possibility occurred to me of putting the old Ziffel plan into operation..." (Ich las in Diderots *Jakob der Fatalist*, als mir eine neue Möglichkeit aufging, den alten Ziffel-Plan zu verwirklichen ...). Diderots Metaroman *Jacques le Fataliste et son maître* (1778–1780, 1796) mag Brecht wohl deshalb inspiriert haben, weil er dem klassischen Erzählen eine radikale Absage erteilt: In ihm wird die Dialektik

von Herrschaft und Knechtschaft oder der freie Wille des Menschen einer experimentellen Lektüre unterzogen, die sich poetologisch in Fiktionsdurchbrechungen und dem fast zufällig wirkenden Ineinanderschachteln verschiedener dialogischer Erzählungen niederschlägt. Das Fragen nach Wortbedeutungen oder das Suchen nach Wahrheit im zwischenmenschlichen Austausch, wie sie beiden Werken, Brechts *Flüchtlingsgesprächen* und Diderots *Jacques le Fataliste et son maître* eigen ist, führen in *Reference Over Time* zu einem Scheitern am gesprochenen Wort. Wer spricht hier mit wem? Welche Rolle nimmt die Schauspielerin ein, und welche spielen wir? Sind wir jene stummen BeobachterInnen „hinter" der buchstäblich Vierten Wand, die keine Sprache/Rolle haben, die Gegenwart der historischen Last der Worte aber dennoch mit der Schauspielerin teilen?

Wie Andrea Geyer setzt auch Wendelien van Oldenborgh in *No False Echoes* auf die Inszenierung einer historischen Stimme, um den Diskurs zur nationalen Identität in den Niederlanden zu schärfen. Schauplatz ist das Gebäude des Radiosenders Kootwijk, ein modernistischer Solitär inmitten einer sanftgrünen niederländischen Landschaft. Während im Inneren des Gebäudes eine Sprachlandschaft entsteht – ein kleines Mädchen singt für eine Radioaufnahme, ExpertInnen diskutieren über die Wirkungsmacht des Radiosenders Philips Omroep Holland Indië, da und dort ein Räuspern, eine Geste des Sprechens einzelner BesucherInnen –, entfaltet sich außerhalb, auf einem Balkon des Gebäudes, in der Sprechperformance des niederländischen Rappers Salah Edin das Echo einer historischen Stimme: Die leidenschaftliche Anklage des indonesischen Freiheitskämpfers Soewardi Soerjaningrat gegen die koloniale Souveränität der Niederlande über Indonesien wird in die Gegenwart geholt, im performativen Sprechakt von Edin nahezu materialisiert. Vergleichbar dem in *Reference Over Time* verkörperten Brecht-Dialog geht auch hier die Politik des Textes durch den Körper von Salah Edin hindurch. Wobei in *No False Echoes* eine eigentümliche Verschärfung sichtbar wird: Die Biografie des Performers, sein Äußeres, schreibt sich in den historischen Text ein, ohne jedoch gänzlich in ihm aufzugehen. Ein schelmisches Lachen da und dort, ein leiser Wortwechsel mit der Künstlerin – Mimik und Gestik kennzeichnen die subtile Grenze zwischen dokumentarischer Aufzeichnung und gegenwärtiger Inszenierung durch Salah Edin.

Das Wechselspiel zwischen Vergangenheit und Gegenwart, innerem und äußerem Dialog, Nähe und Distanz vollzieht sich ebenso auf der Ebene der medialen Übersetzung wie in der Inszenierung der Sprache. Drei Bildebenen gliedern den Raum zwischen den Paraventwänden: eine projizierte Bildfläche auf der einen, ein Monitor und die Projektion der Untertitel auf der anderen, gegenüberliegenden Seite. Immer wieder unterbricht van

27 Thomas Elsaesser und Malte Hagener, *Filmtheorie*, Hamburg: Junius Verlag, 2007, S. 66.

Oldenborgh die suggestive Kraft des Sprechakts, in dem sie die Diskussion im Innenraum auf die Projektionsfläche holt. Am Ende des Videos gibt Edin seine distanzierte Position auf, mischt sich unter die anderen, diskutiert mit ihnen, während schon der Abspann läuft: eine Vielstimmigkeit ohne auflösendes Narrativ. Auf subtile Weise werden die ZuseherInnen zwischen den Paraventwänden in die „Polyphonie vergangener und gegenwärtiger Stimmen" eingebunden, welche, mit den Worten des russischen Literaturwissenschaftlers Michail Bachtin[27], im Akt der Rezeption in eine neue Phase der Aneignung übergehen.

Zwei Videos, *Alles wird wieder gut* und *Donnerstag,* in einem ochsenblutrot gestrichenen Raum, dazwischen Strohballen und der gewichtige Stapel von 5000 Plakaten mit demselben Sujet: der Abstraktion der Grafikkurve des SMI an der Zürcher Börse 2006. Das ist die Bühne für eine Neuauflage von Lenins *Farewell Letter to the Swiss Workers*, eine marxistisch orientierte Analyse der Gesellschaft von Frédéric Moser und Philippe Schwinger. Die Frage, die das Künstlerduo stellt – wie und in welchen Ausmaß Veränderungen innerhalb eines Systems möglich sind und wie groß die Transformationskraft revolutionärer Utopien ist –, impliziert diejenige nach den Mechanismen der bestehenden Ordnung, die sich in *Farewell Letter to the Swiss Workers* über die assoziative Verknüpfung der Filme und Objekte erschließt. Wie in van Oldenborghs *No False Echoes* bildet auch hier ein historischer Text den Ausgangspunkt für eine zwischen Fiktionalität und semidokumentarischen Formen angesiedelte Choreografie. Während *Donnerstag* in ruhigen Bildern den mechanisierten Arbeitstag einer jungen Kuhmelkerin wiedergibt, besteht *Alles wird wieder gut* aus einer Reihe von Sequenzen: einer Arbeiterdemonstration vor den verschlossenen Toren einer Fabrik, szenischen Darstellungen einer Jugendgruppe im Arbeitsalltag, Vorbereitungen einer Party und einer Theaterprobe in der Pfarrei desselben Dorfes, bei der ein kleiner Junge den Arbeiterbrief Lenins performt. Dem gleichnamigen Film von Jean-Luc Godard und Jean-Pierre Gorin *Tout va bien* (1972) vergleichbar wird anhand verschiedener Schauplätze und sozialer Gruppen die Umsetzbarkeit marxistischer Diskurse für das Leben in theatralischem Spiel erprobt. Den Illusionseffekt der bühnenartigen Installation, die den BetrachterInnen unmittelbares Erleben suggeriert, durchbrechen die Künstler gekonnt durch Brecht'sches Sprechen: Stereotype, zuweilen marxistische Parolen schaffen eine spürbare Distanz zwischen SchauspielerInnen und darzustellenden Figuren. Doch scheint gerade dieser Distanzierungseffekt die Ideologie von gestern in das gesellschaftliche wie persönliche Leben von heute glaubhaft übertragen zu können. *Alles wird wieder gut*: die Probe für eine Neuverteilung gesellschaftlicher Rollen?

„Entweder glaubt man an die Klassenverhältnisse, weil man sie erfahren hat, oder man glaubt nicht daran, und in diesem Film geht es nur darum, abgesehen vom Text und vom Raum und von der Vielfalt der Personen

und von der gerafften Zeit [...]."[28] In Harun Farockis Film geht es „noch" nicht um die *Klassenverhältnisse* von Danièle Huillet und Jean-Marie Straub; er zeigt Proben aus dem gleichnamigen Film. In schlichter und ruhiger Kameraführung gelingt es ihm, die Präzisionsarbeit der Regisseure im Wiederholen der immer gleichen Szenen, Worte und Gesten, ihr eigenes „Im-Film-Sein" einzufangen. Entsprechend auch der Titel des Films: *Jean-Marie Straub und Danièle Huillet bei der Arbeit an einem Film nach Franz Kafkas Roman „Amerika".* Wie Brecht geht es Farocki um den signifikanten Gehalt jeder einzelnen Szene: „Auf der Ebene des Stücks [Films] gibt es keine Entfaltung [...], nichts als Ausschnitte, von denen jeder hinreichendes Demonstrationsvermögen besitzt."[29] Die Schlussszene von Farockis Film: eine Wiese, dahinter Wald, es ist dunkel. Wir sehen Karl Roßman, den 16-jährigen Protagonisten von Kafkas Roman, vor einem aufgeklappten blauen Koffer. Er sucht das Bild seiner Eltern. Rechts die Kameras, Scheinwerfer, das Filmteam und Jean-Marie Straub; unvermittelt, im Zentrum des Bilds, ein surreales Tableau, mit dem das „Noch-Nicht", das Zukünftige des Films, in der Gegenwart der Probe eine seltsame Wendung erfährt – ein Bild, das eben jenes „hinreichende Demonstrationsvermögen" besitzt, um das Abwesende anwesend erscheinen zu lassen.

Farocki sucht nach dem Bild „hinter" dem Bild, indem er „hinter" dem präzisen Aufbau der Tableaus und der Inszenierung der Sprache die Präsenz der Filmemacher herausstellt. Dabei kommt es zu einer merkwürdigen Doppelung: Die Brecht'sche Methodik ist nicht nur in Farockis Film spürbar, sondern entfaltet sich auch in der Arbeit von Straub/Huillet: ein distanziertes, betontes Sprechen, das den „Materialwert der Sprache" hervortreibt.[30]

Der Blick „hinter" die Vierte Wand wird in Allan Sekulas *Aerospace Folktales* zur Frage nach der Wirklichkeit im fotografischen Bild. In einer als bühnenhaftes Setting inszenierten Fotoreportage mit erklärenden

28 „Materialien zu KLASSENVERHÄLTNISSE. Von Danièle Huillet und Jean-Marie Straub, nach Franz Kafka", in: new filmkritik, 8. 10. 2007. http://newfilmkritik.de/archiv/2007 -10/materialien-zu-klassenverhaltnissevon-daniele-huillet-und-jean-marie-straub-nach -franz-kafka. (12. 5. 2010)
29 Roland Barthes, „Diderot, Brecht, Eisenstein", S. 33 in diesem Katalog.
30 Vgl. Christian Schulte, S. 43 in diesem Katalog.
31 Allan Sekula, *Allan Sekula. Performance under Working Conditions*, Hg. Sabine Breitwieser, Ausst.-Kat., Wien: Generali Foundation; Ostfildern: Hatje Cantz, 2003, S. 147.
32 Rancière, *Der emanzipierte Zuschauer*, S. 111–112.
33 Sekula, *Allan Sekula. Performance under Working Conditions*, S. 148.
34 Zit. aus: Reinhard Braun, „Wirklichkeit zwischen Diskurs und Dokument", in: *Realitätskonstruktionen in der zeitgenössischen Kultur*, Hg. Susanne Knaller, Wien/Köln/Weimar: Böhlau Verlag, 2008, S. 42.
35 Ian Wallace, „Damals und jetzt und Kunst und Politik. Ian Wallace im Interview mit Renske Janssen", in: *Ian Wallace. A Literature of Images*. Ausst.-Kat., Zürich: Kunsthalle Zürich, Düsseldorf: Kunstverein für die Rheinlande und Westfalen, Rotterdam: Witte de With; Berlin: Sternberg Press, 2008, S. 40 der deutschen Textbroschüre.

Kommentaren und Tonbandaufnahmen verortet er seine familiäre Situation im politischen und sozialen Milieu der beginnenden 1970er-Jahre. Zentraler Topos ist der durch Sozialisierung und Arbeitsmoral geprägte Lebenslauf des Vaters, in dem sich die „Gemachtheit" des kleinbürgerlichen Heims widerspiegelt. „ich habe immer wieder dieses gefühl gehabt wenn ich mit meiner kamera dorthin zurückkehrte die wohnung war ein u-boot sie lag unter wasser sie war eine höhle mit konischen lampen in jedem winkel wir saßen mitten in der maginotlinie fest [...]".[31] Die BetrachterInnen finden sich in eben diesem präzise arrangierten familiären U-Boot zwischen Fächerpalmen und Regiesessel, Bild-, Ton- und Textdokumente, die Sekula, das Publikum ansprechend, kommentiert und in einen größeren politischen Bedeutungszusammenhang stellt. So wird die Evidenz des Realen über den Umweg des Performativen und Inszenierten zwischen der „sichtbaren Form des Bildes" und dem Gesprochenen erfahrbar: „[...] die Stimme ist nicht die Manifestation des Unsichtbaren, das der sichtbaren Form des Bildes entgegengesetzt ist. Sie ist selbst in einen Vorgang der Bilderstellung eingebettet. Sie ist die Stimme eines Körpers, die ein sinnliches Ereignis in ein anderes umwandelt, indem sie sich bemüht, uns etwas ,sichtbar' zu machen, was sie selbst gesehen hat, uns sehen zu lassen, was sie uns sagt."[32] Oder – um mit Sekula abzuschließen: „also habe ich ein paar sachen aufgeschrieben damit sie verstehen wovon ich spreche damit sie nicht glauben ich dokumentiere die dinge einfach um des dokumentierens willen [...] dieses material ist nur insofern interessant als es *soziales* material ist [...]".[33]

Eine Sozialreportage ist Ian Wallace' *Poverty* nicht. Das Ausgangsmaterial, ein 16-mm-Film von 1980, in dem seine Künstlerfreunde stereotype Posen der Armut nachstellen, durchläuft in den darauf folgenden Jahren verschiedene mediale Repräsentationsformen: Wallace montiert die Filmkader auf monochrome großflächige Leinwände, zeigt sie als Serie kleiner Schwarz-Weiß-Bilder, farbig verfremdet im Video oder als Drucke hinter Plexiglas. Die Frage, die *Poverty* aufwirft, ist mit W. J. T. Mitchell nicht die der Repräsentation, „egal ob politisch, ethisch oder epistemologisch gemeint, sondern genau die Form, in der die Frage gestellt wird"[34]. Wenn Wallace der selbstreflexiven modernistischen Malerei den Bildgehalt sozial realistischer Fotografie etwa der 1930er Jahre aufdrückt, dann gelingt ihm ein „Zusammenprall ästhetischer Ideologien, zwischen Form und Inhalt"[35], eine Kollision, die Medialität als Hintergrundbedingung der Vermittlung an vorderste Stelle rückt. Die BetrachterInnen werden in theatralische Szenen versetzt, tauchen in eine rätselhafte, farbigverfremdete, zugleich bekannte Bildwelt ein. Nichts in diesem Werk ist unmittelbar oder authentisch, und doch besteht an der vermittelten Realität kein Zweifel: Hinter den inszenierten Bildern wird die Wahrnehmung als „sozialromantisches Klischee" entlarvt.

In *Give Doubt the Benefit of the Doubt*, einem performativen Akt in drei Teilen, ist für Michael Fliri das Publikum nur „hinter" der Vierten Wand anwesend. Die Frage nach dem Verhältnis zwischen Unmittelbarkeit und Mittelbarkeit stellt er, wenn er gleich zu Beginn zu einem Anderen wird: Die Umwandlung seines Gesichts durch einen professionellen Masken- bildner bestimmt zunächst die Handlung, die erst durch den performativen Akt zum Ereignis wird. „Es gibt mehr Wahrheit in der Maske, in der symbolischen Form, als in dem hinter ihr Verborgenen, als in ihrem Träger. Wenn man ,die Maske wegreißt', wird man nicht auf die verborgene Wahrheit treffen; im Gegenteil, wird man die ,unsichtbare Wahrheit', die in der Maske wohnt, verlieren."[36] Mit Slavoj Žižeks Beobachtung öffnet sich ein Erfahrungsraum, der für Wallace' „maskierte" Fotografien ebenso Gültigkeit hat wie für Fliri: In beiden Fällen bewirkt die „Maskierung" eine Mittelbarkeit, an deren Oberfläche die Differenz zwischen Fiktion und Realität verhandelbar wird. Wenn die Maske, wie Žižek weiter ausführt, „unser tatsächliches, reales Verhalten"[37] reguliert, dann ist sie für Fliri Bedingung, „Regeln einer anderen Effizienz"[38] zu erschaffen, anhand deren er Dinge offenlegt oder die „Kontingenz unserer Welt durchleuchtet"[39], häufig mit pantomimischen Gesten des Scheiterns, wie etwa bei dem Versuch, „richtig" zu fallen.

Dass die Körperlichkeit von Gebärde, Pantomime und Mimik zu einer im Sinne Diderots hieroglyphischen „Poesie im Raum"[40] führt, zeigt die komplexe Choreografie von Marcello Maloberti auf ganz andere Weise: Er leitet seine Mise en Scène aus spezifischen vorgefundenen Kontexten und Atmosphären ab: Zumeist sind dies zufällige Orte, deren angestammte Ordnung oder soziale Dynamik er aufspürt und durch feine Verschie- bungen oder spontan wirkende Aktionen durchbricht und kurzfristig außer Kraft setzt. Hat er es mit (un)sichtbaren Wänden zu tun, markiert er sie beispielsweise mit zwei lebenden Skulpturen, wie sie den Eingang zur Generali Foundation flankieren, oder setzt ein Kind in eine Ecke, das aus Illustrierten Bilder ausschneidet, und stellt einen Kühlschrank in den Ausstellungsraum, der vielleicht als Jukebox fungiert. Maloberti operiert als Katalysator für Geschichten und Handlungen, die ein skurriles Band zwischen Menschen und Dingen knüpfen, besonders dann, wenn, in einer Reihe aufgestellt, fünfzehn PerformerInnen Tiger aus Porzellan halten, so lange sie können.

36 Slavoj Žižek, *Denn sie wissen nicht, was sie tun. Genießen als ein politischer Faktor*, Wien: Passagen Verlag, 1994, S. 259.
37 Ebd., S. 264.
38 Vgl. Sabine Folie, S. 119 in diesem Katalog.
39 Ebd.
40 Johannes Friedrich Lehmann, *Der Blick durch die Wand. Zur Geschichte des Theaterzuschauers und des Visuellen bei Diderot und Lessing*, Freiburg im Breisgau: Rombach, 2000, S. 331.

Dank

Gedankt sei an dieser Stelle all jenen, die zur Realisierung dieses Projekts beigetragen haben, allen voran Sabine Folie für ihr Vertrauen und ihre Zustimmung, diese Ausstellung für die Generali Foundation realisieren zu dürfen. Herzlich danken möchte ich allen KünstlerInnen – Harun Farocki, Omer Fast, Michael Fliri, Andrea Geyer, Marcello Maloberti, Aernout Mik, Frédéric Moser & Philippe Schwinger, Wendelien van Oldenborgh, Judy Radul, Allan Sekula und Ian Wallace – für ihre Bereitschaft, an der Ausstellung teilzunehmen. Mit Daina Augaitis, Bruce Grenville, Emmy Lee, Kim Svendsen, Euridice Arratia, Stephanie Schneider, Philipp Selzer, Jorma Saarikko, Catriona Jeffries, Sandra Blimke, Brady Marks, Wilfried Lentz, Jocelyn Wolff, Alexander Koch, Nikolaus Oberhuber und Serena Porrati danke ich den LeihgeberInnen, GaleristInnen und allen MitarbeiterInnen für ihre Kooperation und ihre Unterstützung bei allen die KünstlerInnen und ihre Werke betreffenden Fragen. Auch den Sponsoren, der Mondriaan Foundation, Pro Helvetia, der italienischen Botschaft und dem Canada Council for the Arts, möchte ich an dieser Stelle meinen Dank aussprechen.

Susanne Knaller und Christian Schulte gilt mein herzlicher Dank für ihre Beiträge zu diesem Katalog. Christian Schulte sei vor allem auch für die anregenden Gespräche gedankt. Danken möchte ich auch Sabine Folie, Georgia Holz, Katharina Menches und Rolf Wienkötter für ihre Texte zu den KünstlerInnen und deren in der Ausstellung gezeigten Werken.

Besonders danke ich Katharina Menches für ihr Engagement bei der Koordination der Erstellung des Katalogs. Gedankt sei auch den Übersetzern Nicholas Grindell und Gerrit Jackson, den LektorInnen Anna Drechsel-Burkhard, Wolfgang Astelbauer und Michael Strand sowie Martha Stutteregger für die grafische Umsetzung und Markus Wörgötter für die Bildbearbeitung.

Ohne die großartige Unterstützung des Teams der Generali Foundation hätte diese Ausstellung nicht realisiert werden können: Allen voran möchte ich Katharina Menches und Thomas Ehringer danken. Katharina Menches hat dieses Projekt von Anfang an begleitet. Ihr Input in allen inhaltlichen und organisatorischen Belangen waren für das Gelingen dieses Projekts ebenso maßgebend wie das Feingefühl und das Verständnis für das Konzept der Ausstellung, das Thomas Ehringer in die Gestaltung und räumliche Übersetzung gelegt hat. Danken möchte ich auch Dietmar Ebenhofer für die audiovisuelle Umsetzung, die gerade bei dieser Ausstellung einen wichtigen Stellenwert einnimmt, Barbara Mahlknecht für die ausgezeichnete Pressearbeit, ihre Geduld und ihr engagiertes Begleiten der Ausstellung sowie Georgia Holz, die in letzter Minute eingesprungen ist und die Koordination der Performances übernommen hat.

Roland Barthes
Diderot, Brecht, Eisenstein

für André Téchiné

Nehmen wir an, Mathematik und Akustik wären seit den alten Griechen durch einen ähnlichen Status und eine ähnliche Geschichte verbunden; nehmen wir an, dieser im Grunde pythagoreische Raum wäre zwei oder drei Jahrtausende hindurch mehr oder weniger verdrängt worden (Pythagoras ist der Namenspatron des Geheimnisses); nehmen wir schließlich an, angesichts dieser Verwandtschaft hätte sich seit eben diesen Griechen eine weitere Verbindung eingestellt, hätte sie an Bedeutung überragt und sie in den Künsten ständig überflügelt – die Verbindung zwischen der Geometrie und dem Theater. Das Theater ist tatsächlich jene Praxis, die einkalkuliert, *wo* die Dinge *gesehen werden:* Bringe ich das Geschehen hier an, so wird der Zuschauer das sehen; bringe ich es dort an, so wird er es nicht sehen, und ich kann dieses Versteck benutzen, um mit einer Illusion zu spielen. Die Bühne ist jene Linie, die sich quer durch das optische Bündel zieht und es in seiner Entfaltung gleichsam begrenzt: Somit wäre als Widerpart zur Musik (zum Text) die *Abbildung* begründet.

Die Abbildung wird nicht unmittelbar durch die Nachahmung definiert: Würde man von Begriffen wie das „Wirkliche", die „Wirklichkeitstreue" oder „Kopie" absehen, so bliebe immer noch die „Abbildung", solange ein Subjekt (Autor, Leser, Zuschauer oder Voyeur) seinen *Blick* auf einen Horizont richtet und darin die Basis eines Dreiecks ausschneidet, dessen Scheitelpunkt von seinem Auge (oder seinem Geist) gebildet wird.

Das Organon der Abbildung (das sich heute, da sich *etwas anderes* abzeichnet, schreiben lässt) wird auf einem doppelten Fundament ruhen, auf der Souveränität des Ausschnitts und auf der Einheit des Subjekts, das den Ausschnitt vornimmt. Auf die Art der Künste wird es also kaum ankommen; gewiss sind das Theater und der Film unmittelbarer Ausdruck der Geometrie (es sei denn, sie betreiben eine seltene Erforschung der Stimme, der Stereophonie), aber auch der klassische (lesbare) literarische Diskurs, der seit langem auf die Prosodie, die Musik, verzichtet, ist ein geometrischer Abbildungsdiskurs, insofern er Teile ausschneidet, um sie zu bemalen: Diskurrieren (hätten die Klassiker gesagt) heißt nur, „das im Geiste vorhandene Bild ausmalen". Die Bühne, das Gemälde, die Aufnahme, das ausgeschnittene Rechteck sind die *Voraussetzung,* von der her das Theater, die Malerei, der Film und die Literatur denkbar sind, das heißt alle Künste, die nicht Musik sind und sich somit als *dioptrische Künste* bezeichnen ließen. (Gegenprobe: Im musikalischen Text lässt sich nicht das geringste Bild ausmachen, es sei denn, man unterwirft ihn dem dramatischen Genre; aus ihm lässt sich nicht der geringste Fetisch heraustrennen, es sei denn, er wird durch die Verwendung als Gassenhauer verdorben.)

Die gesamte Ästhetik Diderots beruht bekanntlich auf der Gleichsetzung der Theaterbühne mit dem gemalten Bild: Das perfekte Stück ist eine Abfolge von Bildern, das heißt eine Galerie, eine Ausstellung: Die Bühne bietet dem Zuschauer „ebenso viele wirkliche Bilder wie es in der Handlung für den Maler günstige Momente gibt". Das Bild (in der Malerei, im Theater, in der Literatur) ist ein unumkehrbarer, unzersetzbarer, reiner Ausschnitt mit sauberen Rändern, der seine ganze unbenannte Umgebung ins Nichts verweist und all das ins Wesen, ins Licht, ins Blickfeld rückt, was er in sein Feld aufnimmt; diese demiurgische Diskriminierung impliziert einen hochstehenden Gedanken: Das Bild ist intellektuell, es besagt etwas (Moralisches, Gesellschaftliches), es sagt aber auch, dass es weiß, wie es dies zu sagen gilt; es ist zugleich bezeichnend und propädeutisch, eindringlich und reflexiv, rührend und sich der Mittel und Wege der Rührung bewusst. Die epische Szene Brechts, die Eisensteinsche Einstellung sind Bilder; sie sind *hergerichtete Szenen* (wie man sagt: *Der Tisch ist gerichtet*), die perfekt der Diderotschen Theorie der dramatischen Einheit entsprechen: fein säuberlich ausgeschnitten (vergessen wir nicht, dass Brecht die italienische Bühne duldete und wie sehr er die unscharfen Bühnen: die Freilichtbühne, das Rundtheater verachtete), einen Sinn herausstellend, aber die Hervorbringung dieses Sinns manifestierend und die Deckung des visuellen Ausschnitts mit dem gedanklichen Ausschnitt vollziehend. Nichts trennt die Eisensteinschen Aufnahmen vom Gemälde eines Greuze (außer natürlich das hier moralische, dort soziale Anliegen); nichts trennt die epische Szene von der Eisensteinschen Aufnahme (außer dass bei Brecht das Bild der Kritik des Zuschauers anheimgegeben wird, nicht seiner Zustimmung).

Ist das Bild (da es ein Ausschnitt ist) ein Fetischobjekt? Ja, auf der Ebene des gedanklichen Ausschnitts (das Gute, der Fortschritt, das Anliegen, das Einsetzen der guten Geschichte), nein, auf der Ebene seiner Komposition. Genauer gesagt, lässt sich durch den *Aufbau* der Begriff Fetisch verlagern und der Aspekt des liebesbedingten Zerlegens erweitern. Einmal mehr ist Diderot der Theoretiker dieser Dialektik des Begehrens; in dem Artikel „Composition" schreibt er: „Ein gut aufgebautes Bild ist ein unter einem einzigen Gesichtspunkt geschlossenes Ganzes, in dem die Teile ein und dasselbe Ziel anstreben und durch ihre wechselseitige Entsprechung eine ebenso wirkliche Ganzheit bilden wie die Gliedmaßen bei einem Tierkörper; folglich gebührt einem Gemälde, das aus einer großen Zahl zufällig hingeworfener Figuren ohne Proportion, Zusammenhang und Einheit besteht, genauso wenig die Bezeichnung *wirkliche Komposition,* wie wirr auf einem Blatt verstreuten Studien von Beinen, Nasen und Augen die Bezeichnung *Porträt* oder gar *menschliche Gestalt* gebührt." Hier wird der Leib ausdrücklich in den Bildgedanken eingebracht, aber der ganze Leib; die durch die Montage angeordneten und gleichsam magnetisch aufgeladenen Organe funktionieren im Namen einer Transzendenz, der der *Gestalt,* die den gesamten Gehalt des Fetischs aufnimmt und zum sublimen Vertreter des Sinns wird. (Man hätte vermutlich keine Mühe, im nachbrechtschen Theater oder im nacheisensteinschen Film Inszenierungen auszumachen, die durch die Aufsplitterung des Bildes geprägt sind, die „Zerstückelung" der Komposition, die Wanderung der „Teilorgane" der Figur, kurz, durch die Eindämmung des metaphysischen Sinns des Werks, aber auch seines politischen Sinns – oder zumindest die Übertragung dieses Sinns auf eine andere Politik.)

Brecht hat deutlich darauf hingewiesen, dass im epischen Theater (das mit aufeinanderfolgenden Bildern arbeitet) der gesamte signifikante und reizvolle Gehalt in jeder Einzelszene steckt, nicht im Ganzen; auf der Ebene des Stücks gibt es keine Entfaltung, kein Heranreifen, zwar einen gedanklichen in jedem Bild enthaltenen Sinn, aber keinen letzten Sinn, nichts als Ausschnitte, von denen jeder ein hinreichendes Demonstrationsvermögen besitzt. Desgleichen bei Eisenstein: Der Film ist eine Kontiguität von Episoden, von denen jede absolut signifikant, ästhetisch perfekt ist; es ist ein Kino, das zum Anthologischen neigt: Es selber reicht dem Fetischisten gleichsam vorgestanzt das Stück, das dieser je nach Belieben im Interesse seiner Lust heraustrennen und mitnehmen soll (heißt es nicht, dem *Panzerkreuzer Potemkin* irgendeiner Cinemathek fehle ein Stück des Films – natürlich die Szene mit dem Kinderwagen –, die von irgendeinem Liebhaber herausgetrennt und gestohlen wurde, ganz so, wie man das mit dem Zopf, dem Handschuh oder der Unterwäsche einer Frau tut?). Das primäre Vermögen Eisensteins beruht auf folgendem: *Das Einzelbild ist nicht langweilig,* man ist nicht gezwungen, das folgende abzuwarten, um zu

begreifen und gefesselt zu werden: keine Dialektik (jene Zeit des Geduldens, die für manche Freuden erforderlich ist), sondern ein beständiger Genuss, der aus einer Summierung perfekter Augenblicke besteht.

An diesen perfekten Augenblick hatte Diderot natürlich gedacht (und hatte ihn durchdacht). Um eine Geschichte zu erzählen, verfügt der Maler nur über einen Augenblick: den, den er auf der Leinwand festhalten wird; diesen Augenblick muss er demnach sorgfältig auswählen, ihn von vornherein so einrichten, dass er ein Höchstmaß an Sinn und Lust hergibt: Als zwangsläufig totaler wird dieser Augenblick künstlich sein (irreal: diese Kunst ist nicht realistisch), er wird eine Hieroglyphe sein, aus der sich auf einen Blick (aus einer Einstellung, wenn wir zum Theater, zum Film übergehen) die Gegenwart, die Vergangenheit und die Zukunft herauslesen lassen, das heißt der historische Sinn der dargestellten Geste. Diesen entscheidenden, absolut konkreten und abstrakten Augenblick wird Lessing (im *Laokoon*) als *prägnanten Augenblick* bezeichnen. Das Theater Brechts, die Filme Eisensteins sind Abfolgen prägnanter Augenblicke: Wenn Mutter Courage in das Geldstück beißt, das ihr der anwerbende Feldwebel hinhält, und durch diese sehr kurze Zeit des Misstrauens ihren Sohn entkommen lässt, führt sie zugleich ihre Vergangenheit als Händlerin vor und die Zukunft, die ihr bevorsteht: dass alle ihre Kinder aufgrund ihres verblendeten Krämergeistes umkommen. Wenn (in der *Generallinie*) die Bäuerin ihren Unterrock zerreißen lässt und mit diesem Stoff der Traktor repariert wird, birgt diese Geste eine Geschichte: Die Prägnanz versammelt den vergangenen Sieg (den der bürokratischen Schlamperei mühsam abgerungenen Traktor), den gegenwärtigen Kampf und die Wirksamkeit der Solidarität. Der prägnante Augenblick ist durchaus die Anwesenheit aller Abwesenheiten (Erinnerungen, Lektionen, Verheißungen), in deren Rhythmus die Geschichte zugleich intelligibel und begehrenswert wird.

Bei Brecht knüpft der *soziale Gestus* an die Idee des prägnanten Augenblicks an. Was ist ein *sozialer Gestus* (hat die reaktionäre Kritik nun zur Genüge über diesen Brechtschen Begriff gespottet, einen der intelligentesten und klarsten, den die dramaturgische Reflexion jemals hervorgebracht hat!)? Er ist eine Geste oder eine Gesamtheit von *Gesten* (aber nie ein Gestikulieren), aus der sich eine ganze soziale Situation herauslesen lässt. Nicht alle Gesten sind sozial: An den Bewegungen eines Mannes, der eine Fliege verjagt, ist nichts sozial, aber wenn sich eben dieser Mann, schlecht gekleidet, gegen Wachhunde wehrt, so wird der *Gestus* sozial; die Geste, mit der die Marketenderin die ihr gereichte Münze prüft, ist ein sozialer *Gestus;* der übertriebene Schriftzug, mit dem der Bürokrat der *Generallinie* seine Akten unterschreibt, ist ein sozialer *Gestus.* Wie weit können die sozialen *Gesten* reichen? Sehr weit, bis in die Sprache hinein: Eine Sprache kann gestisch sein, sagt Brecht, wenn sie gewisse Haltungen anzeigt, die der Sprecher anderen gegenüber einnimmt: „Reiße das Auge, das dich ärgert, aus" ist gestisch ärmer als „Wenn dich dein Auge ärgert, reiß es aus",

weil die Ordnung des Satzes, das Asyndeton, von dem er getragen wird, auf eine Situation der Prophezeiung und Rache verweist. Rhetorische Formen können also gestisch sein: Insofern ist es nutzlos, der Kunst Eisensteins (wie derjenigen Brechts) vorzuwerfen, sie wäre „formalistisch" oder „ästhetisch": Die Form, die Ästhetik und die Rhetorik können, wenn sie bewusst gehandhabt werden, für eine Gesellschaft stehen. Die Abbildung (denn um sie geht es hier) muss unweigerlich den sozialen *Gestus* einbeziehen: Sobald man „abbildet" (sobald man montiert, das Bild abschließt und das Ganze diskontinuiert), muss man entscheiden, ob der Gestus sozial ist oder nicht (ob er nicht auf eine bestimmte Gesellschaft verweist, sondern auf den Menschen schlechthin).

Was tut der Schauspieler im Bild (in der Szene, in der Einstellung)? Da das Bild einen gedanklichen Sinn vorführt, muss der Schauspieler das Wissen um diesen Sinn vorführen, denn der Sinn wäre nicht gedanklich, wenn er nicht sein eigenes Funktionieren beinhalten würde; nun ist aber das Wissen, das der Schauspieler durch einen ungewöhnlichen Zusatz in Szene setzen soll, weder sein menschliches Wissen (seine Tränen sollen nicht bloß auf die Gemütsverfassung eines Unglücklichen verweisen) noch sein schauspielerisches Wissen (er soll nicht zeigen, dass er gut spielen kann). Der Schauspieler soll beweisen, dass er dem Zuschauer nicht unterjocht ist (nicht an der „Wirklichkeit", an der „Menschlichkeit" klebt), sondern dass er den Sinn seiner Idealität zuführt. Diese Souveränität des Schauspielers, der über den Sinn gebietet, ist bei Brecht deutlich ersichtlich, da er sie unter dem Begriff „Verfremdung" theoretisiert hat; sie ist es nicht weniger bei Eisenstein (zumindest beim Autor der *Generallinie,* auf den ich mich hier beziehe), und zwar nicht aufgrund einer rituellen, zeremoniellen Kunst – wie Brecht sie forderte –, sondern durch die Betonung des sozialen Gestus, der ohne Unterlass sämtliche Gesten der Schauspieler prägt (sich ballende Fäuste, nach einem Werkzeug greifende Hände, Bauern vor dem Schalter des Bürokraten usw.). Allerdings nimmt der Schauspieler bei Eisenstein, wie auch bei Greuze (einem in Diderots Augen beispielhaften Maler), mitunter einen äußerst pathetischen Ausdruck an, und dieses Pathos mag recht wenig „verfremdet" erscheinen; nun ist die Verfremdung ein typisch Brechtsches Verfahren, das Brecht benötigt, weil er ein Bild darstellt, das vom Zuschauer kritisiert werden soll; bei den anderen beiden hat der Schauspieler nicht unbedingt zu verfremden; er soll einen idealen Wert vorführen; es genügt folglich, dass der Schauspieler die Hervorbringung dieses Werts eben durch die Maßlosigkeit seines Spiels „freilegt", spürbar, intellektuell sichtbar werden lässt: Der Ausdruck bedeutet dann eine Idee – weshalb er übertrieben ist –, nicht einen Naturzustand; wir sind weit entfernt von den Mienen des Actor's Studio, deren so gepriesene „Zurückhaltung" keinen anderen Sinn hat als den persönlichen Ruhm des Schauspielers (ich verweise zum Beispiel auf die Miene Brandos in *Der letzte Tango in Paris*).

Hat das Bild ein „Sujet" (englisch: *topic*)? Keineswegs; es hat einen Sinn, keinen Gegenstand. Der Sinn beginnt beim sozialen *Gestus* (beim prägnanten Augenblick); außerhalb des *Gestus* gibt es nur Vages, Insignifikantes. „In einer Weise", sagt Brecht, „haben die Stoffe an und für sich etwas Naives, Qualitätsloses, Leeres und Selbstgenügsames. Erst der gesellschaftliche Gestus, die Kritik, die List, die Ironie, die Propaganda und so weiter bringen das Menschliche hinein"; und Diderot fügt (wenn man so sagen kann) hinzu: Die Schöpfung des Malers oder Dramatikers liegt nicht in der Wahl eines Gegenstands, sie liegt in der Wahl des prägnanten Augenblicks, des Bildes. Es kommt letztlich nicht darauf an, dass Eisenstein seine „Gegenstände" der Vergangenheit Russlands und der Revolution entnommen hat, und nicht, „wie er hätte sollen" (sagen seine heutigen Kritiker), der Gegenwart des sozialistischen Aufbaus (außer in der *Generallinie*), es kommt nicht auf den Panzerkreuzer oder den Zaren an, das sind nur vage und leere „Gegenstände", von Belang ist nur der *Gestus,* die kritische Demonstration der Geste, die Einschreibung dieser Geste, welcher Zeit sie auch angehören mag, in einen Text, dessen sozialer Hintergrund sichtbar ist. Der Gegenstand fügt nichts hinzu und nimmt nichts weg. Wie viele Filme gibt es heute „über" Drogen, deren „Gegenstand" die Droge ist? Ein nichtssagender Gegenstand; ohne sozialen *Gestus* ist die Droge insignifikant oder ihre Signifikanz eher die einer vagen und leeren, ewigen Natur: „Die Droge macht impotent" (*Trash*), „die Droge treibt in den Selbstmord" (*Absences répétées*). Der Gegenstand ist ein falscher Ausschnitt: Warum eher diesen Gegenstand als einen anderen? Das Werk beginnt erst beim Bild, wenn der Sinn in die Geste und in die Koordination der Gesten gelegt wird. Nehmen Sie *Mutter Courage*: Das „Sujet" dieses Stücks ist nicht der Dreißigjährige Krieg oder sogar eine allgemeine Verurteilung des Krieges; nicht darin liegt der *Gestus* des Stücks: Er liegt in der Verblendung der Marketenderin, die vom Krieg zu leben glaubt und durch ihn umkommt; mehr noch, er liegt in der *Sicht* des Zuschauers auf diese Verblendung.

Im Theater, im Film und in der traditionellen Literatur werden die Dinge immer von *irgendwoher* gesehen, das ist das geometrische Fundament der Abbildung: Es bedarf eines Fetischobjekts, um das Bild anzuordnen. Dieser Ursprungsort ist immer das Gesetz: das Gesetz der Gesellschaft, das Gesetz des Kampfes, das Gesetz des Sinns. Die engagierte Kunst kann folglich immer nur abbildend, gesetzlich sein. Soll die Abbildung ihren Ursprung einbüßen und ihre geometrische Natur übersteigen, ohne aufzuhören, Abbildung zu sein, so ist dafür ein enorm hoher Preis zu entrichten: nicht weniger als der Tod. In *Vampir* von Dreyer wandert die Kamera, wie mir ein Freund sagt, vom Haus zum Friedhof und nimmt auf, *was der Tote sieht:* Das ist der Grenzpunkt, wo die Abbildung vereitelt wird: Der Zuschauer kann keine Stelle mehr einnehmen, da er sein Auge nicht mit den geschlossenen Augen des Toten identifizieren kann; das Bild hat keinen Ausgangspunkt, keine Stütze, es klafft. Alles, was diesseits dieser Grenze

passiert (das ist der Fall bei Brecht, bei Eisenstein), kann nur gesetzlich sein: Letztlich ist es das Gesetz der Partei, das die epische Szene, die Filmaufnahme montiert, es ist dieses Gesetz, das betrachtet, einstellt, zentriert und aussagt. Und auch hier schließen Eisenstein und Brecht an Diderot an (den Fürsprecher der zahmen und bürgerlichen Tragödie, wie seine beiden Nachfolger die Fürsprecher einer sozialistischen Kunst waren). Diderot unterschied in der Malerei vorrangige Praktiken mit kathartischer Bedeutung, die die Gedanklichkeit des Sinns anstreben, und zweitrangige, rein nachahmende, anekdotische Praktiken; auf der einen Seite Greuze, auf der anderen Chardin; anders ausgedrückt, in einer aufsteigenden Phase bedarf jede Physik der Kunst (Chardin) der Krönung durch eine Metaphysik (Greuze). Bei Brecht, bei Eisenstein existieren Chardin und Greuze nebeneinander (der verwickeltere Brecht überlässt es seinem Publikum, der Greuze des Chardin zu sein, den er ihm vor Augen führt): Wie könnte die Kunst in einer Gesellschaft, die noch nicht zur Ruhe gekommen ist, aufhören, metaphysisch zu sein, das heißt: bedeutungstragend, lesbar, darstellend? Fetischistisch? Wann kommt die Musik, der Text?

Brecht kannte anscheinend Diderot kaum (allenfalls vielleicht das *Paradox*). Gerade auf ihn kann sich jedoch rein zufällig die vorgeschlagene Dreiteilung berufen. Um 1937 kam Brecht auf den Gedanken, als Sammelstelle für Theaterexperimente und -studien eine Diderot-Gesellschaft zu gründen, weil er in Diderot vermutlich über den großen materialistischen Philosophen hinaus auch einen Praktiker des Theaters sah, dessen Theorie auf Lust und Belehrung gleichermaßen bedacht war. Brecht stellte das Programm dieser Gesellschaft auf; er machte daraus ein Rundschreiben, das er wem zuschicken wollte? Piscator, Jean Renoir und Eisenstein.

Französisches Original in: *Cinéma, Théorie, Lectures* (Sonderausgabe der *Revue d'esthétique*),1973.

Deutsche Übersetzung in: *Der entgegenkommende und der stumpfe Sinn. Kritische Essays III*, Übers. Dieter Hornig, Frankfurt am Main: Suhrkamp, 1990, S. 94–102.

Christian Schulte
Hinter die Bilder greifen

Versuche über die Wiederherstellung des Abstands

Vorspann

Das mit der Metapher der Vierten Wand beschriebene Dispositiv, das
die Trennung zwischen den Vorgängen auf der Bühne und dem Zuschauer-
raum, zwischen Darstellung und Wahrnehmung regulierte, verlor an
Geltung in dem Maße, in dem die Legitimationsprobleme der bürgerlichen
Gesellschaft offen zutage traten. Der vermeintlich geschlossene Raum
der Bühnenhandlung korrespondierte im 18. Jahrhundert mit den Intim-
bereichen familiärer Privatheit, in denen sich ein neues Selbstbewusstsein
formieren konnte. Es entspann sich eine Dialektik zwischen der morali-
schen und rational begründbaren Integrität des aufstrebenden Bürgertums
und den Statusprivilegien des Adels, die vom Vernunftparadigma der
Aufklärung als illegitim skandalisiert wurden. Öffentlicher Verhandlungs-
ort dieser Dialektik war unter anderem die Theaterbühne. Diderots
Konzept der Vierten Wand eröffnete dem Zuschauer die Option, imaginativ
eine andere Möglichkeit seiner selbst zu erproben, ohne aus der sicheren
Deckung des Zuschauerraums heraustreten zu müssen. Diese Anordnung
erlaubte ihm, sich in die Situation hinter der unsichtbaren Mauer hinein-
zuspinnen und durch die Stellvertreterfiguren auf der Bühne hindurch sein
Räsonnement öffentlich zur Schau zu stellen. Die Bühne der Aufklärung
machte die Probe auf die moralische Souveränität ihrer Adressaten.[1]

Figuren des Übergangs

Zu einer Reflexionsfigur ganz anderer Art wird die Vierte Wand in der Moderne. Der fundamentale Erfahrungswandel, der sich im Zeitalter industrieller Massenproduktion vollzog, hatte zur Folge, dass die Privatheit als Ort der Genese von Individualität mehr und mehr außer Kurs geriet. Walter Benjamin hat gezeigt, wie sich dieser Prozess, an dessen Ende der *außengeleitete Mensch* steht, bereits in der ersten Hälfte des 19. Jahrhunderts vorbereitet hat. Er nennt drei Stationen: In *Des Vetters Eckfenster* (1822) beschreibt E. T. A. Hoffmann noch eine stabile Beobachterposition, die dem bürgerlichen Subjekt aus sicherer Distanz den Blick vom Interieur der Beletage auf den von der Menge durchfluteten Platz erlaubt; knapp zwei Jahrzehnte später treten bei Edgar Allan Poe, in *The Man of the Crowd* (1840), eine geminderte Form der Subjektivität und ein fragil gewordenes Blickregime auf den Plan, das sich nur mimetisch, in der Anpassung an das Tempo der Straße, bewährt. Verkörpert wird es von einem Vorläufer des Flaneurs, der von Poes Erzähler, einer Variante des Detektivs, durch die Menge verfolgt wird. Bei Baudelaire zergeht die Subjektivität bereits in der Erfahrung des Ephemeren: In seinem Gedicht *À une passante* (1857) beschreibt er, wie das Begehren rhythmisiert vom Wogen der großstädtischen Masse plötzlich entsteht und im nächsten Moment, in dem die Erscheinung aus dem Blickfeld verschwunden ist, wieder erlischt.[2] Das Zeitmaß der Dauer erodiert in dem Maße, in dem die Wahrnehmungsverhältnisse im Wandel begriffen sind. Kunst wird zum Medium der Trauer um den erfüllten Augenblick, die verlorene Zeit.

1 Vgl. Rolf Grimminger, „Aufklärung, Absolutismus und bürgerliche Individuen. Über den notwendigen Zusammenhang von Literatur, Gesellschaft und Staat in der Geschichte des 18. Jahrhunderts", in: *Hansers Sozialgeschichte der deutschen Literatur*, Bd. 3: *Deutsche Aufklärung bis zur Französischen Revolution 1680–1789*, Hg. Rolf Grimminger, München/Wien: Hanser, 1980, S. 15–99; Iwan-Michelangelo D'Aprile und Winfried Siebers, *Das 18. Jahrhundert. Zeitalter der Aufklärung*, Berlin: Akademie Verlag, 2008; Doris Kolesch, *Theater der Emotionen. Ästhetik und Politik zur Zeit Ludwigs XIV.*, Frankfurt/New York: Campus Verlag, 2006, S. 237–255.

2 Walter Benjamin, „Über einige Motive bei Baudelaire", in: *Gesammelte Schriften*, Bd. I, Hg. Rolf Tiedemann und Hermann Schweppenhäuser, Frankfurt am Main: Suhrkamp, 1972–1999, S. 622–629.

3 Am eindringlichsten vielleicht Walter Benjamin 1928 in seiner Denkbilder-Sammlung *Einbahnstraße*, wo es heißt: „Kritik ist eine Sache des rechten Abstands. Sie ist in einer Welt zu Hause, wo es auf Perspektiven und Prospekte ankommt und einen Standpunkt einzunehmen noch möglich war. Die Dinge sind indessen viel zu brennend der menschlichen Gesellschaft auf den Leib gerückt. Die ‚Unbefangenheit', der ‚freie Blick' sind Lüge, wenn nicht der ganz naive Ausdruck planer Unzuständigkeit." In: *Gesammelte Schriften*, Bd. IV, S. 131.

4 Sigmund Freud, *Vorlesungen zur Einführung in die Psychoanalyse*, in: *Studienausgabe*, Bd. 1, Frankfurt am Main: Fischer, 1982, S. 283–284.

5 Walter Benjamin, *Das Passagen-Werk*, in: *Gesammelte Schriften*, Bd. V, S. 181.

6 Benjamin, „Das Kunstwerk im Zeitalter seiner technischen Reproduzierbarkeit", in: *Gesammelte Schriften*, Bd. I, S. 499–500.

Tempo und erstickte Perspektiven

Aus der Grenze zwischen Privatheit und Öffentlichkeit wird eine transitorische Schwelle. Es wird zur Gewissheit, dass intakte Subjektivität unter den Bedingungen immer abstrakter werdender Lebensverhältnisse nicht zu haben ist. Unter den Bedingungen der rationalisierten Arbeitswelt – Taylorismus, Fordismus – wird der Zeitgenosse der Moderne eingepasst in automatisierte Prozesse. Das Tempo auf den Straßen der Großstadt und die Geschwindigkeit des Fließbands scheinen einander zu überbieten. Vom Druck der Arbeitszeitmessung entlasten die Zerstreuungsangebote in den Luna Parks und den Varietés, zugleich wiederholen sie die Anpassung, nur jetzt auf spielerische Weise, indem sie Libido und Fungibilität kurzschließen. Jede Form des Bei-sich-selber-Seins wird zur Ideologie. Die Intellektuellen konstatieren den *Aufstand der Dinge*[3], die Slapstick-Groteske illustriert ihn, in Chaplins Film *Modern Times* ist er längst vollzogen, ist die Überlegenheit der Maschinen offenbar. Für Freud ist das Ich nicht mehr „Herr [...] im eigenen Haus".[4] In einer Welt der Immanenz scheint es kein Außen mehr zu geben. „Die erstickte Perspektive", sagt Benjamin, „ist Plüsch für das Auge."[5]

Plüsch ist der Feelgood-Faktor, der als Suchtstoff den Produkten der Kulturindustrie unmerklich beigemischt ist. Hier kommt die Vierte Wand wieder ins Spiel, sie hat ihr Fortleben auf reaktionärste Weise als Kinoleinwand gesichert – solange die Diegesen hermetisch abgeriegelt sind. Der direkte Blick in die Kamera ist nur als subjektive Einstellung im Setting von Schuss und Gegenschuss erlaubt – so will es die regelpoetische Borniertheit klassischer Kinematographie. Was Benjamin in den 1930er Jahren dem Film, genauer der Filmmontage, als wesenhaft zuschreibt, gilt nur für jene Formen filmischer Kunst, die sich gegenüber der Illusionierung abstinent verhalten.

> Unsere Kneipen und Großstadtstraßen, unsere Büros und möblierten Zimmer, unsere Bahnhöfe und Fabriken schienen uns hoffnungslos einzuschließen. Da kam der Film und hat diese Kerkerwelt mit dem Dynamit der Zehntelsekunden gesprengt, so daß wir nun zwischen ihren weitverstreuten Trümmern gelassen abenteuerliche Reisen unternehmen.[6]

Die These vom Explosivcharakter der Montage ist medienontologisch nicht haltbar. Wofür Eisenstein und vor allem Vertov ohne Weiteres bürgen können, wäre bei Griffith bereits genauer zu befragen. Die dialektische Montage Eisensteins arbeitet sich bei aller Tendenz zur Begriffsbildung immerhin an sozialen Widersprüchen, an realen Kontrasten ab; Dziga Vertov spielt mit seinem Kino-Glaz-Konzept die Überlegenheit des technischen Apparats gegenüber dem menschlichen Auge aus, sodass dieses – etwa bei der Projektion von *Der Mann mit der Kamera* (1929) – mit einem

Multiperspektivismus konfrontiert ist, wie er sonst nur von der kubistischen Malerei bekannt war. Dagegen können die Parallelmontagen bei David W. Griffith bereits als frühe Formen jener spannungsdramaturgischen Schematismen angesehen werden, die in der Folge vom Studiosystem Hollywoods zum Inbegriff des essentiell Filmischen entwickelt werden.

Aus einem Medium der Subjektkonstitution – eben Diderots Vierter Wand – wird in der Moderne, die den Einzelnen zum Verschwinden bringt, tendenziell ein Verblendungsinstrument, das im dominanten Medium des 20. Jahrhunderts, dem Mainstreamkino, seine immersive Kraft erst voll zur Entfaltung bringen kann. Gegen diese heute längst perfektionierte und industriell betriebene Enteignung von Erfahrung, von eigenem Sinn, richten sich die Interventionen der avancierten Kunst seit Meyerhold und Brecht.

Gegengifte

Dass die Welt voller „Möglichkeitssinn"[7] ist, führt Brechts Stück *Mann ist Mann* (1926) drastisch vor Augen: Ein Mann verlässt das Haus, um einen Fisch zu kaufen, doch er kehrt nicht zurück, sondern landet bei der Fremdenlegion. Brecht zerstört den Mythos von der souveränen Persönlichkeit, indem er zeigt, wie ein Mensch sich umbauen lässt, wenn entsprechende Umstände eintreten. Dass die Soldaten nicht in kollektiver Begeisterung ins Feld ziehen, sondern „einrückend gemacht" werden, hatte bereits Karl Kraus hervorgehoben.[8]

Wenn die Stücke inhaltlich darauf insistieren, dass jederzeit alles passieren kann, dann hat diese Kontingenzbehauptung Konsequenzen auch für die Formen der Inszenierung. Diese kann nur authentisch sein, wenn sie den Zuschauer in das Spiel mit der Unberechenbarkeit einbezieht und ihm die Illusion nimmt, dass der Zuschauerraum irgendeine Sicherheit verbürgen könnte. „Entdeckung der Zustände" – so lautet das Programm einer die Vierte Wand skandalisierenden Kunst. Sie zielt auf die Herstellung eines Mehrwerts an Erfahrung und Erkenntnis, und das heißt immer

7 Vgl. Robert Musil, *Der Mann ohne Eigenschaften*, Hg. Adolf Frisé, Reinbek bei Hamburg: Rowohlt, 1978, S. 16–18.
8 Karl Kraus, *Weltgericht I*, Hg. Christian Wagenknecht, Frankfurt am Main: Suhrkamp, 1988, S. 238.
9 In seinem Film *Gelegenheitsarbeit einer Sklavin* (1973) zitiert Alexander Kluge folgendes Diktum von Friedrich Engels und lenkt die Aufmerksamkeit der Zuschauer damit auf die selbstflexive Ebene des Films: „Alles, was die Menschen in Bewegung setzt, muß durch ihren Kopf hindurch; aber welche Gestalt es in diesem Kopf annimmt, hängt sehr von den Umständen ab." Alexander Kluge, *Gelegenheitsarbeit einer Sklavin. Zur realistischen Methode*, Frankfurt am Main: Suhrkamp, 1975, S. 143.
10 Benjamin, „Der destruktive Charakter", in: *Gesammelte Schriften*, Bd. IV, S. 396.
11 Bertolt Brecht, „Anmerkungen zur Oper ‚Aufstieg und Fall der Stadt Mahagonny'", in: Brecht, *Gesammelte Werke*, Bd. 17, Frankfurt am Main: Suhrkamp, 1967, S. 1010.
12 Benjamin, *Ursprung des deutschen Trauerspiels*, in: *Gesammelte Schriften*, Bd. I, S. 212.
13 Benjamin, „Was ist das epische Theater? Eine Studie über Brecht", in: *Gesammelte Schriften*, Bd. II, S. 519, 521, 529.

auch: auf die Konfrontation mit dem eigenen Passivismus. Es heißt aber auch: Entdeckung der Umstände, die der eigenen Wahrnehmung und Reflexion ihren Rahmen setzen.[9]

Es geht darum, die eingezogenen Abstände und verstellten Perspektiven zurückzugewinnen bzw. freizulegen und so Spiel- und Handlungsräume zu eröffnen. Es sind destruktive, eingreifende Gesten, die sich zum Arsenal eines ästhetischen Kriseninterventionismus zusammenfügen. Benjamins allegorische Figur des destruktiven Charakters kennt dementsprechend „nur eine Parole: Platz schaffen; nur eine Tätigkeit: räumen".[10] Bezogen auf das organizistische Gesamtkunstwerk lautet die Parole der Kritik: „Trennung der Elemente"[11]; gegenüber dem roten Faden der kontinuierlichen Darstellung: „Kunst des Absetzens"[12]; und für die Durchbrechung der Vierten Wand lautet sie: „Verschüttung der Orchestra", „Unterbrechung der Handlung" und Zitierbarkeit der Gesten[13].

Wenn es um die Emanzipation, die Aktivierung des Zuschauers geht, so ist es nur konsequent, wenn die Kunst die definierten Dispositive des Theaters, des Kinos verlässt und in Räume emigriert, die eine pluralere Bespielbarkeit und radikalere Formen der Teilhabe zulassen. Ich möchte auf zwei Beispiele näher eingehen:

Entleerung der Bilder

„Ich kann die Fotografie nicht finden", sagt Karl Roßmann. „Was für eine Fotografie?", fragt Delamarche. „Die meiner Eltern", erwidert Roßmann. Es ist kaum ein Bild denkbar, das eine stärkere affektive Bindekraft besitzt als die Fotografie der Eltern. Sie repräsentiert ein Regime der Bedeutung. Ihre Abwesenheit motiviert Roßmanns Suche. In Danièle Huillets und Jean-Marie Straubs Film *Klassenverhältnisse* (1984) verweist sie zugleich reflexiv auf die Möglichkeit, den Blick von heteronomen Bindungen zu befreien.

Die Figur des Delamarche wird von Harun Farocki dargestellt. Es handelt sich noch nicht um eine Szene aus dem Film, sondern um die Probe einer seiner Szenen. Diesen Proben ist Farockis eigener Film gewidmet. Er beobachtet schlicht, wie Straub und Huillet arbeiten, zeichnet mit den einfachsten Mitteln präzise auf, mit welcher Aufmerksamkeit und wie detailversessen das Regiepaar zu Werke geht. Entsprechend schlicht ist sein Titel: *Jean-Marie Straub und Danièle Huillet bei der Arbeit an einem Film nach Franz Kafkas Romanfragment „Amerika"* (1983).

Vor der Arbeit am Set werden in einer Wohnung Dialoge einstudiert. Man sitzt auf dem Fußboden, trinkt Bier, raucht, ist entspannt und aufmerksam zugleich, eine brechtische Situation. Wieder und wieder wird die Betonung einer Silbe erprobt, überprüft und wieder verworfen. Ein repetitiver Umgang mit dem Material, der beinahe vergessen macht, dass am Ende dieses Prozesses ein Resultat steht: der fertige Film.

Straub/Huillet arbeiten den Materialwert der Sprache heraus. Das Resultat ist ein artifizielles Sprechen, das doch nie preziös oder ornamental

wirkt. Die Sprache wird ihrer Mitteilungsfunktion, ihrer konventionellen Gebrauchsform, entfremdet. Das Verfahren ist reduktiv, es zielt – analog zu Brechts Metapher des Messingkaufs – auf Rohstoffbildung, auf etwas, mit dem man vieles, nicht nur das eine Bekannte, machen könnte. Es gibt kaum Filmemacher, die den immersiven Möglichkeiten des Films eine radikalere Absage erteilt und die ihre Mittel kompromissloser denaturiert haben als Straub und Huillet. Stattdessen konstruieren sie Möglichkeitsräume, die den Rezipienten mehr abverlangen als bloße Wahrnehmung: nämlich eigentätige Zuarbeit. Eigensinn. Auf diesen Eigensinn zielt der Reduktionismus ihrer Arbeit, der auf die Entleerung nicht nur der Sprache, sondern vor allem der Bilder hinausläuft:

> Ein Bild muß stehen, ein Bild ist nicht etwas Beliebiges. Und ein Bild, wenn es steht, beschreibt nichts, ein Bild existiert, an sich, es hat schon den Alptraumcharakter. Aber es hat ihn umso mehr, wenn man das Gegenteil von dem tut, was die Gesellschaft tut. Das heißt: keine Inflation. Man versucht das Gegenteil von Inflation: alles zu verdichten, es zu suggerieren, indem man ein Minimum zeigt.[14]

Minimalistisch verfährt auch Farockis Dokumentation, die einfach aufzeichnet, was vor der Kamera passiert. Sein Interesse gilt dem Gegenstand, der Frage, wie Straub/Huillet ihre spezifische filmische Form finden, wie sie Sprache inszenieren, dem Aufbau der einzelnen Tableaus, aus denen sich die sequenziellen Einheiten ihrer Filme zusammensetzen – ein Aufbau, der eigentlich ein Abbau ist. Eine Ausdünnung des Sinns, eine Entleerung.[15] Farocki macht die lebendige Autorschaft hinter den durchkomponierten Bildern des fertigen Films sichtbar, er greift „hinter die Bilder"[16], indem er die kommunikativen Prozesse, die ihre Entstehung begleiteten, in den Fokus rückt. Bearbeiten Straub und Huillet in ihrem Film die lakonische Sprache Kafkas, so sind die Haltung und die Mittel, mit denen sie sich dem Material des Kafka-Textes nähern, die eigentlichen Gegenstände in

14 „Wie will ich lustig lachen, wenn alles durcheinandergeht. Danièle Huillet und Jean-Marie Straub sprechen über ihren Film *Klassenverhältnisse*", in: *Filmkritik*, Heft 9–10 (1984), S. 273.

15 Was Hans-Thies Lehmann über das postdramatische Theater schreibt, das gilt in weiten Teilen auch für die theateraffinen Filme von Straub/Huillet: „Das Theater des Sinnentwurfs und der Synthese und damit auch die Möglichkeit synthetisierender Aneignung schwand dahin. Lediglich ‚work in progress' bleibende, stotternde Antworten, partielle Perspektiven sind möglich, keine Ratschläge, geschweige Vorschriften." Hans-Thies Lehmann, *Postdramatisches Theater*, Frankfurt am Main: Verlag der Autoren, 1999, S. 26.

16 Mit dem Gestus des Hinter-die-Bilder-Greifens attribuiert der frühe Georg Lukács die Praxis des Kritikers und Essayisten. Lukács, *Die Seele und die Formen. Essays*, Neuwied/Berlin: Luchterhand, 1971, S. 13–14.

17 Vgl. *Allan Sekula. Performance under Working Conditions*, Hg. Sabine Breitwieser, Wien: Generali Foundation; Ostfildern: Hatje Cantz, 2003, S. 92–163.

Farockis Film. Nehmen wir die Arbeitsmetapher von der Suche nach dem
Bild wieder auf, dann handelt es sich bei Farockis Arbeit um die Suche
nach dem Bild hinter den Bildern, obwohl diese zum Zeitpunkt der Auf-
nahme noch gar nicht existierten. Und gerade deshalb wäre vielleicht in
diesem Suchbild ein utopisches Noch-Nicht enthalten, das Modell eines
(von Bedeutungen) freien Raums.

Das Jenseits der Bilder hören
Der amerikanische Performance- und Fotokünstler Allan Sekula muss
nicht nach der Fotografie seiner Eltern suchen wie Karl Roßmann. Er hat
sie selbst gemacht, und sie steht im Zentrum seiner Installation *Aerospace
Folktales* aus dem Jahre 1973.[17] Diese „Geschichten von der Luftfahrt"
werden auf den verschiedensten medialen Ebenen erzählt. Im Medium der
Fotografie, als Tonspur, auf der Interviews mit Vater und Mutter zu hören
sind, und als vom Künstler geschriebener Kommentar. Im Zentrum stehen
die Entlassung des Vaters, der Ingenieur bei Lockheed war, und die Frage
nach den Folgen dieser Entlassung für die Familie.

Sekulas Fotosequenz beschreibt Stationen eines Rückzugs: Ausgangs-
punkt ist der Arbeitsplatz des Vaters, der Flugzeughersteller Lockheed,
der sich 1969 in einem Fotobildband, aus dem Sekula zitiert, selbst für seine
„services for human progress and national defense" feiert. Wenig später
sehen wir den Vater auf dem leeren Parkplatz der Firma, dann mit Frau
und Tochter vor der Garage, dann groß im Doppelporträt mit seiner Frau
und schließlich die sterile, menschenleere Außenansicht des Hauses,
den gemähten Rasen und die ordentlich geschnittene Hecke. In wenigen
Bildern beschreibt Sekula den Prozess einer Privation allein durch die
Verengung der Perspektive.

Diese Dramaturgie der Enge findet ihre Fortsetzung im Inneren des
Hauses. Da sind die Plastikschonbezüge der Sessel, die von der Zimmer-
decke herabhängenden Modellflugzeuge, die mit inszenatorischem
Aufwand platzierten Familienfotos mit dem Vater als Mittelpunktsfigur;
all diese Spots aus dem alltäglichen Leben wirken wie kommunizierende
Röhren der verwalteten Welt, wie perfekte Umsetzungen jener „tenant
policies", die der Fotosequenz einverleibt wurden.

Die herausgesprengten Momentaufnahmen der Fotografien werden
durch den „Soundtrack" mit gesprochenen Legenden versehen: der Sohn
mit der Mutter, der Sohn mit dem Vater – zwei akusmatische Stimmen,
die keinen Ort zu haben scheinen, die aus einem unbestimmten Jenseits
im Ausstellungsraum vernehmbar werden. Anders als im Kino, in dem die
Zuordnung von Ton und Bild ebenso fixiert ist wie der Zuschauer an
seinem Platz, sind es hier die Bewegungen im Raum, die über die Kombi-
natorik von Foto und Dialog entscheiden – Suchbewegungen vielleicht, die
vom Gehörten justiert nach assoziativen Anschlüssen auf der Bildebene
fahnden. Suche nach dem integralen Bild. Nach einem Bild, das nicht allein

imaginativ sein eigenes Vorher und Nachher kontrahiert, sondern ebenso Ausdrucks- und Sinnpartikel anderer medialer Herkunft magnetisiert. Das integrale Bild wäre in höchstem Maße reflexiv, ein Nicht-Bild. Oder mit Jean-Luc Godard: „Eine Form, die denkt."[18] Die Vierte Wand der Fotografie kritisieren heißt, nach dem Jenseits des Bildes zu fragen, das Positiv ins Negativ zu übersetzen, so lange bis der Vietnamkrieg an den Rändern der Familienfotos aufscheint. Der prägnante Moment als dialektisches Bild. „Die Lage wird dadurch so kompliziert," schreibt Bertolt Brecht im *Dreigroschen-Prozeß*, dass weniger denn je eine einfache „Wiedergabe der Realität" etwas über die Realität aussagt. Eine Fotografie der Kruppwerke oder der AEG ergibt beinahe nichts über diese Institute. Die eigentliche Realität ist in die Funktionale gerutscht. Die Verdinglichung der menschlichen Beziehungen, also etwa die Fabrik, gibt die letzteren nicht mehr heraus. Es ist also tatsächlich „etwas aufzubauen", etwas „Künstliches", „Gestelltes".[19]

Mehr als vier Jahrzehnte später fügt Alexander Kluge diesem Zitat an anderer Stelle hinzu: „ein Aggregat von Kunstgegenständen".[20] Ein solches Aggregat ist die Mehrspurigkeit der Installation.

Sekulas geschriebener Kommentar, dessen Gestus an das Brecht-Zitat erinnert, vollzieht die Ideologiekritik der Bilder, stellt Zusammenhänge her, die selbst durch die Hängung der Fotos nicht vermittelt werden könnten. „mehr noch aber schreibe ich wegen des beschränkten repräsentationsvermögens der kamera man kann ideologie nicht fotografieren aber man kann ein foto machen zurücktreten und sagen schau in diesem foto hier steckt ideologie zwischen diesen zwei fotos steckt ideologie da ist das und das und das da hängt mit dem da zusammen."[21] Sekula versucht die menschlichen Beziehungen, die das Foto der Fabrik ebenso wenig herausgibt wie das Foto des Hauses, durch seine montageförmige Narration zumindest ansatzweise herauszuarbeiten. Es handelt sich um eine in Parameter des Raums aufgelöste intermediale Formation, eine begehbare emblematische Struktur.

Wie sich die Ideologie der Gesellschaft in der Privatsphäre der Familie eingenistet hat, wird vielleicht an keiner Stelle greifbarer als an den Fotos, die das selbstgebaute und in unmittelbare Nähe eines Kruzifixes gestellte Bücherregal und seinen repräsentativen Inhalt zeigen. Die Märchen der Gebrüder Grimm stehen neben den Werken Joseph Conrads, Jonathan

18 Mit dieser Bestimmung charakterisiert Godard in seinen *Histoire(s) du Cinéma* (1996) das Kino.
19 Bertolt Brecht, *Der Dreigroschen-Prozeß*, in: Brecht, *Werke*, Bd. 21, Hg. W. Hecht, J. Knopf und W. Mittenzwei, Frankfurt am Main: Suhrkamp, 1992, S. 469.
20 Alexander Kluge, *In Gefahr und größter Not bringt der Mittelweg den Tod. Texte zu Kino, Film, Politik*, Hg. Christian Schulte, Berlin: Vorwerk 8, 1999, S. 134.
21 Sekula, *Allan Sekula. Performance under Working Condition*, S. 144.
22 Ebd., S. 147.
23 Kluge, *In Gefahr und größter Not*, S. 134.

Swifts und Nathaniel Hawthornes. Zusammen konfigurieren sie einen
Kanon des vermeintlich Wissenswerten, eine Bürgschaft auf die Zukunft
der Kinder, denen der Vater, wie uns eine Schrifttafel zwischen den Foto-
grafien erklärt, für jedes gelesene Buch einen Dollar gab. In seinem Kom-
mentar reflektiert Sekula das bildungsfetischistische Kulturverständnis
einer ganzen Schicht, die trotz akademischer Ausbildung ins ökonomische
Prekariat abzusinken drohte und umso mehr bemüht war, symbolisches
Kapital anzuhäufen: „die verdammten Bücher sind nie viel aufgeschlagen
worden aber sie waren da totems der hochkultur ständige goldgeprägte
erinnerungen an unsere zukunft als bürger mit hochschulbildung mein
vater baute ein bürgerliches u-boot weil er in einem arbeitermeer schwamm
und nicht wollte dass die haie seine kinder fressen".[22]

Die sozialen Distinktionen treten in den Hintergrund, sobald die
Zeitgeschichte ins Bild drängt: „At some point in his career the engineer
studied the effects of nuclear weapons." Und *The Effects of Nuclear Weap-
ons* ist der Titel des Buches, das auf dem nächsten Foto, direkt neben
den Grimm'schen Märchen, im Querformat ausgestellt ist. Daraus werden
mehrere Abbildungen versehrter Körper, eines brennenden Autos und
eines von einer Druckwelle verwüsteten Hauses gezeigt. Bilder, die den
geordneten und vermeintlich sicheren kleinbürgerlichen Kosmos als illu-
sionäres Konstrukt dekonstruieren. Sekula erzählt seine Gegengeschichte
„in den Komplexitätsgraden der Realität".[23] Seine Montagesequenz kon-
frontiert die nächste Nähe mit der denkbar größten Ferne, das Wahrschein-
liche mit dem Unwahrscheinlichen. Er konstatiert ein Ende der Gewiss-
heiten, die väterliche Autorität ebenso betreffend wie die große Politik.

Man kann Sekulas Fotostrecke auch als Variation der Frage lesen:
In welchem Verhältnis steht das Leben des Einzelnen zur allgemeinen
Geschichte? Wie schreibt sich die Zeitgeschichte in das Leben einer Fami-
lie ein? Und wie modelliert sie dabei die einzelnen Lebensläufe? Sekulas
Arbeit ist darin authentisch, dass sie der Frage nachgeht, wie die Zeit-
geschichte und ihr Katastrophenzusammenhang in den vermeintlich
geschützten Intimbereichen des Hauses, der Familie einschlagen. Seine
Arbeit ist das Dokument dieser Kollision.

Susanne Knaller
Das Paradoxon der Beobachtung

Der Zusammenhang zwischen Diderots Metapher der
Vierten Wand und zeitgenössischen autofiktionalen Formen

I.

In seiner ausführlichen Replik auf die Fragen von Mademoiselle***
zum *Brief über die Taubstummen* beschreibt Denis Diderot die Unzuläng-
lichkeiten des modernen selbstbewussten Subjekts folgendermaßen:

> In der Absicht, zu untersuchen, was in meinem Kopf vorging, und
> meinen Geist sozusagen *in flagranti* zu ertappen, habe ich mich mehr
> als einmal in tiefstes Nachdenken versenkt und mich mit der ganzen
> geistigen Anstrengung, deren ich fähig bin, in mich selbst zurückge-
> zogen; aber diese Bemühungen haben nichts gefruchtet. Mir kam es
> so vor, als müßte man zugleich innerhalb und außerhalb seiner selbst
> sein und gleichzeitig die Rolle des Beobachters und die der beobach-
> teten Maschine spielen. Aber mit dem Geist verhält es sich wie mit
> dem Auge: er sieht sich selbst nicht. [...] Eine Mißgeburt mit zwei
> Köpfen, die auf ein und demselben Hals gewachsen sind, könnte uns
> vielleicht etwas Neues lehren. Wir müssen also warten, bis uns die
> Natur, die alles kombiniert und im Laufe der Jahrhunderte die außer-
> gewöhnlichsten Erscheinungen erzeugt, auch einmal einen zweiköp-
> figen Menschen darbietet, der sich selbst betrachtet und bei dem der
> eine Kopf Beobachtungen über den anderen anstellt.[1]

Dem Bild des doppelköpfigen Menschen geht die in der modernen Episteme entwickelte Vorstellung voraus, dass Ich und Welt auf einem selbst- und fremdbeobachtenden Vorgang basieren. Man ist in der Benennung und Darstellung von Welt zugleich repräsentierendes Element wie Repräsentiertes. „Welt" ist das Ergebnis einer Differenzierung zwischen Beobachter und Beobachtetem, Selbst und Anderem auf Basis eines Realitätsbegriffs. Teilnahme (In-der-Welt-Sein) wie Realitätsbegriff können daher nur von höherstufigen Beobachtungsebenen erfasst werden.

Diderot greift hier die im 18. Jahrhundert gestärkte Wahrnehmungs- form des Beobachtens und mit dieser ein Visualitätsmodell auf, für das die optischen Wissenschaften und die in den moralischen Wochenschrif- ten entworfene Figur des „spectator" exemplarisch sind. Mehrere Aspekte finden in dieser Auseinandersetzung mit dem Beobachtungsparadigma zusammen. Zunächst die von Empirismus und Ästhetik in Gang gesetzte Verlagerung von streng rationalen Erkenntnismodellen zu solchen, die Wahrnehmungsfragen stark machen. Zur Diskussion steht hier der Descartes'sche Rationalismus, der zwei wesentliche Konsequenzen für die westliche Episteme mit sich geführt hat: a. Wissen basiert auf einer Division zwischen kognitiven Subjekten und davon unabhängigen Objek- ten. b. Auf Grund der Tatsache, dass Wahrheit auf Kognition beruht, ist das Reale (im Sinn von Substanz) durch *res extensa* (Objekte, Materie) wie durch *res cogitans* (Denken) formiert. Da *res cogitans* die Wahrheit be- gründet, ist *res extensa* real, d. h. wahr nur aufgrund ihres Seins als Reprä- sentation oder als Inhalt der *res cogitans*. Wissen und Wahrheit sind daher kognitiv und begrifflich. Erst an diesem Punkt wird ein modernes Konzept von Realität möglich: Realität als ontologisches, philosophisches Konzept ist das Andere des Subjekts, das dieses rational begreifen und zu kognitivem Gehalt abstrahieren muss, um wahr zu sein.

Mimesis- und Realismusprogramme des 18. und 19. Jahrhunderts stellen sich dieser Konstellation von Teilnahme, Beobachtung und Begriff/ Form und der Auseinandersetzung mit dem modernen Realitätsbegriff Descartes'. Diderots Beitrag zu dieser Diskussion zeichnet sich dadurch aus, dass er die im rationalen Modell vernachlässigte Medienfrage und die

1 Denis Diderot, „Brief an Mademoiselle***", in: *Ästhetische Schriften*, Bd. 1, Berlin/Weimar: Aufbau-Verlag, 1967, S. 73.
2 Denis Diderot, „Von der dramatischen Dichtkunst", in: *Ästhetische Schriften*, Bd. 1, Berlin/Weimar: Aufbau-Verlag, 1967, S. 284.
3 Vgl. dazu die Beispiele und die Diskussion in Joachim Küpper, „Diderots Auseinandersetzung mit der klassischen Tragödie und die postklassische Ästhetik der Wirklichkeitsdarstellung", in: *Ästhetik der Wirklichkeitsdarstellung und Evolution des Romans von der französischen Spätaufklärung bis zu Robbe-Grillet*, Stuttgart: Steiner, 1987, S. 6–55.
4 Ein Ansatz, den z. B. Jürgen von Stackelberg suggeriert: „Der Briefroman und seine Epoche. Briefroman und Empfindsamkeit", in: *Romanische Zeitschrift für Literatur- geschichte*, Heft 1 (1977), S. 298.

Realitätskonzepte konstituierende Intersubjektivität ästhetisch und theoretisch behandelt. Wobei er Subjektivität auch gesellschaftlich bestimmt. Daher ist Diderots Interesse für die szenischen und inhaltlichen Möglichkeiten des zeitgenössischen Theaters nicht nur Resultat seiner literarischen Ambitionen, sondern ebenfalls auf eine Engführung von philosophischen, ästhetischen und gesellschaftsbezogenen Fragen zurückzuführen. Damit ist neben der Auseinandersetzung mit dem rationalen Modell über die Forcierung der Wahrnehmungsfrage ein weiterer Aspekt im Zusammenhang mit der gestärkten Beobachterfigur benannt, nämlich das mit den aufklärerischen Prämissen möglich gewordene Interesse für die Strukturen und die Funktionen der zeitgenössischen Gesellschaft. Das Individuum handelt stets in gesellschaftlichen und ökonomischen Verhältnissen. Daher postulieren die moralischen Wochenschriften die Beobachtung der Gesellschaft und ihrer Subjekte als oberstes Anliegen. Ein Ansatz, der in neue ästhetische Prämissen führt. Etwa in die Aufforderung zur (auto)biografischen Narrativisierung und Dokumentation des eigenen Lebens, zum Auftrag, einen moralisch selbstbewussten, affektuösen wie intellektuellen Menschen zur Darstellung zu bringen, dessen Wahrnehmung und Handeln anthropologisch und historisch begründet sind. Diderot findet für diese Vorgaben das Konzept der Vierten Wand, mit dem er auf das starre Hoftheater des 17. und 18. Jahrhunderts reagiert, also gegen eine Poetik geschlossener, perspektivischer Kohäsion von Zuschauer, Bühnengeschehen und gesellschaftlichen Strukturen anschreibt. Gleichzeitig ermöglicht ihm das theatralische Raumkonzept, die rationalen Modi der Selbst- und Fremdbeobachtung auf eine Weise zu diskutieren, die das Beobachtungsparadoxon nicht in mimetischer Kohärenz zwischen Subjekt und Objekt aufgehen lässt, sondern Beobachtung zum Thema macht. Die gemeinhin mit der Metapher der Vierten Wand titulierte ideale Kommunikation zwischen Zuschauer/Beobachter und Beobachtetem erklärt Diderot so: „Man denke also, sowohl während des Schreibens als während des Spielens an den Zuschauer ebensowenig, als ob gar keiner da wäre. Man stelle sich an dem äußersten Rande der Bühne eine große Mauer vor, durch die das Parterre abgesondert wird. Man spiele, als ob der Vorhang nicht aufgezogen würde."[2]

Die Kritik hat dieses Verhältnis oft als Postulat eines Illusionstheaters verstanden.[3] So aufgefasst, gehen wesentliche ästhetische und theoretische Komponenten verloren, zumal Diderot immer wieder ein auf verschiedene Texte verteiltes metareflexives Zusammenspiel von Drama, Dialog, Kommentar und Briefwechseln inszeniert und auch für das Geschehen auf der Bühne eine Konstellation der wechselseitigen Beobachtung der Figuren entwirft, die Vierte Wand gleichsam in das szenische Geschehen selbst stellt. Auf diese Weise bleibt Beobachtung im performativen Prozess von szenischen Beobachtungsvorgängen und kommentierenden Dialogspielen der Gattungen reflexiv auf mediale, räumliche und zeitliche Verhältnisse bezogen. Daher ist auch eine Beschreibung Diderots als Vorläufer eines

Realismus, wie er sich im 19. Jahrhundert entwickelt, nur bedingt zutreffend.[4] Zum einen, da sein Realitätsbegriff dem moralischen Diskurs vor wissenschaftlich-empirischen Vorgaben, wie sie im Umfeld des Realismus stark gemacht werden, den Vorrang gibt. Zum anderen, da Diderots Konzept der Vierten Wand weniger eine realistische Abbildung mit Illusionseffekten intendiert, sondern ein performatives Verhältnis von Beobachten und Handeln. Relevant ist im Realismus des 19. Jahrhunderts die Verbindung zwischen Wissenschaft und Kunst, die der aus dem szientistischen Vokabular entliehene Begriff der Objektivität schafft: Ermöglicht durch den auf Basis des rationalen Realitätsbegriffs entwickelten beobachtenden Blick auf die Wirklichkeit, formiert sich ein „empiristisches Wirklichkeitsverständnis der faktographischen Registratur"[5]. Diderots Beobachtungsbegriff lässt sich hingegen so beschreiben:

> Das Verhältnis von Blick und Gebärde, von Beobachtung und Körperausdruck, das gemäß der Vierten Wand zwischen Zuschauern und Bühne besteht, kehrt auf der Bühne selbst wieder und wird hier als Kommunikation beobachtbar. [...] Die Menschen auf der Bühne Diderots erscheinen als empirische Menschen in einem empirischen Raum im Medium ihres Körpers als Ausdrucksmittel; sie erscheinen als „betrachtete Betrachter" im Dialog.[6]

II.

In Diderots Spannungsverhältnis zwischen selbstreflexiven Beobachtungsräumen und aufklärerischer Mimesis eines moralisch zu formenden „réel" lässt sich das Potential für die Analyse jener Formen zeitgenössischer Kunst ausmachen, in denen das Verhältnis von Selbst- und Fremdbeobachtung ästhetisch behandelt wird, wie etwa dem Dokumentarischen und dem eng damit verbundenen Autofiktionalen. Mit dem von Serge Doubrovsky eingeführten Begriff der Autofiktion kann ein Konflikt behandelt werden, der in

5 Küpper, *Ästhetik der Wirklichkeitsdarstellung*, S. 161.

6 Johannes Friedrich Lehmann, *Der Blick durch die Wand. Zur Geschichte des Theaterzuschauers und des Visuellen bei Diderot und Lessing*, Freiburg im Breisgau: Rombach, 2000, S. 110. Vgl. auch die wichtige Untersuchung von Doris Kolesch, *Theater der Emotionen: Ästhetik und Politik zur Zeit Ludwigs XIV.*, Frankfurt/New York: Campus Verlag, 2006, S. 237–255.

7 „L'autobiographie n'est pas un genre littéraire, c'est un remède métaphysique. [...] enfin une vie solide comme du roc, bâtie sur du Cogito: *j'écris ma vie, donc j'ai été.* Inébranlable. [...] par écrit, notre vie prend sens. Nos actes sont légalisés, certifiés conformes. Seules, comme on sait, les écritures authentifient." Serge Doubrovsky, *Le Livre brisé*, Paris: Gallimard, 2003, S. 367 und 371. (Deutsche Übersetzung der Autorin)

8 Uwe Wirth, „Der Performanzbegriff im Spannungsfeld von Illokution, Iteration und Indexikalität", in: *Performanz. Zwischen Sprachphilosophie und Kulturwissenschaften*, Hg. Uwe Wirth, Frankfurt am Main: Suhrkamp, 2002, S. 10–11.

9 Jean-Jacques Rousseau, „Du contrat social", in: *Œuvres complètes*, Bd. 3, Hg. Bernard Gagnebin und Marcel Raymond, Paris: Gallimard, 1964, S. 381.

der modernen Autobiografie qua Identitätsdiskurs von Anfang an angelegt ist: der Versuch von Selbstobjektivierung durch Selbstreflexion und Formierung. Das Ich soll auf sich als ein Vorausliegendes verweisen und damit als Ganzes eingeholt werden. Auf diese Weise konstituiert sich das autobiografische Subjekt über individuelle wie historische Ereignisse, die in einem narrativen Zusammenhang gebündelt das Leben ergeben wie wiedergeben. Resultat des autobiografischen Unternehmens ist ein in Form gesetztes, seiner selbst bewusstes Ich, das dem Risiko der Fiktionalisierung nicht entgehen kann. In seinem Roman *Le Livre brisé* definiert Doubrovsky im Rückgriff auf die Descartes'sche Formel tradierte autobiografische Identität als nur durch medienontologische Festsetzungen legitimierbar: „Die Autobiografie ist keine literarische Gattung, sie ist ein metaphysisches Heilmittel. [...] ein Leben stark wie ein Felsen, auf dem Cogito gebaut: *Ich schreibe mein Leben, daher bin ich gewesen.* Unausweichlich. [...] Durch die Schrift erhält unser Leben Sinn. Unsere Handlungen sind legalisiert, als konform zertifiziert. Nur die Schriften, wie man weiß, beglaubigen."[7]

Jedoch spielt ein autofiktionaler Ansatz nicht binär Repräsentation gegen Konstruktion, Vorgängigkeit gegen das Werden im Medialen aus. Das gelingt durch eine performative Struktur, die eine Koinzidenz von semiotischem Prozess und reflexiver Referenz auf diesen Prozess ermöglicht. Referentialität wird damit nicht obsolet, Realität kein amorphes Material zur freien Disposition, sondern die Gleichzeitigkeit von Beschreibung und Konstitution des Beschriebenen ersetzt Wahrheitsbedingungen durch Gelingensbedingungen – „Im Gegensatz zur ‚konstativen Beschreibung' von Zuständen, die entweder wahr oder falsch ist, verändern ‚performative Äußerungen' durch den Akt des Äußerns Zustände in der sozialen Welt, das heißt, sie beschreiben keine Tatsachen, sondern sie schaffen soziale Tatsachen."[8]

Die Möglichkeiten der Diderot'schen Metapher liegen dabei weniger in einem aktuellen Realitäts- und Kunstbegriff (einen solchen kann man dem Autor des 18. Jahrhunderts nicht zuschreiben), sondern in seinem Umgang mit der Beobachtungsfrage, für die er performative Formen entwirft, die eine Gleichzeitigkeit von Partizipation und Beobachtung, Selbstreflexivität und Referenz, Formierung und Handlung ermöglichen sollen. Die Differenz zwischen Fiktion und Realität bleibt auf diese Weise als Differenz bestehen und ästhetisch behandelbar.

Für das postrationale 18. Jahrhundert führt diese Performativität in ein Spiel mit Faktizität und Fiktionalität, Allgemeinheit und Individualität, das im idealen Fall eine moralische wie historische Kohärenz von Realität (réel) und Ich zum Ergebnis hat. Dieses Vorhaben lässt sich beispielhaft an Rousseau zeigen, der wie nur wenige andere das Subjektverständnis des 18. Jahrhunderts prägte: Seine theoretischen und literarischen Projekte stellen einen Gegenentwurf zu institutionalisierten Rollenspielen dar, postulieren aber gleichzeitig ein individuelles Subjekt („existence physique

et indépendante"), das Allgemeinheit („existence partielle et morale")[9] zu erreichen hat. Individuell akzentuierte Selbsterkenntnis ist einem gesellschaftlichen Gefüge verpflichtet und darin wiederum einer allgemein bestimmten Natur. Erkenntnis basiert in diesem Sinn auf einem kommunikativen Verhältnis von Ich-Reflexion, Fremdbeobachtung und Transzendenz. Ein Beispiel für das Gelingen dieser Relation ist der Briefroman. Nicht anders als in den nichtfiktiven Briefwechseln wird im Briefroman ein Ich modelliert, das aus selbstbeobachtender Perspektive Gefühls- und Selbstbewusstsein reklamieren kann. Im Gegensatz zu klassizistischen Texten tritt in den Briefromanen eine dialogische bzw. mehrstimmige Konstellation in Kraft, mit der man sich gegen gesellschaftlich starre Rollenvorgaben und emotionale Regulierungen wendet. Diderots emphatisches Lob für Richardsons *Pamela* ist daher weniger als realistische Illusionstheorie *avant la lettre* zu verstehen denn als Hinweis auf das dramatische und die moderne Gesellschaft dokumentierende Potenzial der dialogischen Briefromane.[10]

Ein weiterer reizvoller Aspekt für Diderot mag das offene Verhältnis von Faktizität und Fiktionalität gewesen sein. Der Konstruktcharakter eines Briefwechsels hinderte das zeitgenössische Publikum nicht daran, sich mit den Figuren zu identifizieren, sie für reale Personen zu halten und gleichzeitig als Muster in eigenen Texten zu verarbeiten. So können Gefühle und selbst Identitäten im persönlichen Briefwechsel fiktionalisiert sein.[11] Eigene Empfindungen werden durch Beobachtung von Empfindungen ersetzt: „[...] folglich schildre ich auch der Form nach nicht mehr *wahre* Empfindungen, sondern ein Perspektiv von ihnen, in dem sie der andre siehet"[12], schreibt Herder.

III.

Diese gattungsspezifischen Eigenschaften des Briefromans sind es wohl, die Diderot bei der Formulierung seiner Dramentheorie inspirierten:

10 Denis Diderot: „Éloge de Richardson", in: *Œuvres*, Hg. André Billy, Paris: Gallimard, 1951, S. 1060–1061. Vgl. dazu Küpper, *Ästhetik der Wirklichkeitsdarstellung*, S. 13.
11 Vgl. Anette C. Anton, *Authentizität als Fiktion. Briefkultur im 18. und 19. Jahrhundert*, Stuttgart/Weimar: Metzler, 1995, S. 29.
12 Johann Gottfried Herder, „Von der Ode", in: *Werke*, Bd. 1, Hg. Ulrich Gaier, Frankfurt am Main: Deutscher Klassiker Verlag, 1985, S. 68.
13 Niklas Luhmann, „Die gesellschaftliche Differenzierung und das Individuum", in: *Soziologische Aufklärung*, Bd. 6, Opladen/Köln: Westdeutscher Verlag, 1995, S. 130.
14 Alois Hahn und Cornelia Bohn, „Das ‚erlesene' Selbst und die Anderen", in: *Moderne(n) der Jahrhundertwenden. Spuren der Moderne(n) in Kunst, Literatur und Philosophie auf dem Weg ins 21. Jahrhundert*, Hg. Vittoria Borsò und Björn Goldammer, Baden-Baden: Nomos Verlagsgesellschaft, 2000, S. 223–224.
15 Isabelle de Maison Rouge, Hg., *Mythologies personnelles. L'art contemporain et l'intime*, Paris: Scala, 2004; Susanne Düchting, *Konzeptuelle Selbstbildnisse*, Essen: Klartext Verlag, 2001; Martina Weinhart, *Selbstbild ohne Selbst*, Berlin: Reimer, 2004; Barbara Steiner und Jun Yang, *Autobiografie*, Hildesheim: Gerstenberg, 2004. Vgl. auch *art press*, No. 5 (2002), Sonderheft *Fictions d'artists, autobiographies, récits, supercheries*.

Das Zusammenspiel von Dialogstrukturen auf rezeptiver und diskursiver Ebene, von Selbst- und Fremdbeobachtung erlaubt es, den Einzelnen als Ergebnis intersubjektiver Prozesse, d. h. als gesellschaftliches Subjekt zu verstehen. Gesellschaftliches Handeln ist damit ein performatives Wechselspiel von Selbstverständnis und Rolle, eigenen und zugeschriebenen Identitäten. Daraus ergibt sich eine spielerische Konstellation von Identitätsentwürfen zwischen Faktizität und Fiktionalität mit gesellschaftlichen Implikationen, die Diderots Metapher der Vierten Wand als analytisches Instrumentarium für eine Beschreibung von aktuellen autofiktionalen Arbeiten, die Kunst als Spurensuche im Alltag, Durchspielen von Handlungsmustern, Inszenierung und Dokumentation von eigenem und fremdem Leben verstehen, anwendbar macht. Rechnung getragen wird in diesen Ansätzen, dass in dem Moment, in dem das Ich zum Selbst wird, es begründet, darstellbar und modellhaft gemacht werden muss. Identität muss erworben werden.[13] Diese Identität bildet sich, wie Alois Hahn erklären kann, in den Sonderkommunikationen wie Beichte und Autobiografie als fiktive Einheit des sozialen Individuums heraus. Gleichzeitig formiert es sich aber gerade durch wandelbare partizipative, soziale Identität, die quer zur biografischen steht. Die Vorstellung einer (auto)biografischen Einheit erweist sich deshalb mit Blick auf die Gesellschaft der Moderne als ein fiktives Konstrukt:

> Die besondere Schwierigkeit, die sich für das Individuum in diesem Zusammenhang ergibt, ist, daß es sich als Einheit und Ganzheit in keiner realen Situation mehr zum Thema machen kann. [...] Biographische Identität als Einheit, und zwar sowohl synchron als auch diachron, wird also nur themafähig in speziellen Institutionen wie zum Beispiel der Beichte oder der Psychoanalyse oder aber in zunächst jenseits aller Interaktion liegenden rein auf Schrift beschränkten Mitteilungen wie etwa den Autobiographien [...].[14]

Durch Inklusion und Exklusion in Bezug auf bestimmte Rollen, Codes und Diskurse ist das moderne Subjekt ein stets konstruiertes, bewegliches Ergebnis von Selbst- und Fremdzuschreibung. Die gegenwärtigen künstlerischen Strategien in der Auseinandersetzung mit diesem Wechselverhältnis zwischen Einheit und pluraler Identität sind vielfältig und auf verschiedene Medien verteilt: von autobiografischen Lebensentwürfen zu fiktiven Identitätsannahmen, von dokumentarischen Aufzeichnungen, vom Ausstellen autobiografischen Materials in Form persönlicher Gegenstände zu jahrzehntelangen Projekten in Autodokumentationsform.[15] Nicht verwechselt werden darf ein autofiktionaler Ansatz mit einer Poetik des Selberschreibens oder Selbsterschreibens, die durch einen Authentizitätsbegriff gestärkt wird, der als existenzielle wie literarische Vermittlungskategorie zwischen Sinnsuche, Formierung integraler Identität und künstlerischer

Bewältigung fungiert. Das, was Moser subjektive Identität nennt, nämlich die Erfahrung des Selbst als einer individuellen, über einen längeren Zeitraum sich selbst auch in vielen einzelnen Bild- und Textidentitäten gleichenden Person, wird nicht eingelöst.[16]

Vielmehr stellen zeitgenössische Medienkombinationen von Bild und Text die Referenz- und Authentisierungsfrage der Autobiografie zur Diskussion. Gleichzeitig wird damit die Kunst auf ihr autofiktionales Potenzial abgetastet. Über die Beglaubigungsstelle AutorIn und KünstlerIn und deren Selbst- und Außendarstellung werden Identität und Form ästhetisch und politisch bearbeitet.[17] Kunsthistorisch lässt sich im Hinblick auf autofiktionale multimediale Arbeiten an die schon in der Concept Art, der Pop-Art, der Land-Art und bei den Situationisten erkennbare Betonung von Praxis, direkter Erfahrung und Partizipation der KünstlerInnen anschließen. Einzug in die Kunst fanden dadurch Formen des trivialisierten (Medien-) Alltags, alltägliche Rituale der Identitätserhaltung und Außendarstellungsprogramme, gesteigert durch spielhafte und die RezipientInnen einbeziehende Strukturen.

Ein weiterer Anknüpfungspunkt für autofiktionale Formen findet sich auch in der Tradition des neuzeitlichen und modernen Selbstporträts, das eine lange und materialreiche Geschichte seit dem 15. Jahrhundert aufweist, die vor dem Hintergrund der Erfindung der Fotografie im 19. Jahrhundert zu einer Geschichte von Authentizität und Kunst/Bild wird.[18] Die partizipative Kunst seit der zweiten Hälfte des 20. Jahrhunderts leitet die Problemfelder des Selbstporträts über das Verhältnis von KünstlerIn und Form weiter in aufgrund von Medienentwicklungen immer komplexer zu gestaltende Beglaubigungs- und Authentisierungsprogramme. Ein generelles Misstrauen in tradierte Identitäts- und Selbstmodelle führt einerseits – gleichsam in foucaultscher Folge – verstärkt zu Motiven des Überwachens, der Kontrolle und der detektivischen Spurensuche, andererseits in eine Fahndung nach neuen, nichtnormativen Authentizitätsformen.

16 Christian Moser und Jürgen Nelles, Hg., *AutoBioFiktion. Konstruierte Identitäten in Kunst, Literatur und Philosophie*, Bielefeld: Aisthesis Verlag, 2006, S. 12–13.

17 Vgl. Susanne Knaller, *Ein Wort aus der Fremde. Geschichte und Theorie des Begriffs Authentizität*, Heidelberg: Universitätsverlag Winter, 2007, S. 169.

18 Omar Calabrese, *Die Geschichte des Selbstporträts*, München: Hirmer Verlag, 2006, S. 24.

19 Michel Foucault, *Surveiller et punir*, Paris: Gallimard, 1975.

20 Knaller, *Ein Wort aus der Fremde*, S. 178.

21 Michael Renov, „The Subject in History: The New Autobiography in Film and Video", in: *Afterimage*, No. 17 (1989), S. 5. Vgl. Auch Doris Grüter, die von einer Wiederentdeckung des Individuums und einer Relativierung des selbstreferentiellen Ästhetik spricht: Doris Grüter, *Autobiographie und Nouveau Roman. Ein Beitrag zur literarischen Diskussion der Postmoderne*, Münster: LIT Verlag, 1994, S. 318.

22 Knaller, *Ein Wort aus der Fremde*, S. 179.

23 Vgl. zum Dokumentarischen und zur Realismusfrage Susanne Knaller, „Realismus und Dokumentarismus. Überlegungen zu einer aktuellen Realismustheorie", in: *Realismus in den Künsten der Gegenwart*, Hg. Dirck Linck, Michael Lüthy, Brigitte Obermayr, Martin Vöhler, Berlin: diaphanes, 2010 (im Druck).

Was jedoch die autobiografische Kunst seit den Siebzigerjahren nachhaltig bestimmt und die Rede von einer innovativen Autobiografiegeneration legitimiert, sind die Auswirkungen der poststrukturalistischen Auseinandersetzung mit dem Autor-, Künstler- und Erzählerbegriff. Subjekt- und Selbstbegriffe werden in diesen Theorien auf historisch und kulturell bestimmte bzw. wandelbare Verfahrensweisen zurückgeführt: Subjekte stellen sich nicht nur her, sie werden auch hergestellt und funktional zugerichtet.[19] Trotz dieser ambivalenten Konstruktionen sind diesen Theorien die Vorstellung des Verlusts eines Uneinholbaren (Lacans „réel"), vormoderne Ideale (Foucaults „techniques de soi") oder Modelle idealistischer Konstruktivität (Lyotards Erhabenes) zu eigen, die letztlich in der (ästhetischen) Konstruktion eine Form von Selbstbestimmung als vielleicht nur noch vagen utopischen Hintergrund aufrechterhalten.[20] Autobiografiediskussion und -produktion kann hingegen auch versuchen, die Debatte jenseits der Polarisierung von Ganzheit vs. Fragment, Identität vs. Auflösung, Wahrhaftigkeit vs. Konstrukt zu führen, indem sie auf Einheitsutopien oder sentimentale Verlustdiskurse verzichtet. Negativ bescheiden will ich an dieser Stelle die Vorstellung einer vormals stets auf Ganzheit und Kohärenz ausgerichteten Autobiografie, von der sich erst die „neuen" Autobiografieformen abheben würden. Auch an die vielfach beschworene, im Autobiografieboom festgestellte „Wiederkehr des Subjekts", die sich gegen einstmals unproblematische Ich-Konstruktionen abgrenzen möchte, soll der hier vorgeschlagene Performativitätsbegriff nicht anschließen. Michael Renov schreibt:

> The „return of the subject" is not, in these works, the occasion for a nostalgia for an unproblematic self-absorption. If what I am calling „the new autobiography" has any claim to theoretical precision, it is due to this work's construction of subjectivity as a site of instability – flux, drift, perpetual revision – rather than coherence.[21]

Renovs Oppositionierung zwischen Konfliktualitätspoetiken und Ganzheitsdiskursen geht allerdings am Umstand vorbei, dass Konfliktualität im modernen Subjekt- und Subjektivitätsbegriff von Anfang an angelegt ist. Die ausdifferenzierten Sozialsysteme der Moderne bedingen ein in der Identitätszuschreibung flexibles, konfliktfähiges Subjekt. Kunst, Philosophie und Anthropologie sind schon im 18. Jahrhundert entsprechend gefordert. Rousseau ist mit seinen jahrzehntelangen autobiografischen Bemühungen nur ein Beispiel dafür, wie die Autobiografie seinen Selbstbegründungsdiskurs stützt, in den Text selbst aber die genannten Dilemmata als unentscheidbar eingeschrieben sind.[22]

IV.

Arbeiten mit autobiografischen dokumentarischen Verfahren machen jedoch auch nicht beim Aufweisen einer wie auch immer generierten oder erklärten Konstruktivität von Realität und Identität halt.[23] Das Autobiografische (wie das Dokumentarische) präsentiert sich in seiner Form als Selektion, Fragmentierung und Montage von Sachverhalten: Die Autobiografie greift ja zurück in die „rohe" Wirklichkeit in ihrer Kontingenz. Wie jede performative Form umfassen Autofiktionen ein präsentisches, nichtrepräsentatives Moment, das künstlerisch bearbeitet werden kann. Die Autobiografie stellt somit das Dokumentierte und die Verfahren gleichzeitig in einen diegetischen Raum, sie demonstriert die Abhängigkeit von Verzeitlichungs- und Verräumlichungsprozessen und verabschiedet die nicht einlösbare Utopie mimetischer Zeitlosigkeit einer gesellschaftlichen und biografischen Identität. Das Absehen davon zeichnet ebenfalls Diderots Konzept von der Vierten Wand aus. Sein szenisch-performatives Konzept setzt sich sowohl von rationalen Repräsentationsformen (der Klassik wie auch des positivistischen Realismus) wie präsentischen Unmittelbarkeitsphantasien (der Romantik) ab. Als analytische Metapher verstanden, ermöglicht es eine Darstellung der je verschiedenen ästhetischen Umgangsformen mit der paradoxalen Grundlage von Wirklichkeitsbegriffen. In einen Kontext historischer Realitäts- und Subjektkonzeptionen gestellt, könnte gezeigt werden, dass das 18. Jahrhundert einen gerade für die zeitgenössische Situation beispielhaften spielerischen Umgang mit Differenzverhältnissen inszeniert. Ob sich die Kunst dem von Diderot postulierten Moraldiskurs anschließen will, muss von Fall zu Fall entschieden werden.

Werke | Works

Judy Radul

World Rehearsal Court, 2009
Installation | installation
Videostills (digitale Montage der Künstlerin) |
Video stills (digital montage by the artist)
Installationsansichten | Installation views,
Judy Radul: World Rehearsal Court,
Morris and Helen Belkin Art Gallery, Vancouver, 2009

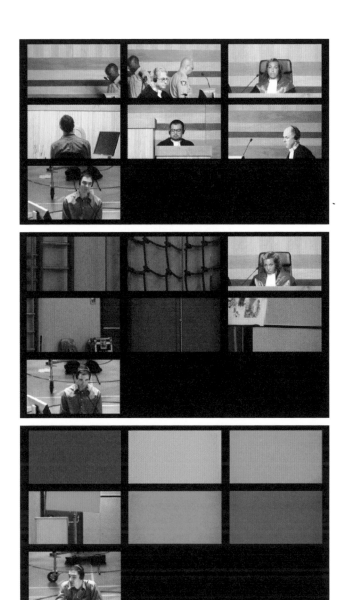

Judy Raduls Videoinstallation *World Rehearsal Court* zeigt auf sieben Monitoren das auf Protokollen beruhende Reenactment von Prozessen des Internationalen Strafgerichtshofes für das ehemalige Jugoslawien und des Sondergerichtshofes für Sierra Leone. Das Skript ist eine Collage aus mehreren Verfahren – unter anderem jener gegen Slobodan Milošević und Charles Taylor, angeklagt der Verbrechen gegen die Menschlichkeit. Doch die Namen aller Beteiligten wurden durch allgemeine Benennungen wie „Mr. Accused" oder „Mr. Prosecution" ersetzt. Im Vordergrund steht hier nicht die Beschäftigung mit den konkreten Fällen, sondern die Auseinandersetzung mit Strukturen der Institution Gericht.

Gerichte sind grundsätzlich theatrale Orte, angewiesen auf die Inszenierung von Autorität, deren traditionelle Elemente, wie beispielsweise Richterbank und Roben, Judy Radul vorführt. Zugleich wird die zunehmend technologisierte Form heutiger Gerichtshöfe thematisiert – überall sind Kopfhörer, Mikrophone, Kameras und Bildschirme zu sehen.

Die Aufnahmen geben in verschiedenen Einstellungen ihren Drehort, einen Turnsaal, preis, und zerstören damit die Illusion eines authentischen Gerichtssaals, womit die Frage nach der Politik des Inszenierens und Aufzeichnens, nach der Wahl des Ausschnitts gestellt wird. Die Betonung von Kameraarbeit und Technik rückt die Manipulierbarkeit der Bilder und die Unsicherheit von Wahrgenommenem ins Bewusstsein. Das Bild

On seven monitors, Judy Radul's video installation *World Rehearsal Court* shows the reenactment, based on court records, of trials before the International Criminal Tribunal for the former Yugoslavia and the Special Court for Sierra Leone. The script is a collage of material from several trials, including those of Slobodan Milošević and Charles Taylor; both were accused of crimes against humanity. But the names of all participants have been replaced by generic designations such as "Mr. Accused" or "Mr. Prosecution." What is in the foreground here are not specific cases, but rather a critical examination of the structures of the court of law as an institution.

Courts are fundamentally theatrical sites, dependent on the mise-en-scène of authority, whose traditional elements such as the judge's bench and robes are shown by Judy Radul. At the same time, she examines the increasing role technology plays in today's courts—we see headphones, microphones, cameras, and screens everywhere.

Shot from a variety of angles, the footage reveals that it was recorded in a gymnasium, disrupting the illusion of an authentic courtroom and raising the issue of the politics of the mise-en-scène and the recording, of the choice of perspective. The emphasis on camera work and technology brings to our awareness the manipulability of images and the uncertainty of perception. The image, the selected detail, can be seen as standing for the

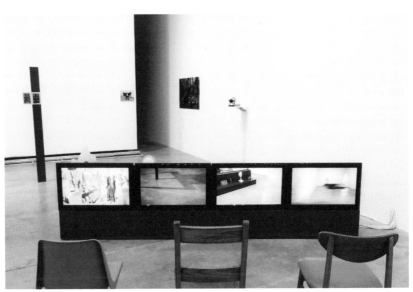

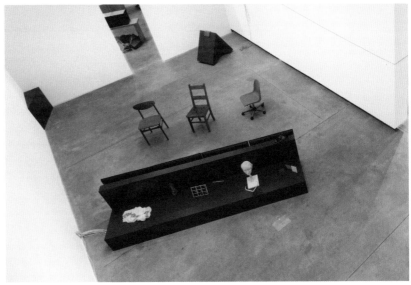

als Ausschnitt kann dabei für die grundsätzliche Logik des Gerichts stehen, einen Rahmen um Handlungen zu konstruieren und „sich ein Bild zu machen".[1] Was Radul sichtbar macht, ist das der Rechtsprechung innewohnende Paradox – ihren Anspruch auf umfassende Wahrheit – im Wissen, diesem nicht gerecht werden zu können.

Das Reenactment wird mitunter von der Einblendung monochromatischer Flächen unterbrochen, die an Farbpunkte erinnern, aus denen visuelle Informationen zusammengesetzt sind, und damit das Bildsein der Bilder, ihr Gemacht-Sein noch deutlicher ins Auge springen lassen.

Der Raum, in welchem die Monitore situiert sind, wird in Raduls Werk durch eine Plexiglaswand abgetrennt – ein Zitat jener Trennwände, wie sie heute an vielen Gerichtshöfen als Sicherheitsvorkehrung üblich sind. Zugleich wird der Raum durch diese buchstäbliche Vierte Wand[2] zu einer Bühne und die Beobachtenden werden zu Beobachteten.

In weiteren Räumen finden sich die BetrachterInnen selbst der Dynamik von Aufzeichnung und Display ausgesetzt. Sie werden von mehreren Kameras gefilmt, deren Bilder auf weiteren Monitoren live zu sehen sind, und dadurch mit ihrem eigenen Sehen und Gesehen-Werden konfrontiert.

Hier finden sich auch Requisiten aus den Videos als eine Art Sammlung von Beweisstücken – Beweisstücke gerade nicht des Faktischen, sondern der Inszeniertheit. Weitere Objekte, wie Gipsköpfe und ein in Plexiglas

logic that is at the foundation of any court of law: providing its own narrative framework, it "forms its own picture."[1] What Radul reveals is the paradox of all administration of justice—the claim it makes to bringing out the whole truth while knowing that it can never live up to this aspiration.

At times, monochromatic inserts interrupt the reenactment, reminiscent of the pixels of which visual information is composed, bringing out even more strikingly the image nature of the images, their being manufactured.

In Radul's installation, the room where the monitors are located is partitioned off from the surrounding exhibition space by a plexiglass wall—referencing the partitions that have become a standard security measure in many courtrooms. Simultaneously, this literal Fourth Wall[2] turns the room into a stage, the observers into objects of observation.

In the other rooms, viewers find themselves exposed to the dynamic of recording and display. Filmed by multiple cameras which produce live feeds shown on additional monitors, they are confronted with their own viewing and being viewed.

Here we also find props from the videos brought together into a sort of body of evidence—evidence, that is, attesting not to facts but to the mise-en-scène itself. Additional objects such as plaster heads and a book in plexiglass, literally under lock and seal, as well as found objects added by

eingelassenes, buchstäblich „unter Verschluss" stehendes Buch, sowie
Fundstücke, welche die Künstlerin am jeweiligen Ausstellungsort hin-
zufügt, eröffnen Assoziationsräume, schaffen eine Verbindung zur Welt
außerhalb des Gerichts. Hinter deren Fülle und Komplexität muss die
Konstruktion kausaler Zusammenhänge in Prozessen immer zurückblei-
ben. Unter den Objekten ist auch eine Ramachandran-Box, eine Spiegelbox
zur Behandlung von PatientenInnen mit Phantomgliedern, die es ermög-
licht, den fehlenden, aber noch gefühlten Körperteil als Spiegelbild seines
intakten Gegenübers sichtbar zu machen – also das innerlich Gefühlte
im Außen zu visualisieren. In diesem einen Objekt ist eine weitere, für das
gesamte Werk entscheidende Problematik kondensiert: das Wechsel-
verhältnis zwischen subjektiver Wahrheit und objektivem, oder, vielleicht
besser, intersubjektivem Raum. км

1 Vgl. Costas Douzinas, „Rehearsals", ab Frühling 2010 verfügbar im Online-Katalog
 zu *Judy Radul. World Rehearsal Court*, Vancouver: Morris and Helen Belkin Art Gallery.
 http://www.belkin.ubc.ca
2 Vgl. Ilse Lafer, S. 15–29 in diesem Katalog.

the artist at each exhibition venue unfold spaces of association and connect
to the world outside the courtroom. Establishing causal relationships
in a trial cannot but fall short of the richness and complexity of this world.
Also among the objects is a Ramachandran box, a mirror box used in the
treatment of patients with phantom limbs. It enables the patient to make
the missing limb that is still being felt visible as a mirror image of the
intact limb—i.e., an outward visualization of an inward reality. This object
represents, in condensed form, another set of issues that is of decisive
importance to the work as a whole: the interplay between subjective truth
and objective—or perhaps we should say: intersubjective—space. км

1 Cf. Costas Douzinas, "Rehearsals," in the online catalogue accompanying
 Judy Radul. World Rehearsal Court, Vancouver: Morris and Helen Belkin Art Gallery,
 http://www.belkin.ubc.ca (available spring 2010).
2 Cf. Ilse Lafer, p. 125–138 of this catalogue.

Aernout Mik

Convergencies, 2007/2010
Videoinstallation | Video installation
Videostills | Video stills

Aernout Miks Arbeit *Convergencies* besteht aus zwei über Eck projizierten Videos, welche sich aus nicht gesendetem Bildmaterial aus den Archiven internationaler Nachrichtenagenturen zusammensetzen. Wir sehen Vorgänge im öffentlichen Raum, Einsatzkräfte bei der Bewältigung von Ausnahmesituationen, mal aus der Distanz gefilmt, mal nahe am Geschehen, wie bei einer Reportage. Wir kennen solche Bilder, die Aktualität und Unmittelbarkeit verheißen, und sind gewohnt, sie unter bestimmten Vorzeichen zu sehen. Im Fernsehen würde uns erklärt, was wir dazu wissen müssen. Bei Aernout Mik haben wir nur den Originalton, ansonsten bleiben die Bilder für sich, kommentieren sich allenfalls gegenseitig. Das Dokumentarische verlangt paradoxerweise nach Erläuterung; fehlt sie, geraten wir in Schwierigkeiten, das Gesehene einzuordnen.

Und doch erschließt sich uns so manches. Katastrophen- oder Antiterrorübungen sind auszumachen, ebenso reale Einsätze. Polizei, Militär, Feuerwehr und andere Uniformierte gehen ihrer Arbeit nach, von Passanten beobachtet oder ignoriert, in städtischer oder ländlicher Umgebung. Beschriftungen, Sprachfetzen oder sonstige Fingerzeige weisen auf verschiedene, meist europäische Länder. Was zunehmend klar wird: Den größten Raum nehmen Situationen ein, die mit Migration oder illegaler Einwanderung zu tun haben. Wir sehen Festnahmen bei Grenzkontrollen, Menschen, die auf freiem Feld aufgegriffen oder von Schiffen geholt werden.

———————

Aernout Mik's work *Convergencies* consists of two videos. Projected crosswise, they are composed of never-broadcast footage from the archives of international news agencies. We see incidents occurring in the public space, relief units coping with emergency situations, now shot from a distance, now close to the action, like in a news report. We know this sort of images, their promise of breaking-news immediacy, and we are used to putting them in a certain perspective. On television, we would be given explanations about what we are to make of them. Aernout Mik gives us nothing but the original sound; otherwise, the images keep to themselves, at most commenting on one another. Paradoxically, the documentary calls for explanation; without it, we find it difficult to make sense of what we are seeing.

And yet there are some things we can figure out. We recognize disaster and anti-terror exercises, as well as real operations. Police, the military, firefighters, and other people in uniform go about their work, watched or ignored by passersby, in urban or rural settings. Signage, snippets of speech, and other hints indicate different, mostly European countries. What becomes increasingly clear is that most space is given to situations that have to do with migration, or illegal immigration. We see arrests at border checkpoints and people being picked up in open field or led off ships.

Die Themen sind heiß, von Terror bis zur Flüchtlingsproblematik, und alle Zutaten wären vorhanden für ein aufwühlendes Panorama. Aber was gezeigt wird, bleibt seltsam flach, als wenn das Entscheidende schon vorüber wäre oder gar nicht stattfände.[1] Vieles sieht planlos aus, es wird viel geschaut und gewartet, nichts spitzt sich zu. Auch die Tatsache, dass sich die Szenen vage zu „Kapiteln" gruppieren, jeweils durch mehrere Sekunden Schwärze getrennt, vermag den Eindruck eines gleichbleibenden Stroms von Bildern nicht zu stören. Ihre Begegnung in der Doppelprojektion folgt einer sorgfältigen Regie, scheint da und dort argumentieren zu wollen, ohne sich einer simplen Deutlichkeit zu verschreiben. Miks Inszenierung wirft die Frage auf, wie weit wir in unserer Wahrnehmung durch die Medien abgerichtet sind. Erkennen wir Dramatik nur, wenn sie als solche für uns aufbereitet wird? Oder ist das schwebende Gefühl, das sich beim Betrachten einstellt, das eigentlich angemessene? Das würde bedeuten, dass die Dinge sind, wie sie sind, laufend stattfinden, routiniert und unaufgeregt, eine fortwährende „Normalisierung des Anormalen".[2] Im Hintergrund dieser Normalität steht die Angst, dass sie zusammenbrechen könnte. RW

1 Vgl. Aernout Mik in: Maria Hlavajova, „Of Training, Imitation and Parody: A Conversation with Artist Aernout Mik", Zusammenstellung mehrerer informeller Diskussionen im Zuge der Vorbereitung des Projektes *Citizens and Subjects*, Amsterdam/Utrecht, Herbst 2006 – Frühling 2007.
2 Michael Taussig, „Aeronautiks", in: Aernout Mik: Shifting Shifting, Ausst.-Kat., London: Camden Arts Centre, 2007, S. 371.

The issues are hot, from terror to the refugee problem, and there would be all the ingredients for a stirring panorama. But what we get to see remains strangely flat, as though the decisive moment was already over or not coming at all.[1] Much of it looks haphazard, there is a lot of looking on and waiting; things never come to a head. Even the fact that the scenes are vaguely grouped in "chapters" and separated by several seconds of black screen cannot disrupt our sense of a steady stream of images. Encounters between images in the double projection are carefully directed and now and then seem designed to make an argument, but without ever subscribing to simplistic explicitness. Mik's dramaturgy raises the question of how far our perception is conditioned by the media. Are we only able to recognize drama if it is made dramatic for us? Or is that sense of drifting that sets in as we watch actually an adequate reaction? This would mean that things are as they are and keep going on and on, routinely and unruffled, a constant "normalization of the abnormal."[2] Looming behind this normality is the fear that it might collapse. RW

1 Cf. Aernout Mik in: Maria Hlavajova, "Of Training, Imitation and Parody: A Conversation with Artist Aernout Mik," a compilation of several informal discussions during the preparations for the *Citizens and Subjects* project (Amsterdam/Utrecht, fall 2006–spring 2007).
2 Michael Taussig, "Aeronautiks," in *Aernout Mik: Shifting Shifting*, exh. cat. (London: Camden Arts Centre, 2007), p. 371.

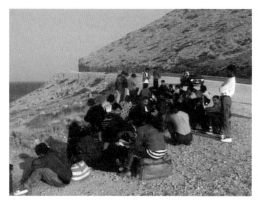

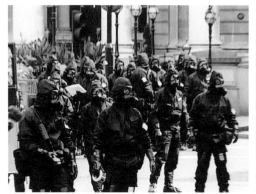

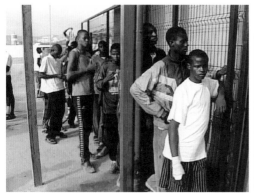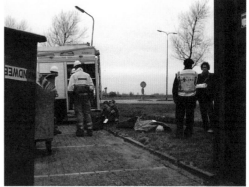

Omer Fast

A Tank Translated, 2002
Videoinstallation I Video installation
Installationsansicht I Installation view,
FICTION OU REALITE?, FRI ART, Art Center, Fribourg 2003

Godville, 2005
Videoinstallation I Video installation
Produktionsfotografien I Production stills

A Tank Translated

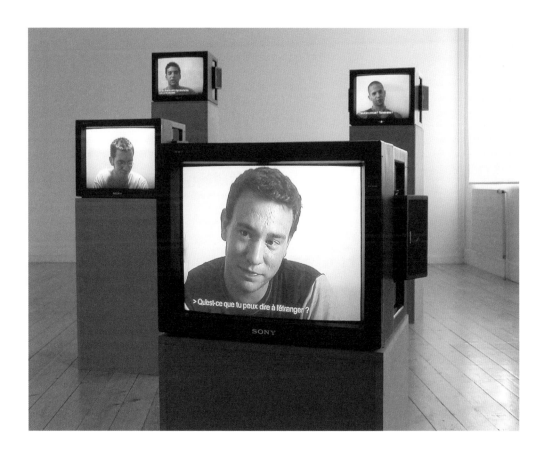

Interviews mit der Besatzung eines Panzers der israelischen Armee sind das Ausgangsmaterial für Omer Fasts Videoinstallation *A Tank Translated*. Auf unterschiedlich hohen Podesten zeigen vier Monitore vier Soldaten, an deren Positionen im Panzer sich die Gesamtanordnung orientiert: Kommandant, Schütze, Ladeschütze und Fahrer. Die jungen Männer berichten von Wahrnehmungen und Gefühlen während des Einsatzes. Das Hebräisch der Gespräche ist deutsch untertitelt. So auch die aus dem Off kommenden Interviewfragen Omer Fasts.

Das mediale Format der Videos ist nur allzu vertraut, und wir vertrauen ihm: Ein Interview verschafft Zugang zu einer Person. Omer Fast hingegen verwendet dieses Medium, um jede Möglichkeit von Vertrauen grundsätzlich in Zweifel zu ziehen. Die Untertitel werden gezielt manipuliert. Schrittweise entfallen Wörter oder Satzteile, kürzere Sätze mit verändertem Sinn entstehen. Einzelne Wörter oder Phrasen werden durch andere, ähnlich klingende, ersetzt. Oder das Interview läuft plötzlich rückwärts, und alles zuvor Gesagte erscheint in verneinter Form.

Die Arbeit *Godville* geht ebenfalls von Interviews aus, diesmal in Williamsburg im US-Bundesstaat Virginia gedreht. „Colonial Williamsburg", das historische Viertel, wird als eine Art Themenpark betrieben, der Amerikas Anfänge als britische Kolonie erlebbar machen soll. Auf einer frei im Raum hängenden Leinwand kommen zuerst Ansichten des

Interviews with an Israeli army tank crew are the source material of Omer Fast's video installation *A Tank Translated*. Placed on pedestals of different heights, four monitors show four soldiers; the arrangement reflects their positions inside the tank: commander, gunner, loader, and driver. The young men speak about what they perceive and feel during deployments. The Hebrew interviews are subtitled in German, as are the questions asked by Omer Fast's off-camera voice.

These videos follow a very familiar media format, one that we trust: an interview gives us insight into a person. Omer Fast, however, uses the medium to cast fundamental doubt on any possibility of trust. The subtitles are selectively manipulated. Step by step, words or parts of sentences are omitted, creating shorter sentences with different meanings. Individual words or phrases are replaced by similar-sounding others. Or the interview suddenly runs backward, and everything that has been said before appears in negated form.

The work *Godville* is similarly based on interviews, shot, in this case, in Williamsburg, Virginia. "Colonial Williamsburg," the historic district, is operated as a sort of theme park that affords visitors an experience of America's beginnings as a British colony. On a screen suspended in the middle of the room, we first see views both of the reconstructed historic Williamsburg and of the contemporary town; appearing on the back side

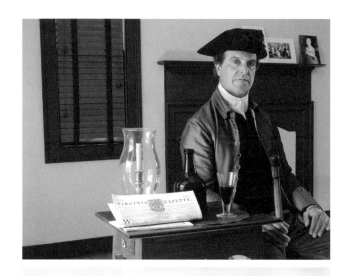

Godville

rekonstruiert-historischen wie des zeitgenössischen Williamsburg in den Blick, auf der Rückseite die Interviewpartner selbst, deren Stimmen die Installation akustisch dominieren. Drei historisch kostümierte „DarstellerInnen" hat Fast in ihren Rollen als Figuren des 18. Jahrhunderts sowie als reale Menschen des 21. Jahrhunderts zu ihrem Leben befragt. Beide Gespräche wurden sodann höchst aufwendig zu einem organisch anmutenden Redefluss montiert, dessen Konstruiertheit sich spätestens in den Bildsprüngen des rückseitigen Videos offenbart. Die Absurdität einer künstlich evozierten Vergangenheit, schon an den Bildern der Vorderseite ablesbar, spitzt sich im Gesprochenen zu. Zeit- und Realitätsebenen geraten völlig durcheinander, Unabhängigkeits- und Irak-Krieg, Sklaverei und Nahost-Problem, Pocken und Political Correctness zeigen sich in irritierender Nachbarschaft.

In beiden Arbeiten wird einvernehmlich hergestellte Kommunikation geradezu perfide hintergangen. Aussagen verkehren sich in ihr Gegenteil, als ob es um eine – oft klischeehafte – Enthüllung verborgener Absichten ginge. In *Godville* etwa dringt durch, die Mitwirkung an einem fiktiven 18. Jahrhundert könnte mit einem rückwärtsgewandten Weltbild zu tun haben. Immer wieder schwingen übergeordnete politische Ebenen mit, so in *A Tank Translated*, wo der Panzer eine metaphorische Note in Bezug auf Israels mediale Selbstdarstellung und sein Verhältnis zur Außenwelt erhält.

of the screen are the interview partners themselves, whose voices dominate on the installation's soundtrack. Omer Fast interviewed three "performers" in historic costumes about their lives, both in their roles as eighteenth-century characters and as real people from the twenty-first century. In a highly complex process, both conversations are montaged to create a single flow of speech that seems organic—its constructed character becomes only obvious from the jumps of the images on the back of the screen. The absurdity of an artificial evocation of the past, readily apparent in the images on the front of the screen, is heightened by the spoken text. Time and reality levels become inextricably confused, the War of Independence and the Iraq War, slavery and the conflict in the Middle East, smallpox and political correctness all appear in irritating proximity.

Both works almost perfidiously undermine consensual communication. Statements are turned into their opposite as if this was about the—often stereotypical—exposure of covert intentions. In *Godville*, for instance, we gain the impression that participating in a fictional eighteenth century might have something to do with a backward worldview. Time and again, there are political overtones, as in *A Tank Translated*, where the tank acquires secondary, metaphorical meaning with a view to Israel's self-presentation in the media and its relations with the world around it. This latter work makes the various stages of manipulation clearly discernible,

In dieser Arbeit werden die Stadien der Manipulation deutlich vorgeführt und damit der ursprüngliche Wortlaut transparent gehalten. Bei *Godville* hingegen ist kaum mehr zu eruieren, was am Anfang stand. Das Gesprochene und das Gemeinte sind radikal getrennt. Von all diesen Operationen nimmt Fast sich selbst als „Täter" nicht aus: In *A Tank Translated* wenden sich auch seine Sätze gegen ihn, und in *Godville* attackieren ihn seine Gesprächspartner und werfen ihm unlautere Absichten vor.

Die Herrschaft, die Fast über sein Material ausübt, die Entstellungen, die er dem Dokumentarischen antut, legen dessen Mechanik bloß und gelten unserer Komplizenschaft mit einem Format, das behauptet, neutral zu sein. Bei der Frage, wie Inhalte im Durchschreiten dieses Zer- und Ersetzungsprozesses neu ins Spiel kommen können, gehen *A Tank Translated* und *Godville* unterschiedlich weit. Während dem Material im ersten Fall ein Überschreiben eher zuzustoßen scheint, an Stellen, wo es sich anfällig zeigt und dazu Gelegenheit bietet, gelangt Omer Fast in *Godville* zu einem weit höheren Grad der Fiktionalisierung. Eine neue „Story" entsteht aus den Bruchstücken des Gegebenen und versieht Fragestellungen, die durch mediale Beanspruchung stumpf geworden sind, mit neuer Dringlichkeit. RW

and thus the original text remains transparent. In *Godville*, by contrast, it becomes virtually impossible to determine what was there in the beginning. A radical split separates what is said from what is intended. Fast does not exempt himself as the "offender" from any of these operations: in *A Tank Translated*, he, too, finds his own sentences turning against him, and in *Godville*, the interviewees attack him, accusing him of dishonest intentions.

The way Fast rules over his material, the distortions he inflicts on the documentary expose its mechanisms and point to our complicity with a format that claims neutrality. *A Tank Translated* and *Godville* go to different lengths when it comes to how contents may be brought into play again after going through this process of disintegration and replacement. In *A Tank Translated*, the material seems to incur overwriting when occasion offers or where it is susceptible to such manipulation; in *Godville*, by contrast, Omer Fast reaches a much higher degree of fictionalization. A new "story" emerges from the fragments of what is given, lending new urgency to issues that have been worn blunt by their ongoing media exposure. RW

Andrea Geyer

Reference Over Time, 2004
Videoinstallation | Video installation
Videostills | Video stills

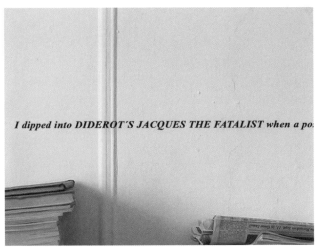

I dipped into DIDEROT'S JACQUES THE FATALIST when a po

Brecht left Germany i

Andrea Geyers Video *Reference Over Time* stellt, wie sie in dem die Arbeit begleitenden Text selbst erläutert, eine unmittelbare Reaktion auf eine Gesetzesvorlage der Ära Bush dar – den sogenannten USA PATRIOT Act II, der in Reaktion auf den 11. September unter dem Deckmantel der Terrorbekämpfung darauf abzielte, Bürgerrechte massiv zu beschneiden, wie etwa AmerikanerInnen auszuliefern oder legale ImmigrantInnen zu deportieren. Geyer erwirkt eine historische Rückkoppelung, indem sie Bertolt Brechts im Exil geschriebene *Flüchtlingsgespräche* in englischer Übersetzung von einer Schauspielerin sprechen lässt: ein fiktiver Dialog zweier Männer auf der Flucht, deren Pässe eingezogen wurden, und die sich in einem Bahnhofsrestaurant über Identität, deren Festschreibung durch den Reisepass und das staatliche „Ordnungssystem" im totalitären Regime des Dritten Reiches unterhalten. Der Akt des Lesens durch die Schauspielerin ist in eine abrupt geschnittene Abfolge sich wiederholender Gesten zersplittert: Sie liest den Text zunächst leise, dann laut vor, denkt über das Gelesene nach, stockt, setzt erneut an, steht auf, setzt sich wieder ... Ihr zunehmendes Unbehagen wird spürbar, und so führt sie mit Nachdruck ein Scheitern am gesprochenen Wort vor, was umso befremdlicher wirkt, als nicht klar ist, welche Rolle sie einnimmt: die von Brecht oder seinen Protagonisten, die einer Schauspielerin, die einen Text einstudiert, oder die der Künstlerin, die durch ihre Schauspielerin spricht.

As Andrea Geyer explains in an accompanying text, her video *Reference Over Time* is an immediate reaction to a bill introduced in the Bush era—the so called USA PATRIOT Act II, which, in response to September 11, used the fight against terror as a pretext for a massive curtailment of civil rights, introducing practices like the extradition of Americans and the deportation of legal immigrants. Geyer effects a historical feedback loop by having an actress recite an English translation of Bertolt Brecht's *Flüchtlingsgespräche* (*Conversations in Exile*), written while the author was himself in exile: a fictional dialogue between two men, political refugees from Germany whose passports have been confiscated and who meet in a railway station restaurant and talk about identity and how a passport codifies it and, more generally, about the state "system of order" under the totalitarian regime of the Third Reich. The act of reading performed by the actress is split up into a sequence of repetitive gestures separated by abrupt cuts: first she reads in a low, then in a loud voice, thinks about what she has read, halts, starts again, stands up, sits down again ... Her growing discomfort becomes palpable, and so her rendition is ultimately a dramatic instance of a performer coming to grief against the spoken word, a failure that seems all the more disconcerting as it remains unclear which role she is taking: that of Brecht or that of his protagonists, that of an actress rehearsing lines or that of the artist who speaks through the actress.

Geyers Video beginnt mit einem Textinsert aus Bertolt Brechts Tagebuch von 1940, der angibt, Denis Diderots Roman *Jacques le fataliste et son maître* (*Jacques der Fatalist und sein Herr*) gelesen zu haben und von dessen dialogischem Aufbau zu seinen *Flüchtlingsgesprächen* inspiriert worden zu sein. Die Frage nach dem freien Willen des Menschen ist Hauptthema von Diderots aufklärerischem Roman, der häufig als Anti- oder Metaroman verstanden wird, da er die Problematik des Erzählens selbst zum Gegenstand macht. Wie Diderots *Jacques* sind die *Flüchtlingsgespräche* über Dialoge aufgebaut, es wird nicht linear erzählt, sondern ein verwirrendes Geflecht aus Erzählfäden geknüpft. „Auch Brecht fördert die Erkenntnis, dass Wahrheit nicht festgelegt ist, sondern im zwischenmenschlichen Austausch geschaffen und angeeignet wird …"[1] Für ihn ist vor allem im intersubjektiven Dialog eine dialektische Entwicklung von Gedanken möglich.

In der Inszenierung von *Reference Over Time* generiert Geyer ebenfalls eine dialogische Situation, indem sie den Betrachter/die Betrachterin an einem Tisch, dem Monitor gegenüber, positioniert. Dies forciert eine nahezu intime Begegnung mit der Schauspielerin und ihrem Versuch, den in den *Flüchtlingsgesprächen* artikulierten Widerstand zu veranschaulichen. GH

1 Isabella von Treskow, *Französische Aufklärung und sozialistische Wirklichkeit. Denis Diderots* Jacques le fataliste *als Modell für Volker Brauns* Hinze-Kunze-Roman, Würzburg: Königshausen & Neumann, 1996, S. 306.

Geyer's video begins with a text insert from Bertolt Brecht's diary of 1940, in which he notes having read Diderot's novel *Jacques le fataliste et son maître* (*Jacques the Fatalist and his Master*), whose dialogical structure inspired his own *Conversations in Exile*. The question of human free will is the central problem in Diderot's enlightenment-era novel, which is often read as an anti-novel or meta-novel because it makes the problem of narration the very subject of narration. Like Diderot's *Jacques*, the *Conversations* are built on dialogues; instead of a linear plot, they present a tangle of narrative strands. "Brecht cultivates the insight that truth is not predefined, but created and appropriated in interhuman exchange."[1] For him, it is intersubjective dialogue in particular that facilitates the dialectical elaboration of ideas.

The mise-en-scène of Geyer's *Reference Over Time* likewise generates a dialogical situation in that it positions the viewer at a table across from the monitor, forcing an almost intimate face-to-face encounter with the actress and her attempt to dramatize the resistance articulated in the *Conversations in Exile*. GH

1 Isabella von Treskow, *Französische Aufklärung und sozialistische Wirklichkeit. Denis Diderots* Jacques le fataliste *als Modell für Volker Brauns* Hinze-Kunze-Roman (Würzburg: Königshausen & Neumann, 1996), p. 306. (Trans. GJ)

Wendelien van Oldenborgh

No False Echoes, 2008
Videoinstallation | Video installation
Videostills | Video stills

The Basis For A Song, 2005
Diainstallation | Slide installation
Videostills | Video stills

Der Titel der Videoinstallation *No False Echoes* spielt auf die Sendepolitik der Philips Omroep Holland Indië an, einer zu Philips gehörenden Rundfunkanstalt, die zur Zeit der niederländischen Kolonie im heutigen Indonesien ein Programm machte, das politische Debatten ausschloss und auf die Stärkung der niederländischen Identität ausgerichtet war. Drehort ist der modernistische Bau der Radiostation Radio Kootwijk.

Die BetrachterInnen finden sich zwischen zwei Paravantwänden wieder. In die eine ist ein Monitor integriert, die andere zeigt eine große Projektion. Auf beiden ist zunächst der niederländische Rapper Salah Edin beim Vortrag eines Pamphlets des indonesischen Freiheitskämpfers Soewardi Soerjaningrat zu sehen. Der Text „Als ik eens Nederlander was" (Wenn ich ein Niederländer wäre) – eine „ironische Ode an nationale Identität"[1] – und sein Sprecher, der marokkanischer Herkunft ist und dessen eigene Raps Kritik an den heutigen Niederlanden üben, entfalten mannigfache Bezüge. Verbindungen zwischen Vergangenheit und Gegenwart werden aufgespürt. In Momenten, in denen Edin sich mit dem indonesischen Autor identifiziert, erscheint sein Vortrag als authentischer Sprechakt, wo jedoch seine Reaktion auf Soerjaningrats Rede oder seine Interaktion mit der Regisseurin wahrnehmbar wird, kommt es zu Brecht'schen Verfremdungseffekten – die Differenz zwischen Performer und Rolle tritt in den Vordergrund. Während der Vortrag auf dem Monitor von Außenaufnahmen der Rundfunk-

The title of the video installation *No False Echoes* alludes to a programming policy maintained by Philips Omroep Holland Indië, a broadcasting station operated by the Philips corporation: in the era of the Dutch colony in today's Indonesia, it broadcast a program that excluded political debate and aimed to strengthen Dutch identity. The video material was shot at the modernist building housing the radio station Radio Kootwijk.

Viewers find themselves between two partition walls. Integrated into one of them is a monitor; the other serves as a large projection screen. Both initially show the Dutch rapper Salah Edin reciting a lampoon by Indonesian independence activist Soewardi Soerjaningrat. Entitled "Als ik eens Nederlander was" (If I were a Dutchman), the text—an "ironic ode to national identity"[1]—and its speaker, who is of Moroccan origin and whose own rap lyrics criticize the Netherlands of today, unfold a broad range of references, tracing relationships between the past and the present. At moments when Edin identifies with the Indonesian author, his recitation appears as an authentic speech act; but where his response to Soerjaningrat's wording or his interaction with the director becomes perceptible, a Brechtian defamiliarization effect sets in—bringing to the fore the difference between performer and role. As the recital shown on the monitor is followed by exterior shots of the broadcasting station, the projection on the other wall shows an event taking place inside: on a balustrade, experts

No False Echoes

station abgelöst wird, zeigt die Projektion eine Veranstaltung im Inneren: Auf einer Balustrade diskutieren ExpertInnen über die Rolle des Radios in der ehemaligen niederländischen Kolonie, in der Halle befinden sich ZuhörerInnen. In der Arbeit mit dem eigenen Skript und mit AkteurInnen, die ihre persönlichen Erfahrungen mitbringen, entsteht eine Mehrstimmigkeit, die als „Polyphonie" im Sinne Michail Bachtins aufgefasst werden kann: ein Text voll Widersprüchlichkeiten, die keinem auflösenden Narrativ untergeordnet werden.[2] Das Sichtbarmachen von Filmtechnik rückt das Gemacht-Werden der Bilder, die Frage nach den Absichten medialer Inszenierungen ins Bewusstsein. Der Einsatz der Kamera läuft den Konventionen zuwider: Sie lässt Unschärfen zu, schwenkt lange vom Sprecher weg – gewährt Raum zum Nachdenken. Neben diesem medienreflexiven Ansatz durchziehen die emotionalen Momente von Edins Performance Oldenborghs Werk. In diesem Wechselspiel scheinen die BetrachterInnen aufgefordert, nach der eigenen Position „zwischen den Wänden", gegenüber dem medialen Raum und seinen Oberflächen, zu fragen. Sie werden zu BeobachterInnen ihrer eigenen Betrachtung – können ihre eigene Affektion, ihre Identifikation mit bestimmten Stimmen reflektieren, wobei die Reflexion ihrerseits durch die emotionale Einbindung eine andere Qualität gewinnt.

Auch die Diainstallation *The Basis For A Song* bringt Stimmen von heute mit Stimmen der – diesmal jüngeren – Vergangenheit zusammen:

———————

debate the role of radio in the former Dutch colony before an audience in the hall. Working with her own script and with actors who bring their personal experiences to the project, the artist engenders a multiplicity of voices that can be read as "polyphony" in the sense elaborated by Mikhail Bakhtin: a text full of contradictions that are not subjected to any resolving narrative.[2] The showing of technical film equipment makes us aware that images are made, raising the question of the intentions behind media enactments. The use of the camera runs counter to convention: it admits of blurry images and pans away from the speaker for long stretches—leaving room for thought. Besides this media-reflective approach, Oldenborgh's work is pervaded by the emotional moments in Edin's performance. This structure seems to challenge viewers to interrogate their own position "between the walls," vis-à-vis the media space and its surfaces. They become observers of their own viewing—and can reflect on their own affective response, their identification with certain voices, a reflection that in turn is given a new quality through their emotional engagement.

The slide installation *The Basis For A Song*, too, brings together voices of today with voices from the—this time, more recent—past: the artists Herman Helle and Viola van Oostrom recall the Rotterdam of the 1970s, when people could simply write a letter to let municipal authorities know they had squatted a building. At the time, visual artists found spaces to

Die KünstlerInnen Herman Helle und Viola van Oostrom erzählen vom Rotterdam der 1970er Jahre, als man den Behörden einfach einen Brief schreiben konnte, um sie über eine Hausbesetzung zu informieren. Bildende Künstler fanden damals Lebens- und Arbeitsraum in besetzten Gebäuden, Bands der Punkszene hatten hier ihre Proberäume.

Im Rotterdam von heute treffen verschiedene Kulturen aufeinander, mehr Raum denn je wird für unterschiedliche Bedürfnisse gebraucht, während ganze Stadtviertel gentrifiziert werden. Ausgehend von der Erzählung der KünstlerInnen und der Musik der 70er-Jahre-Punkband *Rondos* erarbeiten die Rapper Scep und DJ Fader einen Song über Hausbesetzungen und über die Notwendigkeit, auch im übertragenen Sinn einen Platz in der Gesellschaft zu finden. Die Bilder sind aus einem Video entstanden und werden von drei Projektoren so gezeigt, dass bei jedem Bildwechsel kurze Überblendungen entstehen. Im Mittelpunkt stehen Austausch und gemeinsamer Arbeitsprozess. Die Tafel, auf welche die Dias projiziert werden, ist in eine Ecke gelehnt. Das Arrangement wirkt provisorisch, die Projektionen erscheinen und verschwinden: „Culture is madly moving", heißt es einmal in *The Basis For A Song*. ᴋᴍ

1 *Wendelien van Oldenborgh. As Occasions*, Ausst.-Kat., Rotterdam: Tent, 2008, S. 26.
2 Vgl. Anke Bangma, „The polyphonic work of Wendelien van Oldenborgh", in: *Metropolis M*, No. 4 (2008), S. 103–105.

live and work in squatted buildings, bands from the punk scene had their rehearsing rooms there.

In today's Rotterdam, different cultures collide, more space than ever is needed for many different needs, while entire neighborhoods are undergoing gentrification. Based on the artists' narration and the music of the 70s punk band *Rondos*, the rappers Scep and DJ Fader develop a song about squatting and the need to find one's place in society, also in a figurative sense. The images are stills from video material that are displayed by three projectors so that a brief fade-over occurs with every change of slide. The focus is on communication and the collaborative creative process. The board onto which the slides are projected leans in a corner. The arrangement looks makeshift, with projections appearing and disappearing: "Culture is madly moving," as one line from *The Basis For A Song* has it. ᴋᴍ

1 *Wendelien van Oldenborgh. As Occasions*, exh. cat. (Rotterdam: Tent 2008), p. 26.
2 Cf. Anke Bangma, "The polyphonic work of Wendelien van Oldenborgh," in *Metropolis M*, No. 4 (2008), pp. 103–105.

The Basis For A Song

Frédéric Moser &
Philippe Schwinger

Farewell Letter to the Swiss Workers, 2006–2009
Installation | installation

Alles wird wieder gut, 2006
Video
Videostills | Video stills

Donnerstag, 2006
Video
Produktionsfotografie | Production still

Der Titel *Farewell Letter to the Swiss Workers* nimmt auf Lenins 1917, anlässlich seiner Rückkehr aus dem Zürcher Exil nach Russland, verfassten *Abschiedsbrief an die Schweizer Arbeiter* Bezug und kündigt das thematische Feld der Installation an: Mit den Videos *Alles wird wieder gut* und *Donnerstag* werden die dem heutigen Arbeitsmarkt zugrunde liegenden Ideologien vor der Folie vergangener revolutionärer Utopien problematisiert. Moser & Schwinger setzen Zitate historischer Momente, hier der Russischen Revolution, strategisch für eine Neuverhandlung des Status quo ein. „Zu welcher Gesellschaftsform sind wir fähig und von welcher gemeinsamen Lebensweise träumen wir?"[1]

Alles wird wieder gut zeigt Jugendliche in einem deutschen Dorf, die über ihr Leben in einer kapitalistischen Welt – zwischen Arbeitslosigkeit und der Suche nach alternativen Lebensentwürfen – diskutieren und dabei den Linien globalisierungskritischer und marxistischer Diskurse folgen. Schließlich planen sie eine Party, um etwas gegen die Langeweile im Ort zu tun, während die Generation ihrer Eltern ihre bereits Jahre während Demonstration vor einer geschlossenen Fabrik fortsetzt. Die Übertragung des Konflikts von einer Generation auf die nächste erfährt eine weitere Verschiebung, als ein ins Dorf gekommener Journalist in seiner Reportage die ArbeiterInnen zu klischeehaften „Helden auf verlorenem Posten" stilisiert. Das Video endet mit einer Theaterprobe, bei welcher sich die Frage

The title *Farewell Letter to the Swiss Workers* refers to a letter from Lenin published under that name in 1917 on his leaving his Zurich exile for Russia and presages the thematic field of this installation: the videos *Alles wird wieder gut* (Everything will be alright) and *Donnerstag* (Thursday) problematize the ideologies at the foundation of today's labor market against the backdrop of the revolutionary ideologies of the past. Moser & Schwinger strategically use the citation of historic moments—in this case, the Russian Revolution—for a renegotiation of the status quo. "Of what kind of society are we capable? Of what common way of life do we dream?"[1]

Alles wird wieder gut shows teenagers in a German village discussing their lives in a capitalist world—between unemployment and the quest for alternative visions of life—along the lines of globalization-critical and Marxist discourses. They eventually plan a party to act up against the boredom in their community while the generation of their parents keeps manning a protest demonstration outside a closed-down factory that has been going on for years. The transfer of the conflict from one generation to the next takes yet another turn when a journalist who has come to the village stylizes the workers into clichéd "heroes fighting a losing battle" in his reportage. The video ends with a theater rehearsal in which the question of the validity of discourses and their appropriation for people's own situations becomes acute with a ten-year-old boy reciting Lenin's letter

Alles wird wieder gut

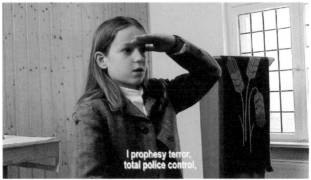

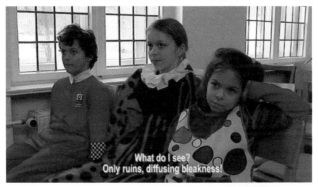

nach der Gültigkeit und Aneigenbarkeit von Diskursen zuspitzt: Lenins Brief wird von einem zehnjährigen Jungen in der Pfarrei vorgetragen. Das Durchspielen ein und derselben Problematik in verschiedenen Kontexten und der Rückgriff auf Brecht'sche Verfremdungseffekte (wie zum Beispiel das direkte Sprechen in die Kamera) lassen die unterschiedliche Rhetorik, mit der soziale Themen dargestellt werden, in den Vordergrund treten – ein Effekt, der auch die andere Referenz des Werks, Jean-Luc Godards und Jean-Pierre Gorins Film *Tout va bien* (1972), auszeichnet.

Der zweite Film, *Donnerstag*, zeigt den entfremdeten Alltag einer jungen Frau auf einem industrialisierten Bauernhof, aber auch Bruchstücke aus ihrem Leben jenseits der Arbeit, und verweist damit auf die Auslassungen propagandistischer ArbeiterInnen-Bilder. Sie durch eine Klassenzugehörigkeit definieren zu wollen, greift offensichtlich zu kurz. „Können wir uns andere Formen von Ideologien vorstellen, die uns verbinden, außer denjenigen der Gesetze des Marktes [...]?"[2] Die Filme sind eingebettet in eine bühnenartige Situation, in der die BetrachterInnen unweigerlich Teil des Werkes werden. Zwischen Strohballen und Postern, die Börsenkurven zitieren, stellt sich die Frage: Was kann ich sagen, was kann ich tun? KM

1 Aus der Projektskizze der Künstler, abgedruckt in: *KOW Issue* 2, Ausst.-Kat., Paris: Galerie Jocelyn Wolff, Berlin: KOCH OBERHUBER WOLFF, 2009, o. S.
2 Ebda., o. S.

in the parsonage. Acting out one and the same set of problems in different contexts and drawing on Brechtian defamiliarization effects (such as actors directly speaking to the camera), the work moves the different rhetorics to the foreground that are used to address social issues—an effect *Alles wird wieder gut* shares with its other point of reference, Jean-Luc Godard's and Jean-Pierre Gorin's film *Tout va bien* (Everything's alright, 1972).

The second film, *Donnerstag*, shows a young woman's alienated everyday life on an industrialized farm, as well as glimpses of her life away from work, pointing to what propaganda images of workers omit. Trying to define her by class membership alone obviously falls short. "Can we magine forms of ideology that might connect us apart from those of the laws of the market [...]?"[2] The films are embedded in a stage-like situation that inevitably renders the viewers part of the work. Between straw-bales and posters referencing stock-market graphs, one is faced with the question: What can I say, what can I do? KM

1 From the artists' project sketch, published in *KOW Issue* 2, exh. cat. (Paris: Galerie Jocelyn Wolff, Berlin: KOCH OBERHUBER WOLFF, 2009), n. p.
2 Ibid., n. p.

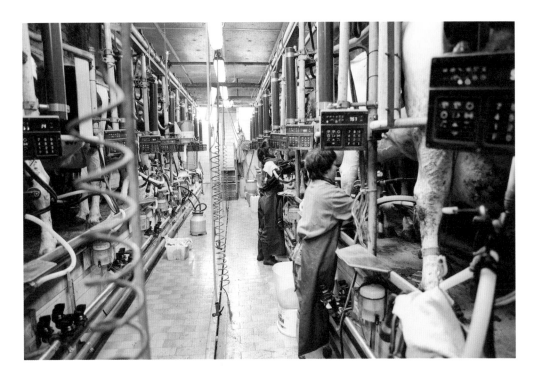

Donnerstag

Allan Sekula

Aerospace Folktales, 1973
Foto-Audio Installation I Photo-audioinstallation

In *Aerospace Folktales* bildet Allan Sekula die unmittelbare soziale Realität seiner Familie anhand eines, wie er es nennt, „sequenziellen fotografischen Portraits"[1] ab: Der Vater, Ingenieur beim Flugzeughersteller Lockheed, hat infolge von Misswirtschaft seinen Job verloren, die Mutter ist Hausfrau. Für die BetrachterInnen werden diese mikrosoziologischen Beobachtungen anhand dreier Komponenten veranschaulicht. Eine an Reportagefotografie angelehnte Serie von Schwarz-Weiß-Fotografien dokumentiert den unmittelbaren Lebensraum der Eltern und die sozialen Interaktionen innerhalb der Familie: der Vater auf dem leeren Firmenparkplatz, die Mutter in der Küche, Detailansichten der Apartmenteinrichtung ... Die beiden zentralen ProtagonistInnen kommen in Form von Interviews als „Ingenieur" und „Ingenieursgattin" zu Wort. Der gesprochene und geschriebene Kommentar des Interviewers/Fotografen/Sohns bildet die Klammer.

Die sozio-politischen Implikationen für die Familie werden so aus unterschiedlicher Perspektive erfahrbar und ergeben ein Gesamtbild: Die Ausführungen des Ingenieurs spiegeln Sozialisierung und ideologische Beeinflussung durch den ehemaligen Arbeitgeber wider, die Mutter schildert vordergründig die emotionale, psychologische Verfasstheit einzelner Familienmitglieder. Der Sohn, gleichsam als Brecht'scher Erzähler fungierend und das Publikum direkt ansprechend, kommentiert das gesammelte Bild- und Tonmaterial und führt es einem größeren Bedeutungszusammen-

In *Aerospace Folktales*, Allan Sekula depicts the immediate social reality of his own family in what he calls a "sequential photographic portrait"[1]: his father, who worked for the aircraft manufacturer Lockheed, has lost his job due to mismanagement; his mother is a housewife. Three components serve to illustrate these micro-sociological observations for the viewers. A series of reportage-style black-and-white photographs documents the parents' immediate environment, as well as social interactions within the family: the father in the empty company parking lot, the mother in the kitchen, details of the furniture in their apartment ... Both central protagonists speak about themselves in interviews, where they appear as the "engineer" and the "engineer's wife," respectively. This is held together by spoken and written commentary created by the interviewer/photographer/son.

The socio-political implications for the family become experienceable from a variety of perspectives that coalesce into one comprehensive picture: the engineer's remarks reflect his socialization and his employer's ideological influence; the mother offers a superficial description of the emotional and psychological states of individual family members. The son, acting as a Brechtian narrator of sorts and addressing the audience directly, comments on the visual and audio material he has collected, placing it in a larger context. Yet he never does so from a pseudo-objective angle, but always also reflects on his own position within the family structure.

The engineer and his old friend stood in the empty Lockheed
parking lot while I photographed them.

Unable to fathom my motives, they were uneasy.

hang zu. Er tut dies jedoch nie aus einem pseudo-objektiven Blickwinkel, sondern reflektiert seine Position innerhalb der Struktur der Familie mit. Brechts Begriff des „sozialen Gestus"[2] folgend, besitzen auch ausschnitthafte Gesten oder nebensächlich erscheinende Äußerungen „Demonstrationsvermögen" und lassen Rückschlüsse auf die gesamte soziale Situation zu.

Die Fotografien sind einzeln, paarweise oder zu viert in Rahmen angeordnet, und die unterschiedlichen Sequenzen werden durch kurze erklärende Texte des Fotografen eingeführt. Drei rote Regiesessel fungieren als Stellvertreter für die sprechenden Personen und fordern zum Verweilen und Zuhören auf. Gemeinsam mit den im Raum positionierten Palmen generieren sie so etwas wie ein filmisches Setting. Die BetrachterInnen finden sich somit in einer präzise arrangierten Installation aus Bild-, Ton- und Textdokumenten, einer narrativen, sequenziellen Montage, die Sekula selbst zufolge an einen „in seine Bestandteile zerlegten Film"[3] erinnert. Die episch theatrale Orchestrierung forciert divergierende Leseweisen und ermöglicht so eine umfassendere Kommunikation mit dem Publikum. GH

1 Allan Sekula, Dieter Buchhart und Gerald Nestler, „Lügen ist heute ein Leistungsprinzip ersten Grades", in: *Kunstforum International*, Bd. 201 (März – April 2010), S. 151.
2 Vgl. Roland Barthes, „Diderot, Brecht, Eisenstein", in: ders. *Der entgegenkommende und der stumpfe Sinn. Kritische Essays III*, Frankfurt a. M.: Suhrkamp, 1990, S. 98 (franz. Original 1973).
3 Allan Sekula, in: *Allan Sekula. Performance under Working Conditions*, Hg. Sabine Breitwieser, Ausst.-Kat., Wien: Generali Foundation; Ostfildern: Hatje Cantz, 2003, S. 25.

According to Brecht's concept of the "social *gest*,"[2] body language, however fragmentary, and utterances, however insignificant they may seem, possess a "demonstrative power" that permits conclusions about the social situation as a whole.

The photographs are arranged and framed individually, in pairs and in groups of four, and brief explanatory notes by the photographer introduce the various sequences. Three red director's chairs act as stand-ins for the speakers, inviting visitors to stay and listen. Together with the palm trees placed in the middle of the room, they generate something like a film setting. Viewers thus find themselves in a precisely arranged installation comprising visual, audio, and textual documents, a narrative and sequential montage that, according to Sekula himself, is reminiscent of a "disassembled movie."[3] The epic theatrical orchestration strongly suggests divergent readings, enabling a more expansive form of communication with the audience. GH

1 Allan Sekula, Dieter Buchhart, and Gerald Nestler, "Lügen ist heute ein Leistungsprinzip ersten Grades," in *Kunstforum International*, Bd. 201 (März – April 2010), p. 151. (Trans. GJ)
2 Cf. Roland Barthes, "Diderot, Brecht, Eisenstein," trans. Stephen Heath, in *Screen*, vol. 15, no. 2 (1974), pp. 33–39 (French original 1973).
3 Allan Sekula, in *Allan Sekula. Performance under Working Conditions*, ed. Sabine Breitwieser, exh. cat. (Vienna: Generali Foundation, Ostfildern: Hatje Cantz, 2003), p. 25.

Harun Farocki

**Jean-Marie Straub und Danièle Huillet bei der Arbeit
an einem Film nach Franz Kafkas Roman „Amerika"**, 1983
Film, 16mm, transferiert auf Video |
Film, 16mm, transferred to video
Videostills | Video stills

Immersion, 2009
Videoinstallation | Video installation
Videostills | Video stills

Harun Farockis *Jean-Marie Straub und Danièle Huillet bei der Arbeit an einem Film nach Franz Kafkas Roman „Amerika"* dokumentiert die Probe- und Dreharbeiten des Films *Klassenverhältnisse* (1984) mit ihrer außergewöhnlich genauen, zeitaufwendigen Führung der SchauspielerInnen. Jede Geste, jedes Wort ist hier überlegt. Diese Arbeitsweise selbst, sowie Farockis Entscheidung, ihr einen Film zu widmen, zeugt vom Widerstand der FilmemacherInnen gegen das kommerzielle Kino, der ihre Werke allgemein prägt.[1]

Farockis Filme kreisen immer wieder um Proben, Rollenspiele und Trainingssituationen. Doch wie weit ist diese Probe von jenen in *Die Schulung* (1987) oder *Die Umschulung* (1994) entfernt, in denen die Anpassung von Menschen an den Arbeitsmarkt dokumentiert wird: Während dort Individuen sich selbst für dessen Bedürfnisse zurichten lassen, wird hier an der Darstellung Karls aus Kafkas Roman gearbeitet, an dem gerade die Zwänge, die eine Gesellschaft ihren Subjekten auferlegt, sichtbar werden.

Farockis Aufnahmen zeigen uns allerdings, dass auch hier, wie tendenziell in jedem Film, die Schauspieler zu Objekten der Regie werden. Und in Bezug auf sein eigenes Filmen spürt man, dass gerade die sonst hinter der Kamera Situierten, Straub und Huillet, von ihrem Objekt-Werden gegenüber seiner Kamera wissen. Dieses Werk ist zugleich eine Art Selbstportrait: Farocki, der bei Straub studiert hat, dokumentiert dessen Arbeit und ist

Harun Farocki's *Jean-Marie Straub and Danièle Huillet at work on a movie based on Franz Kafka's novel "Amerika"* documents rehearsals and shooting for the movie *Klassenverhältnisse* (*Class Relations,* 1984). Straub and Huillet guide the actors with extraordinary precision, a highly time-consuming process. Every gesture, every word is carefully considered. This method, as well as Farocki's decision to devote a film to it, attests to the filmmakers' resistance to the commercial cinema, an attitude that informs their works in general.[1]

Farocki's films time and again revolve around rehearsals, role-plays, and training situations. Yet how far removed is this rehearsal from those in *Die Schulung* (*Indoctrination,* 1987) or *Die Umschulung* (*Reeducation,* 1994), which document what people do to adapt to the labor market: whereas the individuals in those other films let themselves be conformed to market needs, the protagonists in this film are working on the depiction of Karl from Kafka's novel, who reveals the compulsions a society imposes on its subjects.

Yet Farocki's pictures also show us that here, as more or less in any film, the actors become objects of the director. And with regard to his own shooting his film, we feel that Straub and Huillet, whose place is otherwise behind the camera, are clearly aware that they are becoming objects of his camera. Farocki's work is at once also a sort of self-portrait: Farocki, who

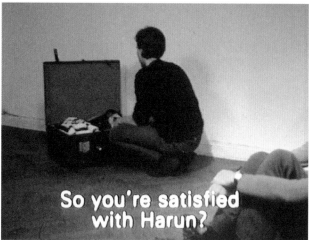

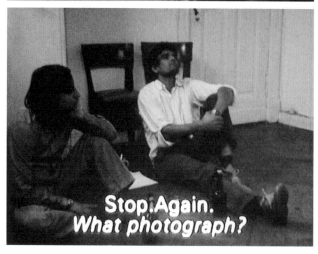

Jean-Marie Straub
und Danièle Huillet bei
der Arbeit an einem
Film nach Franz Kafkas
Roman „Amerika"

Let's do it. Luis!

dabei selbst in der Rolle des Delamarche zu sehen – ein Zeichen der Anerkennung durch den bewunderten Lehrer. Darüber hinaus kommt es zu einer Art Ausgleich der Beziehungen: Straub und Huillet, Regisseure ihres Films, sind Protagonisten seines Films, ebenso wie er zugleich Darsteller ihres Films und Regisseur seines eigenen ist. Sein Film erscheint als ein subtiles, selbstreflexives Spiel mit dem Bewusstmachen der Macht und Verantwortung, die im Auswählen, Aufzeichnen, Inszenieren liegt – im Einnehmen der Rolle des Filmemachers. Eine Reflexion, die auch vom Sichtbarmachen der Filmtechnik, wie Stative und Leuchten, getragen wird. Zugleich erscheinen die dokumentierten Dreharbeiten, das ausgeleuchtete Set im nächtlichen Wald unwirklich, fiktional: der Regisseur als magische, fast surreale Figur.

Farockis neuer Film *Immersion* dokumentiert einen Workshop für Psychologen der U.S. Air Force zur „Behandlung posttraumatischer Störungen durch die Konfrontation mit virtueller Realität". Ein Splitscreen zeigt SoldatInnen mit Visier und Kopfhörer, während sie in die virtuelle Realität eines simulierten Kampfgebietes eintauchen – und daneben eben jene computergenerierten Bilder, die sie gerade wahrnehmen. Manchmal geschieht dies parallel, manchmal bleibt eine der beiden Bildschirmseiten schwarz, zwischendurch werden die Therapeutinnen bei der Arbeit gezeigt, gleich zu Beginn des Films die technischen Möglichkeiten der Software erläutert.

studied under Straub, documents the director's work while also appearing in the role of Delamarche—a sign of recognition from the admired teacher. Moreover, a sort of counterbalancing of relationships takes place: Straub and Huillet, the directors of their own movie, are the protagonists of his film, just as he is at once an actor in their movie and the director of his own film. The latter thus appears as a subtle and self-reflective play with the conscious acknowledgment of the power and responsibility that come with selecting, recording, directing—with taking on the role of the filmmaker; a reflection sustained also by revealing the technology of film, such as camera tripods and lighting equipment. At the same time, the shooting he documents, the illuminated set in a forest at night appears unreal and fictional: the director as a magical and almost surreal figure.

Farocki's new film *Immersion* documents a workshop for U.S. Air Force psychologists on the "treatment of post-traumatic disorders by confrontation with virtual reality." A split screen shows soldiers wearing a visor and headphones as they immerse themselves in the virtual reality of a simulated battle zone—and, on the other side, the computer-generated images they are seeing at the moment. Sometimes, the two images appear in parallel; sometimes one of the two half-screens remains black; interspersed are shots showing the therapists at work; at the very beginning of the film, someone explains the technical possibilities offered by the software.

Der Immersionseffekt virtueller Welten wird innerhalb der Struktur des Splitscreens situiert: Sie bricht die Sogwirkung der Bilder, indem die BetrachterInnen immer wieder wählen müssen, worauf sie ihre Aufmerksamkeit richten. Während die SoldatInnen von ihren Kriegserfahrungen erzählen, sieht man, was sie sehen, und begreift dabei zugleich, dass man doch nicht sieht, was sie sehen: Die Bilder simulieren einen Erfahrungsraum, zu dem die meisten BetrachterInnen wohl keinen Zugang haben.

Nicht nur ist der Bildschirm gespalten, der Film hat auch einen doppelten Boden: Während es zunächst scheint, als ob man eine tatsächliche Therapiesitzung mitverfolgt, bricht ein Soldat seine Erzählung plötzlich ab, und es zeigt sich erst hier, dass die Therapie in einem Workshop vorgeführt wurde. Farocki demonstriert, wie einfach BetrachterInnen – selbst in einer Situation, in der Immersion und Schein(realität) thematisiert werden – manipuliert werden können: Die Wahl des filmischen Raumausschnitts erlaubt es ihnen nicht, die eigentliche Situation zu erfassen, wodurch eine falsche Annahme entsteht. Der Bruch mit dieser Erwartungshaltung ist so überraschend, dass ihm ein Moment intensiver Reflexion entspringt. Man wird daran erinnert, sich gegenüber Bildern niemals zu sicher zu fühlen. KM

1 Vgl. Tilman Baumgärtel, *Vom Guerillakino zum Essayfilm. Harun Farocki. Werkmonografie eines Autorenfilmers*. Berlin: b_books, 1998, S. 148.

The immersion effect of virtual worlds is situated within the structure of the split screen, which disrupts the pull of the images by forcing viewers to choose, again and again, where to direct their attention. While the soldiers recount their war experiences, we see what they see, realizing at once that we do in fact not see what they see: the images simulate a sphere of experience to which most viewers probably would find it hard to relate.

Not only is the screen split, the film also has a false bottom: it first appears that what we are following is an actual therapy session, but then one of the soldiers suddenly breaks off his report, and only now do we understand that this was a demonstration therapy held during a workshop. Farocki shows how easy it is to manipulate the viewer, even in a situation that explicitly addresses issues of immersion and the semblance of reality: the choice of camera angle renders the viewer incapable of taking in the real situation, leading to false assumptions. This breach of expectations is so surprising that it prompts intense reflection. We are reminded that we should never feel safe when confronted with images. KM

1 Cf. Tilman Baumgärtel, *Vom Guerillakino zum Essayfilm. Harun Farocki. Werkmonografie eines Autorenfilmers* (Berlin: b_books, 1998), p. 148.

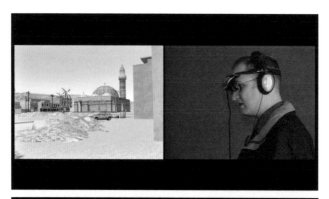

Immersion

Ian Wallace

Poverty, 1980
Film, 16mm, transferiert auf Video |
Film, 16mm, transferred to video
Videostills | Video stills

Poverty, 1980
8 Blaupausen und Xerox-Drucke auf Tonpapier |
8 blue prints and xerox prints on color construction paper

Ärmlich gekleidete Menschen gehen verlassene Straßen entlang, hocken vor Backsteinbauten auf dem Gehsteig, stehen inmitten weggeworfener Kartons oder liegen in Hut und Mantel auf einer Wiese. *Poverty* zeigt in einer Serie von acht Bildern Gestrandete am Rand einer Stadt.

Jedes der Bilder ist auf monochromes Papier gedruckt – die Farben bewegen sich vorrangig im Bereich von beige bis grünlich-gelb, das zweite Bild der Reihe sticht jedoch durch ein leuchtendes Giftgrün hervor. Während die Bilder selbst an Fotografien aus der Depressionszeit der 1930er Jahre erinnern, in deren Ästhetik sich die gedeckten Farben gut einfügen, öffnet dieses Grün einen völlig anderen Assoziationsraum: Es gehört in die Welt synthetischer Farben, Massenprodukte, der Pop-Art. Die Sujets stehen in betontem Gegensatz zu dieser Farbigkeit – Inhalt und Form gehen ein spannungsgeladenes Verhältnis ein.

Offensichtlich geht es hier nicht um eine Sozialreportage. Bei genauem Hinsehen fallen Unstimmigkeiten auf: Einige Protagonisten wirken, als ob sie posierten, scheinen zu unbeschwert für ihre Rolle. Tatsächlich stammen die Bilder aus einem 16mm-Film, auf dem der Künstler 1980 seine Freunde in einem aufgelassenen Industrieviertel in Vancouver aufgenommen hat. Die Drucke werden in dieser Ausstellung gemeinsam mit dem Film präsentiert, dessen Aufnahmen von monochromen Kadern durchbrochen werden, was den Fluss der Bilder immer wieder anhält. Wie die Kolorierung des

Shabbily dressed people walking down deserted streets, squatting on the sidewalk in front of brick buildings, standing amid discarded cardboard boxes, or lying in a meadow, dressed in hats and coats: *Poverty*, a series of eight pictures, shows people stranded on the outskirts of a town.

Each picture is printed on colored paper, with colors ranging mostly from beige to greenish-yellow; but the second picture in the series stands out with its bright bilious green. While the images themselves recall photographs from the era of the Great Depression, an aesthetic that fits well with the muted colors, this green opens up an entirely different association space: it belongs to the world of synthetic colors, mass products, Pop art. The motifs are in marked contrast with this coloration—a tension-charged relationship emerges between content and form.

This is obviously not about social reportage. Upon closer inspection, some striking inconsistencies are discernible: some of the protagonists appear to be posing or seem too insouciant for their roles. In fact, these images were taken from a 16-mm film made in 1980 by the artist, shooting his friends in an abandoned industrial area in Vancouver.

In this exhibition the images are presented together with the film, in which monochrome frames are cut in between shots, repeatedly halting the flow of images. Like the coloration of the celluloid strip, the conspicuous coloring of the photo prints brings viewers back to the media surface. In

Zelluloidstreifens holt die auffallende Farbgebung der gedruckten Bilder die BetrachterInnen an die mediale Oberfläche zurück. Auf subtile Weise wird in *Poverty* das modernistische Erbe, das Wallace' Werk im Allgemeinen prägt, greifbar. Während Fotografie und Film zunehmend die Abbildung der Welt übernahmen, begann die modernistische Malerei in einer selbstreflexiven Wendung den Bildgehalt zu eliminieren und in der Abstraktion ihre eigenen medialen Konventionen auszutesten. Wallace setzt Fotografie ein, um soziale Inhalte in sein Werk einzubringen – eine Inspirationsquelle für *Poverty* war auch seine damalige Recherche über frühe sozialrealistische Fotografie – und konfrontiert sie mit einem formalen Rahmen, der vorrangig die Darstellung von Inhalten, nicht die Inhalte selbst, zum Thema macht. Auch die Sujets – weniger Träger sozialer Kritik denn sozialromantischer Klischees – legen einen verzerrenden gesellschaftlichen Blick offen.[1]

Der Künstler schätzt den „Zusammenprall ästhetischer Ideologien, zwischen Form und Inhalt [...] oder Ästhetik und Politik" als einen „aufgehobenen Widerspruch."[2] In *Poverty* kommt es zu einer Politisierung des Ästhetischen: Die Welt wird ins Bild gesetzt und die Bilder werden hinterfragt. ᴋᴍ

1 Richard Rhodes, „Ian Wallace", in: *Vanguard*, Vol. 11 #7 (September 1982).
2 Ian Wallace, „Damals und jetzt und Kunst und Politik. Ian Wallace im Interview mit Renske Janssen", in: *Ian Wallace. A Literature of Images*. Ausst-Kat., Zürich: Kunsthalle Zürich, Düsseldorf: Kunstverein für die Rheinlande und Westfalen, Rotterdam: Witte de With; Berlin: Sternberg Press, 2008, S. 40 der deutschen Textbroschüre.

subtle ways, *Poverty* renders the modernist heritage palpable that defines Wallace's work in general. As photography and film took over the role of depicting the world, modernist painting took a self-reflective turn, gradually eliminating the figurative content and using abstraction to explore its own conventions as a medium. Deploying photography to bring social content into his works—*Poverty* was also inspired by the research into social-realist photography Wallace did at the time—the artist confronts it with a formal framework that moves the focus from content itself to its representation. The motifs, too, are vehicles not so much of social critique but rather of clichés of social romanticism, revealing a distorting social perspective.[1]

The artist prizes "collisions of aesthetic ideologies, between form and content [...] or aesthetics and politics" as a "contradiction in suspension."[2] *Poverty* thus enacts a politicization of the aesthetic: the world is framed in an image while the images are being called into question. ᴋᴍ

1 Richard Rhodes, "Ian Wallace," *Vanguard*, vol. 11, no. 7 (September 1982).
2 Ian Wallace, "Then And Now And Art And Politics. Ian Wallace interviewed by Renske Janssen," in *Ian Wallace. A Literature of Images*, exh. cat. (Zürich: Kunsthalle Zürich, Düsseldorf: Kunstverein für die Rheinlande und Westfalen, Rotterdam: Witte de With; Berlin: Sternberg Press, 2008), p. 144.

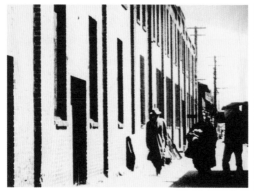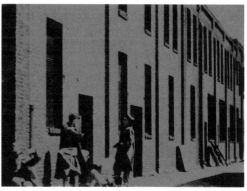
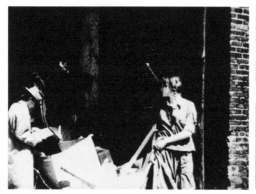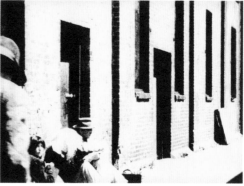

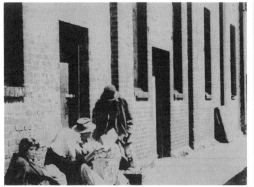

Michael Fliri

Give Doubt the Benefit of the Doubt, 2010
Performance

Maskenprobe | Make-up rehearsal

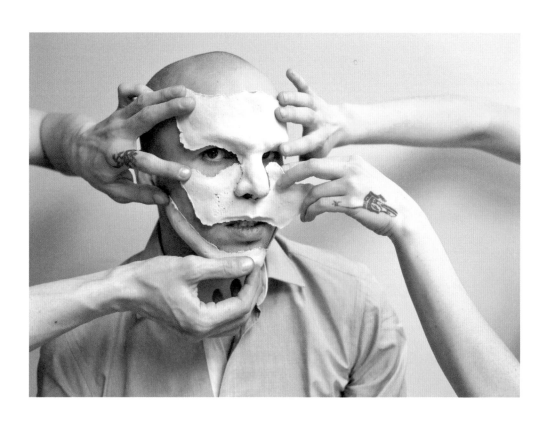

Michael Fliri ist selbst Protagonist seiner Performances. Sie sind Versuchs-anordnungen und Testläufe des Subjekts gegen eine widerständige oder indifferente Außenwelt, was letztlich auf dasselbe hinausläuft. Travestie und Maskierung verwandeln die antiheroisch agierenden „Helden" in pla-kative Klischeefiguren oder Wesen, deren Kreatürlichkeit nicht eindeutig bestimmt werden kann.

Der Cowboy, Punk, Footballspieler oder Selbstmordattentäter ist völlig unpathetisch in etwas hilflose Formen des Scheiterns verwickelt, so als wäre die wahre Heldentat die akribische Wiederholung und Demonstration eben jenes Scheiterns. Ständig wirkt die Figur, leicht überrascht und dabei doch heiter, mit dem Aufstand der Dinge beschäftigt, die animiert oder gar ein Eigenleben zu führen scheinen, dem Helden aber vielmehr wie zufällig in die Quere kommen, aus einer unglücklichen Verkettung der physikali-schen Ereignisse heraus. Bisweilen ist er mit der Inversion des Logischen beschäftigt: wirft einen Plastikanker mitten in den Ozean, um sich als Schiffbrüchiger zu retten, baut ein Haus unter Wasser, das er gegen die Gesetze der Schwerkraft bewohnen will, oder wirft einen Anker auf einen Baum, um sich hochzuziehen und in der Luft „unterzugehen". Atmosphäri-schen Widerständen wie Schnee und Wasser setzt er sich mutig aus und stoisch entgegen. Aber auch die Grenzen der Machbarkeit und eine plötzli-che Kreativität und Leichtigkeit, die es möglich machen, mit den gekonnten

Michael Fliri is the protagonist of his own performances. They are experi-mental arrangements and test-runs of the subject against a refractory or indifferent outside world, which ultimately comes to the same thing. Travesty and masquerade transform the antiheroic "heroes" into broad-brush clichéd figures or beings of indefinite creatureliness.

Entirely without pathos, the cowboy, punk, footballer, or suicide attacker is entangled in somewhat helpless forms of failure as if painstaking repetition and demonstration of that very failure were the only real act of heroism. Slightly surprised yet cheerful, the protagonist seems to be kept forever busy by the revolt of things that appear to be animated, even to have a life of their own, but in fact only get in the hero's way as though by chance, because of an unfortunate chain of physical events. Sometimes he is occupied with an inversion of logic: a castaway throwing a plastic anchor into the middle of the ocean to save himself; building a house under water he intends to inhabit against the laws of gravity; or casting an anchor into a tree in order to pull himself up and "drown" in the air. He courageously exposes himself to, and stoically faces, atmospheric resistances such as snow and water. Yet he also probes the limits of feasibility as well as a sud-den creativity and ease that allow him to change his world in accordance with his wishes with the sleight of hand of the bricoleur. Accompanied by

Griffen des Bricoleurs die Welt nach eigenen Wünschen zu verändern, werden ausgelotet. Begleitet von simpler, monotoner Musik verändert er ohne Mühe sein Haus im Minutentakt durch flinkes Verschieben seiner Teile.

Für die Generali Foundation führt Michael Fliri in der Menschenmenge des Eröffnungspublikums eine solitäre konzentrierte Handlung vor. Hier wird gewissermaßen hinter die Kulissen oder „hinter die Vierte Wand" geschaut und „the work in its making" gezeigt. Zunächst wird der Protagonist von einem Maskenbildner zu einem Anderen gemacht, einem hybriden Wesen mit anthropoiden Zügen, das in der Folge Fallübungen ausführt: Tests, wie beispielsweise eine Person, die umgebracht wird, wohl gefallen sein könnte – die Bodenmarkierungen halten in Umrissen die Möglichkeiten eines präjudizierten Ereignisses fest, schließlich wird die Illusion in der letzten Szene vollends aufgehoben, indem der Protagonist den Trick offenbart, der Blut spritzen lässt, wenn Helden zu Fall kommen ...

Die komischen, stummen Helden von Fliri erinnern an Buster Keatons oder Jacques Tatis gleichmütige Lakonik, Figuren, die mit minimalen Gesten des täglichen Scheiterns und der Poesie einfacher Handlungen die Funktionsweise, Paradoxie und Kontingenz unserer Welt durchleuchten und dabei doch offenbaren, wie mit Hingabe Dinge ganz einfach in den Griff zu bekommen sind, wenn auch nach den Regeln einer anderen Effizienz und dem Regime einer anderen Ordnung. SF

simple and monotonous music, he effortlessly makes changes to his house at one-minute intervals by nimbly shifting its parts around.

For the Generali Foundation, Michael Fliri performs a solitary and focused act amid the opening-night crowd. He allows us a glimpse, as it were, behind the scenes or "behind the Fourth Wall," showing us the "work in its making." First, a make-up artist turns the protagonist into someone else, a hybrid being with anthropoid features which then does some falling practice: testing, for instance, how a murder victim may have dropped—the body outline on the floor marks out the possibility of an envisaged event. The last scene, finally, completely kills the illusion, as the protagonist reveals the trick that makes blood gush when heroes fall ...

Fliri's mute comic heroes recall Buster Keaton's or Jacques Tati's imperturbable laconism; their tiny gestures of everyday failure and the poetry of their simple actions illuminate the way our world works, its paradoxes and contingencies, and yet reveal how easy it is, with devotion, to get a handle on things—if perhaps by the rules of a different type of efficiency and under a different order of things. SF

Marcello Maloberti

Die Schmetterlinge essen die Bananen, 2010
Performance

TAgADÀ, 2007
Performances und Installationen I and installations
Marcello Maloberti. TAgADÀ, Galleria Raffaella Cortese, Mailand I Milan, 2007

TAgADÀ

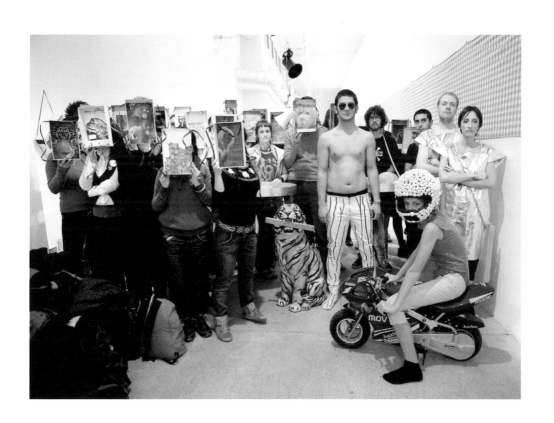

Für die Generali Foundation in Wien entwickelt Marcello Maloberti ein ortsspezifisches performatives Setting mit dem eklektischen Titel *Die Schmetterlinge essen die Bananen*. Eklektisch ist auch die Methode seiner künstlerischen Produktion. Worum handelt es sich? Um Performance, Theater, Film, Happening, Installation, Fotografie, Malerei, Collage? Von allem ist etwas zu finden: zum Beispiel zwei lebende Skulpturen, die den Eingang der Generali Foundation wie neoklassizistische Säulen beim Entrée von Luxusvillen flankieren, ein Tablett mit Bäumchen haltend, woraus zudem trashiges Alltagsradio ertönt; ein Kind, das in einer Ecke sitzt und aus Illustrierten Bilder ausschneidet, verstreute Scherben von (betrunkenen) Flaschen in Matrosenanzügen, ein ausrangierter Kühlschrank irgendwo im leeren Ausstellungsraum, aus dem kakophonische Geräuschmischungen kommen, und schließlich, in einer Reihe aufgestellt, ziemlich kräftige Menschen, die Tiger aus Porzellan halten, so lange sie können ...

Maloberti bereitet Orte vor, und die Menschen, die dort zu AkteurInnen werden, bekommen bestimmte Requisiten: Decken, Handtücher mit kitschigen Leoparden- und Tigermotiven, wie man sie von „Vu-Cumprà"-Verkäufern an Stränden kennt, rot-weiß karierte Tischtücher, wie sie in italienischen Trattorien üblich sind, billige Spiegel, Bleistifte und Buntstifte, Postkarten, leere Verpackungen von Medikamenten, billige Aurora-Plastikstühle: Ingredienzien für ein kleines, manchmal etwas verrücktes

———————

Marcello Maloberti has developed a site-specific performative setting for the Generali Foundation. It bears the eclectic title *Die Schmetterlinge essen die Bananen* (The butterflies are eating the bananas). Equally eclectic is the method of his artistic production. What is this all about? Is it performance, theater, film, happening, installation, photography, painting, collage? There is something of everything: two living sculptures, for example, flanking the entrance to the Generali Foundation like neoclassical columns framing the doorway of some luxury villa, and holding a tray with little trees on it, blaring with trashy run-of-the-mill radio sounds; a child sitting in a corner, cutting out pictures from illustrated magazines; the shattered glass of (drunken) bottles in sailor suits scattered around; a discarded fridge somewhere in the empty exhibition space, from which a cacophony of noises emerges; and, finally, lined up in a row, fairly strong humans holding up porcelain tigers for as long as they can ...

Maloberti prepares a space, and the people who become actors in it are equipped with certain paraphernalia: blankets, towels with kitschy leopard and tiger motifs—like those sold by "vu cumprà" vendors on beaches—the red-and-white checkered tablecloths typical of Italian *trattorie*, cheap mirrors, pencils and markers, postcards, empty medicine bottles, cheap plastic garden chairs: ingredients for a small, sometimes slightly weird world theater with precarious architectures—a flurry and

Welttheater mit prekären Architekturen – ein märchenhaftes Treiben und Tun, in dem Groß und Klein, Alt und Jung, „Indigen" oder Zugewandert, Gebildet oder Ungebildet, Arm und Reich, mehr Arm als Reich, ihren Auftritt haben.

Es ist nicht Theater, was hier passiert, auch wenn die theatralischen Momente stark präsent sind, es ist eher „Theater ohne Theater": Die Bühne ist ausgesucht, wenn ihre Wahl auch zufällig wirkt, die Orte sind meistens ungeschützt, offen für alle Flaneure und Streuner der Stadt, die sich einmischen können, mitmachen wollen, um ihre Meinung gefragt werden.

Die „Eingriffe" sind temporär, aber sie verändern Atmosphären. Maloberti ist kein Soziologe, eher eine Art Naturforscher, der beobachtet und „ermöglicht", er ist weniger Regisseur als Katalysator für diese merkwürdigen und heiteren Simultanaktionen, die dennoch einem bestimmten ästhetischen Parameter folgen und durch eine gewisse Strenge zusammengehalten werden, obwohl oberflächlich betrachtet alles so leicht und zart aussieht, prekär, am Rande der Auflösung, ständig ausfransend in Richtung tragikomische Katastrophe. Diese Grenze tangiert Maloberti, ohne jemals die Glaubwürdigkeit in Frage zu stellen, wobei die zarten Bande der künstlerischen „Werkzeuge" das Geschehen zu einem Teppich von ambivalenter Schönheit verweben, voll krasser Realität und ekstatischem, fabulierendem Tun – einem surrealen Tun außerhalb der Zeit. SF

scurry like in a fairytale, in which big and small, old and young, "indigenous" and immigrant, educated and uneducated, poor and rich—rather poor than rich—each play their role.

It is not theater that occurs here, although there are strong theatrical aspects to it; it is more like "theater without a theater": the stage is set, even though the choice seems accidental. The locations are usually unguarded, open to the city's flâneurs and roamers, who may get involved, who want to participate, who are asked for their opinions.

The "interventions" are temporary, but they make atmospheres change. Maloberti is not a sociologist, rather a natural scientist of sorts, an observer and "enabler"; not so much the director but rather a catalyst for these odd and hilarious simultaneous actions that nonetheless follow a certain aesthetic parameter, bracketed together by a certain rigor, although seen superficially, it all looks so very light and delicate, teetering on the brink of dissolution, constantly unraveling toward a tragicomic catastrophe. This is the line Maloberti walks, without ever compromising credibility, and the tender strings of his "tools" weave what is going on here into a tapestry of ambivalent beauty, full of crass realism and ecstatic, fanciful action—surreal action outside time. SF

Marcello Maloberti,
*Die Schmetterlinge essen
die Bananen*
Performance, 20. 5. 2010

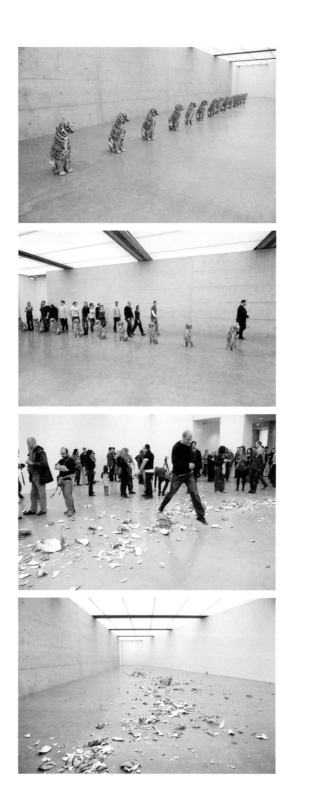

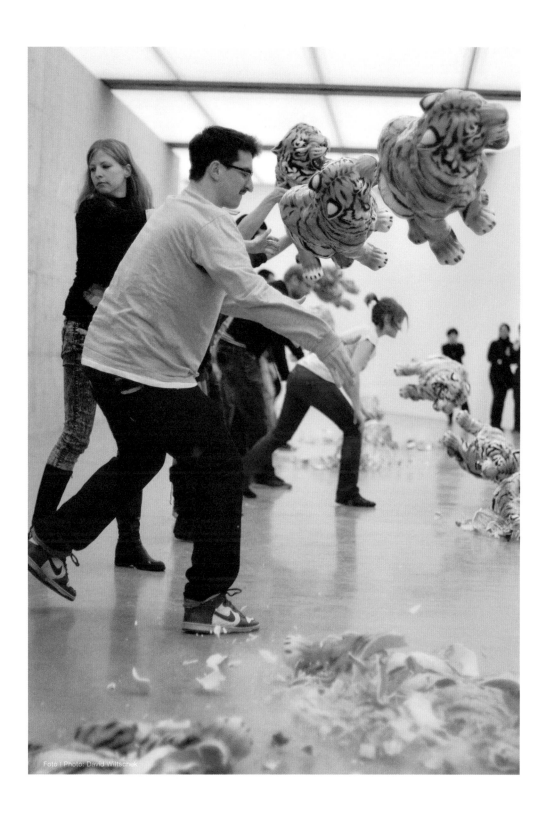

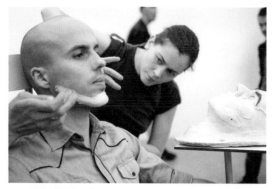

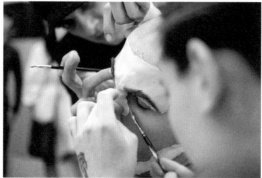

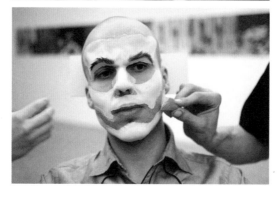

Michael Fliri,
Give Doubt the Benefit of the Doubt
Performance, 1. 6. 2010

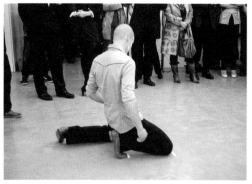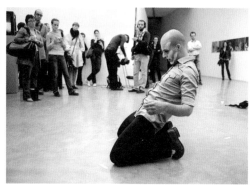

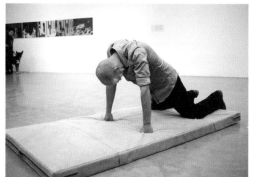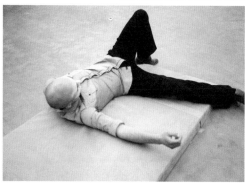

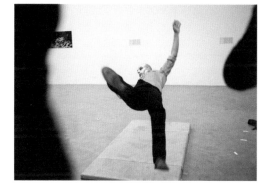

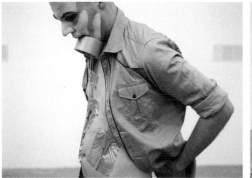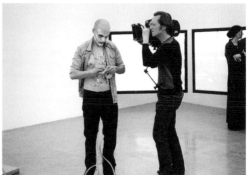

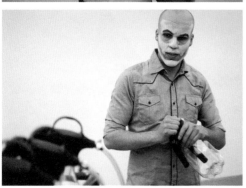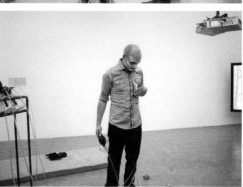

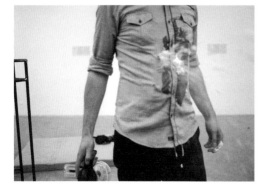

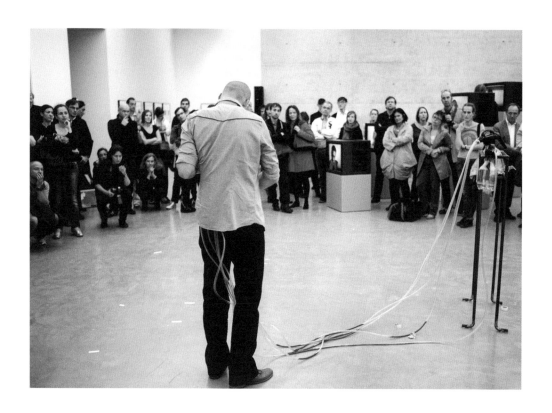

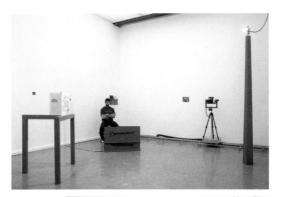

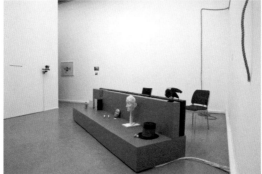

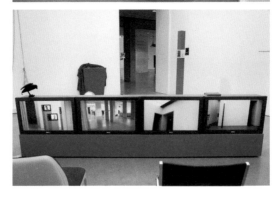

Ausstellungsansichten | Installation views

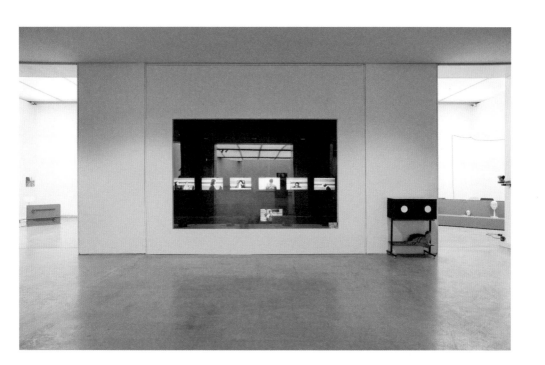

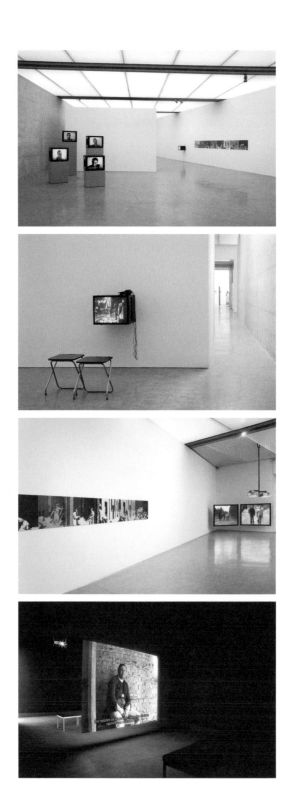

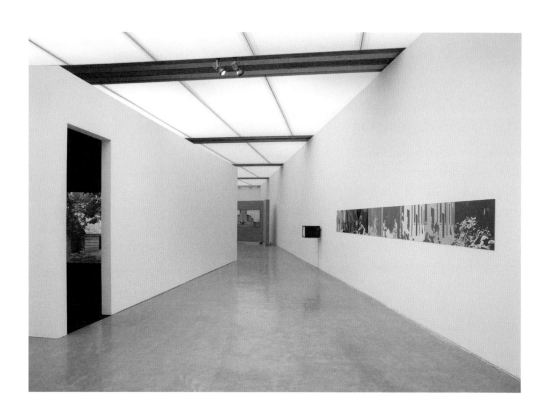

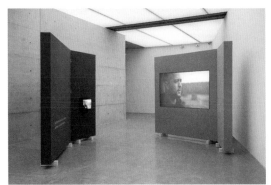

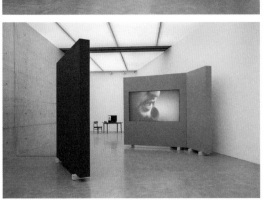

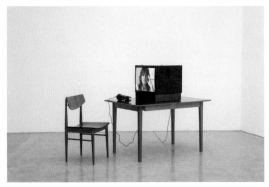

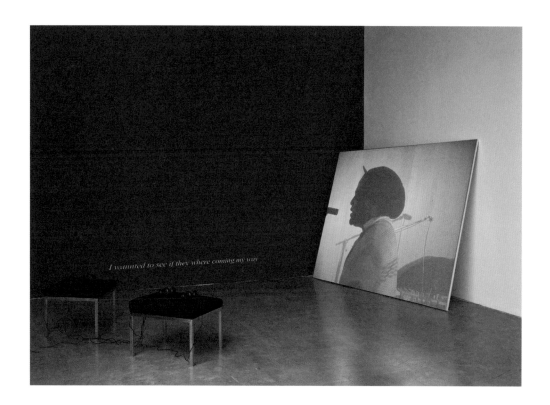

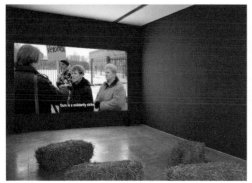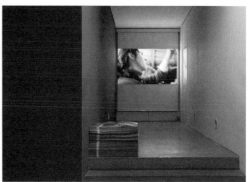

Ilse Lafer
Behind the Fourth Wall

Introduction

Prologue

Whether you write or act, think no more of the audience than
if it had never existed. Imagine a huge wall across the front of the
stage, separating you from the audience, and behave exactly as
if the curtain had never risen.
—*Denis Diderot*[1]

This paradox constitutes the basis for Denis Diderot's concept of the
"Fourth Wall." In eighteenth-century theater, the Fourth Wall marks the
boundary between mise-en-scène and real world and mediates between
stage and auditorium. It is the threshold where two spaces interlock, where
the difference between fiction and reality becomes manifest. Diderot's
Fourth Wall introduced a caesura that has informed the spatial dispositif of
the theater (cinema) to this day: the stage becomes an independent space
of action from which the viewers are, at least imaginarily, excluded. This
separation provides Diderot with the foundation for unfolding a concept of
affective and cognitive perception that interlinks subject and object, activity
and passivity, distance and intensity, self-observation from within and
without in a novel way. According to Doris Kolesch, these "are no binary
or even essentializable oppositions, but dynamic processes within the

performative process of representation and perception."[2] Diderot's – not systematized – concept of the Fourth Wall extends far beyond the stage of the theater and shows itself in his theoretical writings, letters, and novels.

While Diderot "enacted a meta-reflexive interplay of drama, dialog, commentary, and correspondence" in his texts, in which he appears, for example, as first speaker, second speaker, author, and narrator at the same time and sometimes converses with an imagined reader, he "engaged his figures on stage in a constellation of mutual observation," setting up the Fourth Wall inside the action on stage, so to speak, as Susanne Knaller explains in her contribution to this catalogue.[3] However perplexing the intertwined moments of the mise-en-scène, all of them are situated at the boundary between reality and fiction; elements of reality are always incorporated into the fiction, mirrored into it by means of the Fourth Wall, as it were, without ever abandoning the difference between imagination and reality.

As is well known, the whole of Diderot's aesthetics rests on the identification of theatrical scene and pictorial tableau: the perfect play is a succession of tableaux, that is, a gallery, an exhibition; the stage offers the spectator "as many real tableaux as there are in the action moments favourable to the painter."[4]

1 Denis Diderot, *On Dramatic Poetry* (1758), in B. H. Clark, *European Theories of the Drama* (New York: Crown Publishers, 1947), pp. 286–298.
2 Doris Kolesch, "Bestürmte Bühnen. Diderots erotische Verflechtung von Gefühl und Reflexion," in: D. Kolesch, *Theater der Emotionen* (Frankfurt am Main: Campus Verlag, 2009), p. 238.
3 Cf. Susanne Knaller, p. 159 of this catalogue.
4 Roland Barthes, "Diderot, Brecht, Eisenstein," p. 140 of this catalogue.
5 Elisabeth Cowie, "Dokumentarische Kunst: das Reale begehren, der Wirklichkeit eine Stimme geben," in *Auf den Spuren des Realen. Kunst und Dokumentarismus*, ed. Karin Gludovatz (Vienna: Museum Moderner Kunst, 2003), p. 24.
6 Cf. Roland Barthes, "Diderot, Brecht, Eisenstein," p. 142 of this catalogue.
7 Günther Heeg, "Bilder-Theater: Zur Intermedialität der Schwesterkünste Theater und Malerei bei Diderot," in *Crossing Media: Theater – Film – Fotografie – Neue Medien*, ed. Christopher Balme, Markus Moninger (Munich: epodium Verlag, 2003), p. 87.
8 Cf. Samuel Weber, "'Mittelbarkeit' und 'Exponierung' – Zu Walter Benjamins Auffassung des 'Mediums'," http://www.thewis.de/?q=node/35 (January 2004).
9 Roland Barthes, "Kommentar (Vorwort zu Brechts *Mutter Courage und ihre Kinder* mit Photographien von Pic)," in Roland Barthes, *Ich habe das Theater immer sehr geliebt, und dennoch gehe ich fast nie mehr hin, Schriften zum Theater*, ed. Jean-Loup Rivière (Berlin: Alexander Verlag, 2001), p. 244.
10 Cf. Juliane Rebentisch, "Der Auftritt des minimalistischen Objekts, die Performanz des Betrachters und die ethisch-ästhetischen Folgen," in *Performativität und Praxis*, ed. Jens Kertscher, Dieter Mersch (Munich: Wilhelm Fink Verlag, 2003), p. 113–139. Rebentisch argues against the dinstinction postulated by Fried and concludes "we might raise the objection that there is no non-theatrical art, to use the author's own vocabulary." (p. 139)
11 Cf. Doris Kolesch, Annette Jael Lehmann, "Zwischen Szene und Schauraum – Bildinszenierungen als Orte performativer Wirklichkeitskonstitution," in *Performanz. Zwischen Sprachphilosophie und Kulturwissenschaften*, ed. Uwe Wirth (Frankfurt am Main: Suhrkamp, 2002), p. 353.

To "[b]ehave exactly as if the curtain had never risen": this conception of a (closed) stage is the foundation for Diderot's "theater of tableaux," whose central mover is the mimetic representation of the *vrai de nature* (the truth of Nature). The role he assigns to the tableau vivant is one of irritation, which is to "shake" – and change – the viewer's perception and self-assuredness through its emotional impact and contemplative immersion. He is concerned with the aesthetic experience of "reality," which, according to him, can just be conceived as mediated, only constituting itself in its representation in the memory. In the tableau, comparable to Lessing's "pregnant moment," an "understanding of motion in standstill takes effect,"[5] which runs counter to the dramatic action, the *vrai de nature*. Thus, the tableau reveals its artificial nature and turns into a quotation within the development of the plot or to a "visible" Fourth Wall.

Roland Barthes's essay "Diderot, Eisenstein, Brecht" offers a remarkable comparative study: Barthes maintains that not only Diderot's plays, but also Brecht's epic scenes and Eisenstein's films are to be seen as sequences of tableaux, whose essence he describes as the mise-en-scène of a "pregnant moment." The common ground they share according to him is the quest for that "carefully" chosen "total" moment, in which "the present, the past and the future" can be read, which is the "presence of all the absences."[6] The specific methods employed for this correlate to Diderot's theory of the tableau, which according to Günther Heeg has been taken up by Sergei Eisenstein in his "montage of attractions" and particularly by Bertolt Brecht in his concept of social "gesture."[7] The principle of interruption or the gesture's quotability on which the aesthetics of the tableau is based has also been made out in Brecht's epic theater by Walter Benjamin. Contrary to Diderot, Brecht's tableau is not aimed at "shifting something inside, something invisible outside to make it visible...what matters is the outside, the spatial, the rational."[8]

> Brecht's tableau is almost a tableau vivant; like painting, it presents a gesture that remains in the balance and is virtually immortalized in the most fragile and intense moment of its meaning...hence his realism, since realism can never be anything but an insight into the real.[9]

Brecht's "pregnant moment" is completely different: his epic theater and Diderot's "theater of tableaux" could not be any more different if we follow Michael Fried's opposition of "absorption" (Diderot/theater of illusions) and "theatricality" (Brecht/epic theater).[10] What both have in common, though, is that their distancing methods aim for a redefinition of the relationship of stage/illusion and viewer/reality in order to trigger an intricate process of reflection and self-reflection – a process enabling the individual viewer to create his or her own story[11] or to sharpen their powers of judgment. What is to be evolved is "a method of acting which ensures that

the observing mind remains free and flexible. The viewer must be able
to make continuous fictitious adaptations to our building,"[12] says Brecht.
He regards the viewer as an active co-author, who – contrary to Diderot –
must not be "hypnotized" under any circumstances. This attitude provides
Brecht with a basis for developing complex strategies that, summarized
under the term A-effect (alienation effect), "guarantee the defamiliarization
of the viewer's perspective, his detachment, and the control of illusion."[13]
Similar to the idea of the Fourth Wall, the A-effect comes to bear above all
in working with a play's actors: both Diderot and Brecht insist on their
detachment from their roles. While Diderot regards the actors' inner and
outer distance as the prerequisite for achieving an illusionary experience of
"truth" through a calculated imitation of nature,[14] the difference between
actor and character in the play turns into a productive source of friction in
the gesture of presentation for Brecht.

Against the background of a changed understanding of reality and a
different theater concept, Brecht pursued a similar objective with his
A-effect as Diderot did with his idea of the Fourth Wall: both imagine the
stage as a distancing mirror revealing the true/false nature of the world to
the eye. When Brecht repeatedly interrupts the flow of time and exposes
time as a medium in his plays, he, unlike Diderot, questions the illusion of
reality as a coherent whole, though. For him, the "pregnant moment"
(Laocoon) does not spring from a representative whole (Diderot), but turns
into the image of "a truth flashing up" in time. Or, in Walter Benjamin's
words: "The true picture of history *flits* by. The past can be seized only as an
image which flashes up at an instant when it can be recognized and is never
seen again."[15]

12 Bertolt Brecht, "Schriften zum Theater 2," in *Gesammelte Werke*, Vol. 16 (Frankfurt
 am Main: Suhrkamp, 1999), p. 680.

13 Heiner Goebbels, "Von der Unabhängigkeit der Mittel," in *Brecht frißt Brecht. Neues
 Episches Theater im 21. Jahrhundert*, ed. Frank-M. Raddatz (Berlin: Henschel Verlag, 2007),
 p. 105.

14 Cf. Isabella von Treskow, *Französische Aufklärung und sozialistische Wirklichkeit.
 Denis Diderots Jacques le fataliste als Modell für Volker Brauns Hinze-Kunze-Roman*,
 PhD thesis, Heidelberg University, 1995 (Würzburg: Königshausen & Neumann, 1996),
 pp. 41–42.

15 Walter Benjamin, "Theses on the Philosophy of History", in *Illuminations*, ed. and with
 an introduction by Hannah Arendt, transl. by Harry Zohn (New York: Schocken Books, 1987),
 p. 255.

16 Cf. Hito Steyerl, *Die Farbe der Wahrheit. Dokumentarismen im Kunstfeld* (Vienna:
 Turia + Kant, 2008), p. 93.

17 Tom Holert, "Die Erscheinung des Dokumentarischen," in *Auf den Spuren des Realen.
 Kunst und Dokumentarismus*, ed. Karin Gludovatz (Vienna: Museum Moderner Kunst,
 2003), p. 52.

18 Ruth Sonderegger, "Nichts als die reine Wahrheit? Ein Versuch die Aktualität des
 Dokumentarischen mit den materialistischen Wahrheitstheorien Benjamins und Adornos
 zu verstehen," in *Auf den Spuren des Realen*, p. 65.

19 Steyerl, *Die Farbe der Wahrheit*, p. 93.

20 Jacques Rancière, *Der emanzipierte Zuschauer* (Vienna: Passagen Verlag, 2008), p. 79.

With Charles Baudelaire and Walter Benjamin, Christian Schulte in his contribution relates to two voices which found "the fundamental transformation of lived experience that took place in the age of industrial mass production," the process of fragmentation and alienation, already anticipated in the first half of the nineteenth century. In the early days of the twentieth century, Dziga Vertov's triumphant exclamation "Long live life as it is!"[16] gave expression to the belief that the camera lens could objectively capture any detail in the world and render reality as it is. Since that time, the objectivity produced by the cinematic or photographic picture "determined the understanding of what was true and truthful, of visual testimony and evidence."[17]

However, since the era of Structuralism and Post-Structuralism, at the latest, it has been generally accepted that "[t]here is no truth. There is no reality. There are just its randomly born and impenetrable constructions."[18] That the "made" character of the world, or the construction of always new models of reality and life, is not purely accidental, but rather organizes, steers, and controls how we live together has probably given emergence to Alain Badiou's "passion for the real": he identifies the desire for "reality" as the twentieth century' crucial trait: "The real is never real enough not to be suspected as appearance."[19] If the world has turned into an impenetrable web of fiction and reality, an effect of incessantly changing media surfaces, the desire for orientation is more pressing than ever. Understanding reality as having disappeared behind its representation implies, as its reverse, the message and legitimate demand to look "behind" the scenery, to create one's own stages if the need arises, and to ground one's mise-en-scène of the fictional in the real. How to convey "truth" at the interface between reality and illusion, between our "direct" existence and the virtual worlds? Or, to put it differently: can reverting to Diderot's Fourth Wall as a historical model of sophisticated disruptions of fiction or Brecht's alienation effect help bring forth a stage which permits a "new seeing" or a critical description of the world we live in?

The Exhibition

Fiction is not the creation of an imaginary world opposed to the real world. It is a work that operates multiple forms of *dissensus*, and that changes the forms of enunciation and the ways in which the sensible is presented, by changing its very frames, scales, and rhythms, turning them into new relations between appearance and reality, between the individual and the common, between the visible and its signification. This work changes the coordination of the representable. It changes our perception of sensible events [...].[20]

The artists in the exhibition aim to show reality *under construction*, in all its complexity. They focus on (micro)political communities, transforming common places into theatrical sceneries and analyzing their structures with the rhetoric of film and theater. In their respective specific ways, they transcend "the frames and scales of what is visible and enunciable"[21], looking out beyond the edge or behind that which is to be represented, creating interstitial spaces and references where there were none before. In photographic pictures, slide or video projections, multi-perspective video installations as well as live performances and performative installations, the artists use stylistic means that come close to Diderot's Fourth Wall or Brecht's alienation effect. This mostly involves setting up (smaller or larger) stages, on which viewers' gazes are distracted or reflected back onto themselves, whether by subtle or perplexing observer perspectives (Judy Radul), the scattering of the gaze through double or multiple projections (Aernout Mik, Omer Fast, Wendelien van Oldenborgh), cross-dissolves or the deceleration of images (Wendelien van Oldenborgh), the alienation of language, of the textural or visual level (Andrea Geyer, Omer Fast, Ian Wallace), the deliberate disclosure of technical equipment (Harun Farocki, Michael Fliri), or the creation of distance through performative or theatrical elements (Frédéric Moser & Philippe Schwinger). What brackets the individual works together is the question of how reality is communicated, perceived in images, statements, and signs. What is explored here is the relationship between immediacy and mediacy, affect and distance, passivity and activity, with the Fourth Wall, as a metaphor, becoming the actual pivotal point for the re-conquering of a reflected standpoint, in which the questionable distinction of reality and appearance subtly manifests itself.

The question of "truth," of the relationship between "reality" and its (re)presentation takes Judy Radul back to her roots as she transfers the International Court of Justice from The Hague to the exhibition space. A four-hour reenactment of a number of tribunals (against, among others, Slobodan Milošević or former Liberian President Charles Taylor) takes place here in which the question of the representability and staged nature of "truth" comes into focus. Radul's mise-en-scène takes its orientation from the organization and perspective of the recording apparatus: in her spectacle of the controlled gaze the director is the camera eye which is used to enact a performance of nested observer situations. *World Rehearsal Court* is a spectacle of observing and being observed, in which we, viewing,

21 Ibid.
22 Michel Foucault, *Discipline and Punish. The Birth of the Prison,* 2nd ed. (New York: Vintage, 1995), p. 221.
23 Cf. Katharina Menches, pp. 102–109 of this catalogue.
24 Rancière, *Der emanzipierte Zuschauer,* p. 114.

encounter ourselves viewing. It gives the piece somewhat of a false bottom if Radul unfolds her thoughts about the politics of segmenting, out of all places, in a courtroom: like Diderot's stage, it is a place which is separated from the outside world and in which the ever-same setting, costumes, and well-rehearsed roles, the language and the manner of speaking all suggest truth. Here the aesthetics of authenticity and of the controlled segment, of which Roland Barthes says that "everything that surrounds it is banished into nothingness, remains unnamed, while everything that it admits within its field is promoted into essence, into light, into view," share a common space of visibility in which the "panoptic modality of power"[22] openly emerges. This becomes all the more clear as Judy Radul conceives *World Rehearsal Court* as an enclosed space plus surroundings, with the stage in the middle as a "pure cut-out segment with clearly defined edges," and left and right of it the spaces that usually remain outside our view: viewing and being viewed – live cameras connected to monitors that constantly reproduce our movement in space. We also come across alleged pieces of evidence – props and found objects of all kinds – whose causal nexus, however, remains obscure.

An image as a "pure cut-out segment with clearly defined edges" is not what Aernout Mik produces in *Convergencies*, for his image frays along the edges, wearing away into indefinite space and time. Like Harun Farocki's *Immersion*[23], a piece that puts the impact of virtual worlds to the test, this is a critical view of the pull that makes the visual attraction of the media image. On two panoramic picture panels mounted at right angles to each other and referencing the genre of the history painting, an incessant flow of found footage from international new channels is projected. Emergency training situations – crowds of people, among them persons in uniform, police and military – suggest a propulsive burst of images which paradoxically only leads to stagnancy. Cut together without narrative climaxes or explanatory commentary, the material leaves viewers in a limbo of disorientation. The Fourth Wall they face could not become more literally visible than in showing images divorced from words. What we see is "too many bodies without a name, too many bodies unable to reciprocate the look we give them; too many bodies that are subjects of speech without being able to take to speech themselves."[24]

The propulsive burst of images may also be one of words fired from an Israeli tank. In *A Tank Translated*, Omer Fast does interviews in Hebrew with four young men, positioning them in four monitors on pedestals of different heights in accordance with their rank on the tank crew – commander, gunner, loader, and driver. While emphasizing, at the image level, the character of staged authenticity – four heads in frontal view against a neutral backdrop –, Fast interferes in the structure and meaning of the subtitles, manipulating sentence after sentence, altering the syntax until the individual words are combined in new contexts of hardly decipherable

content. By deleting, replacing, permuting words, he illustrates the process of remembrance, or of the reconstruction of history, which is neither linear nor objective. It is only the obvious manipulation that makes the space behind the purportedly authentic visible, showing through eye-witness testimony how an image of reality is made up and arranged, whether at the media level or at the level of the memory – a deconstruction of accustomed certainties.

Godville is a strange place, *Godville* is permanent reenactment, museum, everyday living environment. The stories of *Godville* are as real as they are made up; in *Godville*, a fiction of the eighteenth century und the reality of the twenty-first century coincide – is *Godville* ruled by God in the end? This in the impression one might get when watching the end of Omer Fast's fifty-minute double video projection: one of the protagonists from the Williamsburg Living History Museum keeps repeating the words "God is...," completing the sentence with all sorts of unexpected predications: electric light, a transformer, an economist, etc.[25] Interwoven and taken to the point of absurdity, the present and the historical are edited in a very special way in *Godville*: Omer Fast interviewed three residents in their historic costumes about their everyday life in the present time and in their historical roles, montaging the raw material into an uninterrupted torrent of words. Consistent linear narration, however, is thwarted by the obvious jump-cut editing at the image level – a distraction that is further accentuated by the projection on the back side of the screen: quiet impressions of the town, simple camera shots, architectures, outdoor spaces, and interiors. With this mise-en-scène of negated historicity and individuality, Fast undermines unshatterable notions of past and present, rearranging the material – whether role play or real life, Potemkin village or living environment – in new relations, without concealing his own role as a potential (re-)creator. Looming behind the hopeless muddle of War of Independence, terror, slavery, Middle-East conflict, and religious fanaticism is a "different" perception of reality: eternal recurrence of the same, as is inherent by definition in any reenactment.

A rewriting of historical events which invalidates the relationship between temporality and causality is also effected by Andrea Geyer in *Reference Over Time*. Stammering and voice failing, together with visible physical discomfort, epitomize the precarious situation of being stateless as the artist has – in a direct response to a bill introduced in the Bush era, the so-called USA Patriot Act II empowering the government, among other

25 Cf. Steyerl, *Die Farbe der Wahrheit*, p. 68.
26 Personal communication between the artist and Parveen Adams, Parveen Adams, "Art and the Time of Repetition," in *Exile of the Imaginary. Politics, Aesthetics, Love* (Vienna: Generali Foundation; Cologne: Verlag der Buchhandlung Walther König, 2007), p. 151.

things, to deport legal immigrants – Bertolt Brecht's *Conversations Among Refugees* recited by an actress.

A monitor on a table, a chair in front of it: a woman appears on the screen, she sits down, staring at us, and starts speaking – it seems as if she did not understand the words – she stops, gets up, turns away, walks out of the picture, comes back, sits down again, goes on speaking, breaks off... Geyer is looking for a "way to situate a body to speak," or for a "position from which to speak"[26], assigning the viewer a place at the table across from the monitor. She thus makes reference to the protagonists of Brecht's *Conversations Among Refugees*, Ziffel, a physicist, and Kaller, a metal-worker, who sit together at a station restaurant, discussing "passports", the "equality of beer and cigars", and "the love of order" in the totalitarian regime of the Third Reich.

Another, perhaps accidental, historical reference is added to the work through a line of text running across the screen: "I dipped into Diderot's JACQUES THE FATALIST when a possibility occurred to me of putting the old Ziffel plan into operation..." Diderot's meta-novel *Jacques le Fataliste et son maître* (1778–1780, 1796) may well have inspired Brecht because of its radical repudiation of classical narration: in the book, the dialectic of mastery and servitude, or human free will, is made subject to an experimental reading which, poetologically, manifests itself in disruptions of the fictional and an almost random-seeming nesting of different dialogical narratives. The question of the meaning of words and the search for truth in human exchange, which inform both works, Brecht's *Conversations Among Refugees* and Diderot's *Jacques le Fataliste et son maître*, lead to foundering on the spoken word in *Reference Over Time*. Who's talking to whom here? What is the role the actress plays, and what is ours? Are we those silent observers "behind" the literal Fourth Wall, who have no language and no role, but nevertheless share with the actress the presence of the historical burden of the words?

Like Andrea Geyer, Wendelien van Oldenborgh also relies on the reenactment of a historical voice in *No False Echoes* to give some edge to the discourse on national identity in the Netherlands. The venue is the Radio Kootwijk building, a modernist solitaire structure in the midst of a gentle green Dutch landscape. While, inside the building, a language landscape unfolds with a little girl singing for a radio recording, experts debating the power of the corporate Philips Omroep Holland Indië radio station, with occasional throat clearing and gestures of speaking of individual visitors, on the outside, on a balcony of the building, the echo of a historical voice makes itself heard in a speech performance by Dutch rapper Salah Edin: the fierce tirade launched by Indonesian freedom activist Soewardi Soerjaningrat against the Netherland's colonial rule over Indonesia is brought back to the present and almost materializes in Edin's performative speech act. Comparable to how the Brecht dialogue was acted out in

Reference Over Time, the politics of the text is conveyed through the body of Salah Edin here, though with the difference that a strange intensification becomes visible in *No False Echoes*: the biography of the performer, his outward appearance, inscribes itself in the historical text, however without being entirely absorbed by it. An impish laugh every now and then, a quiet exchange with the artist – facial expressions and gestures mark the line between documentary recording and instantaneous enactment by Salah Edin.

The interplay of past and present, of inner and outer dialogue, of closeness and distance occurs at the level of media translation as well as in the enactment of language. The space between the partition walls is structured by three pictorial planes: a projected image on the one side and a monitor and the projection of the subtitles on the other, opposite side. Van Oldenborgh keeps undercutting the suggestive power of the speech act by bringing the debate that is going on inside back to the projection surface. At the end of the video, Edin gives up his distanced position and mingles with the others to discuss with them, with the closing credits already rolling: a polyphony without a redeeming narrative. Subtly, viewers between the partition walls are involved in the "polyphony of past and present voices," which, in the words of Russian literary critic Mikhail Bakhtin[27], enter a new stage of appropriation in the act of reception.

Two videos, *Alles wird wieder gut* und *Donnerstag*, in an oxblood-painted room, with straw bales in between and a weighty pile of 5,000 posters which all show the same motif: an abstracted Swiss Market Index chart of 2006 from the Zurich Stock Exchange. This is the stage set for a new production of Lenin's *Farewell Letter to the Swiss Workers*, a Marxist-oriented analysis of society by Frédéric Moser and Philippe Schwinger. The issue raised by the artist duo – how and to what extent changes are possible within a given system and how big the transformative power of revolutionary utopias is – implies the question concerning the mechanism operative in the existing order which unfolds in *Farewell Letter to the Swiss Workers* through the associative linking of films and objects. Like in van Oldenborgh's *No False Echoes*, a historical text provides the starting point for a choreography between fictionality and semi-documentary forms. While *Donnerstag* shows, in quiet images, the mechanized workday of a young milkmaid, *Alles wird wieder gut* is a line-up of different sequences: a demonstration of workers outside the closed gates of a factory, scenic

27 Thomas Elsaesser and Malte Hagener, *Filmtheorie* (Hamburg: Junius Verlag, 2007), p. 66.
28 "Materialien zu KLASSENVERHÄLTNISSE. Von Danièle Huillet und Jean-Marie Straub, nach Franz Kafka," in *new filmkritik*, 8. 10. 2007. http://newfilmkritik.de/archiv/2007-10/materialien-zu-klassenverhaltnissevon-daniele-huillet-und-jean-marie-straub-nach-franz-kafka. (12. 5. 2010)
29 Roland Barthes, "Diderot, Brecht, Eisenstein," p. 141 of this catalogue.
30 Cf. Christian Schulte, p. 151 of this catalogue.

performances of a youth group in an everyday working situation, prepara-
tions for a party, and a theater rehearsal in the parsonage of the village,
where a young boy performs a recital of Lenin's letter to the workers.
Similar to Jean-Luc Godard's and Jean-Pierre Gorin's movie of the same
title, *Tout va bien* (1972), the implementability of Marxist discourses for life
is rehearsed in theatrical play. The illusion effect of the stage-like installa-
tion is skillfully broken by the actors through a Brechtian mode of speaking:
stereotypes, sometimes Marxist slogans, create a noticeable distance be-
tween the actors and the characters represented. And yet, it seems that
it is precisely this distancing effect that can credibly transpose the ideology
of yesterday to the social and personal life of today. *Alles wird wieder gut:*
a rehearsal for the redistribution of social roles?

"You either believe in class relations, because you've experienced
them, or you don't, and this is what this film is all about, aside from the text
and the space and the diversity of characters and the compressed time..."[28]
Harun Farocki's film is not "actually" about *Class Relations* by Danièle
Huillet und Jean-Marie Straub; rather, it shows rehearsals for that film.
With simple and quiet camerawork, Farocki succeeds in capturing the
directors' precision work in repeating the same scenes, words, and gestures
again and again, their "being in the film." The title of the film therefore is
*Jean Marie Straub and Danièle Huillet at work on a movie based on Franz
Kafka's novel "Amerika."* Like Brecht, Farocki is interested in the significant
content of every single scene: "At the level of the play itself, there is no
development, no maturation; [...] nothing but a series of segmentations
each which possesses a sufficent demonstrative power."[29] The final scene
of Farocki's film: a meadow, behind it a forest, it is dark. We see Karl
Roßmann, the 16-year-old protagonist of Kafka's novel, before an opened
blue suitcase. He is looking for the photo of his parents. On the right, there
are the cameras, spotlights, the film team, and Jean-Marie Straub; all
of a sudden, in the center of the picture, a surreal tableau, in which that
which is "not yet," the film-to-be, takes a strange turn in the now of
the rehearsal – a picture that has that "sufficient demonstrative capacity"
to give presence to the absent.

Farocki looks for the image "behind" the image in which he highlights
the filmmakers' presence "behind" the precise setup of the tableaux and the
enactment of language. This induces a striking double effect: the Brechtian
method makes itself felt not only in Farocki's film, but also unfolds in the
work of Straub/Huillet: a distanced emphatic mode of speaking that brings
out the "material value of language."[30]

In Allan Sekula's *Aerospace Folktales*, looking "behind" the Fourth
Wall is turned into the question of reality in the photographic image. In a
photo-reportage in a stage-like setting with explanatory commentary and
tape recordings, Sekula locates his family situation in the political and
social milieu of the early 1970s. The central topos is his father's life story,

informed by his socialization and work ethic, which reflects the "made" character of the petty-bourgeois home. "i kept getting that feeling when i went back there with my camera—the apartment was a submarine—it was underwater—it was a cave with conical lamps in every corner—we were stuck in the middle of the maginot line [...]".[31] Viewers find themselves inside this precisely arranged family submarine between fan palms and director's chair, image, sound, and text documents which Sekula, addressing the audience, comments and places in a larger political context. So the evidence of the real becomes experienceable, via the performative and enacted, between the "visible form of the image" and the spoken word: "[...] the voice is not the manifestation of the invisible as opposed to the visible form of the image. It is itself embedded in an imaging process. It is the voice of a body that transforms one sensible event into another in that it strives to make 'visible' to us what it has seen itself, to make us see what it says to us."[32] Or to conclude in the words of Sekula: "so i have written down some things so you will understand what i am talking about—so you won't think i'm documenting things for the love of documenting things—[...] this material is interesting only insofar as it is social material [...]".[33]

Ian Wallace's *Poverty* is not a social reportage. Its basic material, a 16-mm film of 1980 of his artist friends enacting stereotype postures of poverty, has gone through different forms of media representation in the following years: Wallace mounted the film frames on large monochrome canvases, showed them as a series of small black-and-white pictures, with alienating coloration on video, or as prints under Plexiglas. The question raised by *Poverty* is, according to W. J. T. Mitchell, not representation, "whether it is meant politically, ethically, or epistemologically, but precisely the form in which the question is posed."[34] If Wallace imposes the visuality of the photographic social realism of the 1930s on self-reflexive modernist

31 Allan Sekula, *Allan Sekula. Performance under Working Conditions*, ed. Sabine Breitwieser, exh. cat. (Vienna: Generali Foundation; Ostfildern: Hatje Cantz, 2003), p. 160.
32 Rancière, *Der emanzipierte Zuschauer*, pp. 111–112.
33 Sekula, *Allan Sekula. Performance under Working Conditions*, p. 160.
34 Quoted in Reinhard Braun, "Wirklichkeit zwischen Diskurs und Dokument," in *Realitätskonstruktionen in der zeitgenössischen Kultur*, ed. Susanne Knaller (Vienna, Cologne: Böhlau Verlag, 2008), p. 42.
35 Ian Wallace, "Then And Now And Art And Politics. Ian Wallace interviewed by Renske Janssen," in Ian Wallace, *A Literature of Images*, exh. cat. (Zurich: Kunsthalle Zürich, Düsseldorf: Kunstverein für die Rheinlande und Westfalen, Rotterdam: Witte de With; Berlin: Sternberg Press, 2008), p. 144.
36 Slavoj Žižek, *For they know not what they do. Enjoyment as a political factor*, 2nd ed. (London: Verso, 2002), p. 247.
37 Ibid., p. 251.
38 Cf. Sabine Folie, p. 119 of this catalogue.
39 Ibid.
40 Johannes Friedrich Lehmann, *Der Blick durch die Wand. Zur Geschichte des Theaterzuschauers und des Visuellen bei Diderot und Lessing* (Freiburg im Breisgau: Rombach, 2000), p. 331.

painting, he causes "collisions of aesthetic ideologies, between form and content"[35], collisions that bring mediality as a background condition of communication to the fore. Viewers find themselves placed into theatrical scenes, plunged into a mysterious, strangely colorized, yet familiar visual world. Nothing in this work is immediate or authentic, and yet there can be no doubt about the reality conveyed: behind the staged images, perception is debunked as a "socially romantic cliché."

In *Give Doubt the Benefit of the Doubt*, a performative action in three parts, the audience is present for Michael Fliri only "behind" the Fourth Wall. He raises the question of the relationship between immediacy and mediacy from the very start by becoming an altogether different person: it is the transformation of his face by a professional make-up artist that advances the action in the first place, which turns into an event only through the performative act: "[...] there is more truth in the mask, in the symbolic form, than in what is hidden behind it, than in its bearer. If we 'tear away the mask' we will not encounter the hidden truth; on the contrary, we will lose the invisible 'truth' which dwells in the mask."[36] Slavoj Žižek's observation opens up a space of experience that is as operative for Wallace's "masked" photographs as it is for Fliri: in both cases, the "masking" entails a mediacy, at whose surface the difference between fiction and reality becomes negotiable. If the mask, as Žižek continues, "regulates our actual, real behaviour"[37], it is a condition for Fliri to define "rules of a different type of efficiency"[38], by which he reveals things or tries to "illuminate the way our world works [...] its contingencies"[39], frequently doing so with pantomimic gestures of failure, as when trying to fall "in the right way."

That the corporeality of gesture, pantomime, and facial expression unfolds a hieroglyphic "poetry in space"[40] in the sense of Diderot is demonstrated in an entirely different way by the choreography of Marcello Maloberti. He derives his mise-en-scène from specific found contexts and atmospheres: these are mostly random places whose accustomed order or social dynamic he traces out only to break or temporarily suspend it with subtle maneuvers or spontaneous-looking actions. Confronted, for example, with (in)visible walls, he marks them with two living sculptures, or places a child in a corner to cut out pictures from magazines, or puts up a fridge in the exhibition space which might also work as a jukebox. Maloberti operates as a catalyst for stories and actions that create whimsical ties between people and things, particularly so in the case of a line-up of fifteen performers holding up porcelain tigers for as long as they can.

Thanks

I wish to extend my thanks to all those who contributed to the realization of this project, above all to Sabine Folie for her trust and her approval to have this exhibition realized at the Generali Foundation. I would also like to thank all artists – Harun Farocki, Omer Fast, Michael Fliri, Andrea Geyer,

Marcello Maloberti, Aernout Mik, Frédéric Moser & Philippe Schwinger, Wendelien van Oldenborgh, Judy Radul, Allan Sekula, and Ian Wallace – for their readiness to participate in this exhibition. My thanks also go to the lenders, gallerists, and all assistants – Daina Augaitis, Bruce Grenville, Emmy Lee, Kim Svendsen, Euridice Arratia, Stephanie Schneider, Philipp Selzer, Jorma Saarikko, Catriona Jeffries, Sandra Blimke, Brady Marks, Wilfried Lentz, Jocelyn Wolff, Alexander Koch, Nikolaus Oberhuber and Serena Porrati – for their cooperation and support in all matters related to the artists and their works. I would also like to use this occasion to extend thanks to our sponsors, the Mondriaan Foundation, Pro Helvetia, the Italian Embassy, and the Canada Council for the Arts.

Moreover, I extend sincere thanks to Susanne Knaller and Christian Schulte for their textual contributions to this catalogue, to Christian Schulte also and in particular for the inspiring discussions we had. And I would like to thank Sabine Folie, Georgia Holz, Katharina Menches, and Rolf Wienkötter for their elucidative texts about the artists and the works exhibited.

My special thanks go to Katharina Menches for her commitment in coordinating this catalogue production. I also thank the translators Nicholas Grindell and Gerrit Jackson, the copy-editors Anna Drechsel-Burkhard, Wolfgang Astelbauer, and Michael Strand, as well as Martha Stutteregger for the graphic design and Markus Wörgötter for the image processing.

Without the great and untiring support of the team of the Generali Foundation this exhibition could not have been realized: first and foremost, I would like to thank Katharina Menches and Thomas Ehringer. Katharina Menches accompanied this project from the very beginning. Her input in all matters of content and organization were as essential for the success of this project as was the fine feeling and understanding of the exhibition concept that Thomas Ehringer brought to bear in the exhibition design and layout. I also want to thank Dietmar Ebenhofer for the audiovisual setup which plays a particularly important part in this exhibition, Barbara Mahlknecht for her excellent presswork, her patience and committed collaboration, and Georgia Holz who helped us out in the last minute and took over the coordination of the performances.

From the German by Wolfgang Astelbauer and Michael Strand

Roland Barthes
Diderot, Brecht, Eisenstein

for André Téchiné

Let us imagine that an affinity of status and history has linked mathematics and acoustics since the ancient Greeks. Let us also imagine that for two or three millennia this effectively Pythagorean space has been somewhat repressed (Pythagoras is indeed the eponymous hero of Secrecy). Finally, let us imagine that from the time of these same Greeks another relationship has been established over against the first and has got the better of it, continually taking the lead in the history of the arts—the relationship between geometry and theatre. The theatre is precisely that practice which calculates the place of things *as they are observed:* if I set the spectacle here, the spectator will see this; if I put it elsewhere, he will not, and I can avail myself of this masking effect and play on the illusion it provides. The stage is the line which stands across the path of the optic pencil, tracing at once the point at which it is brought to a stop and, as it were, the threshold of its ramification. Thus is founded—against music (against the text)—*representation.*

Representation is not defined directly by imitation: even if one gets rid of notions of the "real", of the "vraisemblable", of the "copy", there will still be representation for so long as a subject (author, reader, spectator or voyeur) casts his *gaze* towards a horizon on which he cuts out the base of a triangle, his eye (or his mind) forming the apex. The "Organon of Representation" (which it is today becoming possible to write because there

are intimations of *something else*) will have as its dual foundation the sovereignty of the act of cutting out [*découpage*] and the unity of the subject of that action. The substance of the various arts will therefore be of little importance; certainly, theatre and cinema are direct expressions of geometry (unless, as rarely, they carry out some research on the voice, on stereophony), but classic (readable) literary discourse, which has for such a long time now abandoned prosody, music, is also a representational, geometrical discourse in that it cuts out segments in order to depict them: to discourse (the classics would have said) is simply "to depict the tableau one has in one's mind". The scene, the picture, the shot, the cut-out rectangle, here we have the very *condition* that allows us to conceive theatre, painting, cinema, literature, all those arts, that is, other than music and which could be called *dioptric arts*. (Counter-proof: nothing permits us to locate the slightest tableau in the musical text, except by reducing it to a subservience to drama; nothing permits us to cut out in it the slightest fetish, except by debasing it through the use of trite melodies.)

As is well known, the whole of Diderot's aesthetics rests on the identification of theatrical scene and pictorial tableau: the perfect play is a succession of tableaux, that is, a gallery, an exhibition; the stage offers the spectator "as many real tableaux as there are in the action moments favourable to the painter". The tableau (pictorial, theatrical, literary) is a pure cut-out segment with clearly defined edges, irreversible and incorruptible; everything that surrounds it is banished into nothingness, remains unnamed, while everything that it admits within its field is promoted into essence, into light, into view. Such demiurgic discrimination implies high quality of thought: the tableau is intellectual, it has something to say (something moral, social) but it also says that it knows how this must be done; it is simultaneously significant and propaedeutical, impressive and reflexive, moving and conscious of the channels of emotion. The epic scene in Brecht, the shot in Eisenstein are so many tableaux; they are scenes which are *laid out* (in the sense in which one says *the table is laid*), which answer perfectly to that dramatic unity theorized by Diderot: firmly cut out (remember the tolerance shown by Brecht with regard to the Italian curtain-stage, his contempt for indefinite theatres

—open air, theatre in the round), erecting a meaning but manifesting the production of that meaning, they accomplish the coincidence of the visual and the ideal *découpages*. Nothing separates the shot in Eisenstein from the picture by Greuze (except, of course, their respective projects: in the latter moral, in the former social); nothing separates the scene in epic theatre from the Eisenstein shot (except that in Brecht the tableau is offered to the spectator for criticism, not for adherence).

Is the tableau then (since it arises from a process of cutting out) a fetish-object? Yes, at the level of the ideal meaning (Good, Progress, the Cause, the triumph of the just History); no, at that of its composition.

Or rather, more exactly, it is the very *composition* that allows the displacement of the point at which the fetish comes to a halt and thus the setting further back of the loving effect of the *découpage*. Once again, Diderot is for us the theorist of this dialectic of desire; in the article on "Composition", he writes: "A well-composed picture [*tableau*] is a whole contained under a single point of view, in which the parts work together to one end and form by their mutual correspondence a unity as real as that of the members of the body of an animal; so that a piece of painting made up of a large number of figures thrown at random onto the canvas, with neither proportion, intelligence nor unity, no more deserves to be called a *true composition* than scattered studies of legs, nose and eyes on the same cartoon deserve to be called a *portrait* or even a *human figure*." Thus is the body expressly introduced into the idea of the tableau, but it is the whole body that is so introduced—the organs, grouped together and as though held in cohesion by the magnetic power of the segmentation, function in the name of a transcendence, that of the *figure,* which receives the full fetishistic load and becomes the sublime substitute of meaning: it is this meaning that is fetishized. (Doubtless there would be no difficulty in finding in post-Brechtian theatre and post-Eisensteinian cinema *mises-en-scène* marked by the dispersion of the tableau, the pulling to pieces of the "composition", the setting in movement of the "partial organs" of the human figure, in short the holding in check of the metaphysical meaning of the work—but then also of its political meaning; or, at least, the carrying over of this meaning towards *another* politics).

Brecht indicated clearly that in epic theatre (which proceeds by successive tableaux) all the burden of meaning and pleasure bears on each scene, not on the whole. At the level of the play itself, there is no development, no maturation; there is indeed an ideal meaning (given straight in every tableau), but there is no final meaning, nothing but a series of segmentations each of which possesses a sufficient demonstrative power. The same is true in Eisenstein: the film is a contiguity of episodes, each one absolutely meaningful, aesthetically perfect, and the result is a cinema by vocation anthological, itself holding out to the fetishist, with dotted lines, the piece for him to cut out and take away to enjoy (isn't it said that in some *cinémathèque* or other a piece of film is missing from the copy of *Battleship Potemkin*—the scene with the baby's pram, of course— it having been cut off and stolen lovingly like a lock of hair, a glove or an item of women's underwear?). The primary force of Eisenstein is due to the fact that *no image is boring*, you are not obliged to wait for the next in order to understand and be delighted; it is a question not of a dialectic (that time of the patience required for certain pleasures) but of a continuous jubilation made up of a summation of perfect instants.

Naturally, Diderot had conceived of this perfect instant (and had given it thought). In order to tell a story, the painter has only an instant at his disposal, the instant he is going to immobilize on the canvas, and he must thus choose it well, assuring it in advance of the greatest possible yield of meaning and pleasure. Necessarily total, this instant will be artificial (unreal; this is not a realist art), a hieroglyph in which can be read at a single glance (at one grasp, if we think in terms of theatre and cinema) the present, the past and the future; that is, the historical meaning of the represented action. This crucial instant, totally concrete and totally abstract, is what Lessing subsequently calls (in the *Laocoon*) the *pregnant moment*. Brecht's theatre, Eisenstein's cinema are series of pregnant moments: when Mother Courage bites on the coin offered by the recruiting sergeant and, as a result of this brief interval of distrust, loses her son, she demonstrates at once her past as tradeswoman and the future that awaits her—all her children dead in consequence of her money-making blindness. When (in *The General Line*) the peasant woman lets her skirt be ripped up for material to help in repairing the tractor, the gesture bears the weight of a history: its pregnancy brings together the past victory (the tractor bitterly won from bureaucratic incompetence), the present struggle and the effectiveness of solidarity. The pregnant moment is just this presence of all the absences (memories, lessons, promises) to whose rhythm History becomes both intelligible and desirable.

In Brecht, it is the *social gest* which takes up the idea of the pregnant moment. What then is a social gest (how much irony has reactionary criticism poured on this Brechtian concept, one of the clearest and most intelligent that dramatic theory has ever produced!)? It is a gesture or set of gestures (but never a gesticulation) in which a whole social situation can be read. Not every gest is social: there is nothing social in the movements a man makes in order to brush off a fly; but if this same man, poorly dressed, is struggling against guard-dogs, the gest becomes social. The action by which the canteen-woman tests the genuineness of the money offered is a social gest; as again is the excessive flourish with which the bureaucrat of *The General Line* signs his official papers. This kind of social gest can be traced even in language itself. A language can be gestual, says Brecht, when it indicates certain attitudes that the speaker adopts towards others: "If thine eye offend thee, pluck it out" is more gestual than "Pluck out the eye that offends thee" because the order of the sentence and the asyndeton that carries it along refer to a prophetic and vengeful situation. Thus rhetorical forms may be gestual, which is why it is pointless to criticize Eisenstein's art (as also that of Brecht) for being "formalizing" or "aesthetic": form, aesthetic, rhetoric can be socially responsible if they are handled with deliberation. Representation (since that is what we are concerned with) has inescapably to reckon with the social gest; as so on as one "represents" (cuts out, marks off the tableau and so discontinues the overall

totality), it must be decided whether the gesture is social or not (when it refers not to a particular society but to Man).

What does the actor do in the tableau (the scene, the shot)? Since the tableau is the presentation of an ideal meaning, the actor must present the very knowledge of the meaning, for the latter would not be ideal if it did not bring with it its own machination. This knowledge which the actor must demonstrate—by an unwonted supplement—is, however, neither his human knowledge (his tears must not refer simply to the state of feeling of the Downcast) nor his knowledge as actor (he must not show that he knows how to act well). The actor must prove that he is not enslaved to the spectator (bogged down in "reality", in "humanity"), that he guides meaning towards its ideality—a sovereignty of the actor, master of meaning, which is evident in Brecht, since he theorized it under the term "distanciation". It is no less evident in Eisenstein (at least in the author of *The General Line* which is my example here), and this not as a result of a ceremonial, ritual art—the kind of art called for by Brecht—but through the insistence of the social gest which never ceases to stamp the actors' gestures (fists clenching, hands gripping tools, peasants reporting at the bureaucrat's reception-desk). Nevertheless, it is true that in Eisenstein, as in Greuze (for Diderot an exemplary painter), the actor does sometimes adopt expressions of the most pathetic quality, a pathos which can appear to be very little "distanced"; but distanciation is a properly Brechtian method, vital to Brecht because he represents a tableau for the spectator to criticize; in the other two, the actor does not necessarily have to distance: what he has to present is an ideal meaning and it is sufficient therefore that he "bring out" the production of this value, that he render it tangible, intellectually visible, by the very excess of the versions he gives it; his expression then signifies an idea—which is why it is excessive—not some natural quality. All this is a far cry from the facial affectations of the Actors' Studio, the much praised "restraint" of which has no other meaning than its contribution to the personal glory of the actor (witness in this respect Brando's grimacings in *The Last Tango in Paris*).

Does the tableau have a subject (a topic)? Nowise; it has a meaning, not a subject. The meaning begins with the social *gest* (with the pregnant moment); outside of the gest, there is only vagueness, insignificance. "In a way," writes Brecht, "subjects always have a certain naivety, they are somewhat lacking in qualities. Empty, they are in some sort sufficient to themselves. Only the social gest (criticism, strategy, irony, propaganda, etc.) introduces the human element." To which Diderot adds (if one may put it like that): the creation of the painter or the dramatist lies not in the choice of a subject but in the choice of the pregnant moment, in the choice of the tableau. It matters little, after all, that Eisenstein took his "subjects" from the past history of Russia and the Revolution and not—"as he should

have done" (so say his censors today)—from the present of the construction
of socialism (except in the case of *The General Line*); battleship or czar are
of minor importance, are merely vague and empty "subjects", what alone
counts is the gest, the critical demonstration of the gesture, its inscription—
to whatever period it may belong—in a text the social machination of which
is clearly visible: the subject neither adds nor subtracts anything. How
many films are there now "about" drugs, in which drugs is the "subject"?
But this is a subject that is hollow; without any social gest, drugs are insig-
nificant, or rather, their significance is simply that of an essential nature—
vague, empty, eternal: "drugs lead to impotence" (*Trash*), "drugs lead to
suicide" (*Absences répétées*). The subject is a false articulation: why this
subject in preference to another? The work only begins with the tableau,
when the meaning is set into the gesture and the coordination of gestures.
Take *Mother Courage*: you may be certain of a misunderstanding if you
think that its "subject" is the Thirty Years War, or even the denunciation
of war in general; its *gest* is not there, but in the blindness of the trades-
woman who believes herself to live off war only, in fact, to die of it; even
more, the gest lies in the *view* that I, spectator, have of this blindness.

In the theatre, in the cinema, in traditional literature, things are always
seen *from somewhere*. Here we have the geometrical foundation of repre-
sentation: a fetishist subject is required to cut out the tableau. This point of
meaning is always the Law: law of society, law of struggle, law of meaning.
Thus all militant art cannot but be representational, legal. In order for
representation to be really bereft of origin and exceed its geometrical nature
without ceasing to be representation, the price that must be paid is enor-
mous— no less than death. In Dreyer's *Vampyr*, as a friend points out, the
camera moves from house to cemetery recording *what the dead man sees*:
such is the extreme limit at which representation is outplayed; the specta-
tor can no longer take up any position, for he cannot identify his eye with
the closed eyes of the dead man; the tableau has no point of departure, no
support, it gapes open. Everything that goes on before this limit is reached
(and this is the case of the work of Brecht and Eisenstein) can only be legal:
in the Iong run, it is the Law of the Party which cuts out the epic scene,
the filmic shot; it is this Law which looks, frames, focusses, enunciates.
Once again Eisenstein and Brecht rejoin Diderot (promoter of bourgeois
domestic tragedy, as his two successors were the promoters of a socialist
art). Diderot distinguished in painting major practices, those whose force
is cathartic, aiming at the ideality of meaning, from minor practices, those
which are purely imitative, anecdotal—the difference between Greuze
and Chardin. In other words, in a period of ascendency every physics of
art (Chardin) must be crowned with a metaphysics (Greuze). In Brecht, in
Eisenstein, Chardin and Greuze coexist (more complex, Brecht leaves it
to his public to be the Greuze of the Chardin he sets before their eyes).
How could art, in a society that has not yet found peace, cease to be meta-

physical? that is, significant, readable, representational? fetishist? When are we to have music, the Text?

It seems that Brecht knew hardly anything of Diderot (barely, perhaps, the *Paradoxe sur le comédien*). He it is, however, who authorizes, in a quite contingent way, the tripartite conjuncture that has just been proposed. Round about 1937, Brecht had the idea of founding a *Diderot Society*, a place for pooling theatrical experiments and studies—doubtless because he saw in Diderot, in addition to the figure of a great materialist philosopher, a man of the theatre whose theory aimed at dispensing equally pleasure and instruction. Brecht drew up the programme for this Society and produced a tract which he contemplated sending out. To whom? To Piscator, to Jean Renoir, to Eisenstein.

French original in *Cinéma, Théorie, Lectures* (special number of the *Revue d'esthétique*),1973.

English translation by Stephen Heath in *Screen*, vol. 15, no. 2 (1974), pp. 33–39.

Christian Schulte
Reaching Behind the Image

Some remarks on the restoration of distance

Opening credits

The apparatus described by the metaphor of the Fourth Wall, which regulated the separation between events on stage and the auditorium, between performance and perception, was eventually to lose its importance as the legitimacy of bourgeois society began to be openly contested. In the eighteenth century, the supposedly closed space of the action on stage corresponded to the private sphere of family life in which a new self-confidence could take shape. A dialectic unfolded between the morally and rationally founded integrity of the rising bourgeoisie and the privileged status of an aristocracy denounced as scandalously illegitimate by the Enlightenment paradigm of reason. One public forum for the articulation of this dialectic was the stage. Diderot's concept of the Fourth Wall gave theatergoers the option of imaginarily testing out a possible alternative persona without having to step out of the safe haven of the auditorium. As well as such involvement in the situation behind the invisible wall, the set-up also allowed the audience to have its reasoning publicly displayed by proxy figures on stage. In the theater of the Enlightenment, the moral sovereignty of the audience was publicly put to the test.[1]

Figures of transition
In the modern era, the Fourth Wall became a figure for reflection of an entirely different kind. As a result of the fundamental transformation of lived experience that took place in the age of industrial mass production, the private sphere increasingly lost its currency as a site for the genesis of individuality. Walter Benjamin has shown how this process—which led, ultimately, to the "other-directed person"—initially took shape in the first half of the nineteenth century. He cites three stages: In *My Cousin's Corner Window* (1822), E.T.A. Hoffmann describes a stable observer position offering the bourgeois subject a safe piano-nobile view of the crowded street below; not quite two decades later, in Edgar Allan Poe's *The Man of the Crowd* (1840), a diminished form of subjectivity appears, together with a now fragile gaze dependent on adapting mimetically to the pace of the street. This is embodied by a proto-flaneur who is pursued through the crowd by Poe's narrator, a kind of detective. For Baudelaire, subjectivity dissolves in the experience of the ephemeral: In his poem *À une passante* (1857), he describes how desire suddenly arises out of the wave-like rhythm of the city crowd, only to lapse again the very next moment when the apparition vanishes from sight.[2] Nothing lasts, duration erodes in proportion to the change affecting conditions of perception. Art becomes a medium of mourning for the fulfilled moment, for lost time.

Velocity and stifled perspectives
The boundary between private and public spheres was becoming a transitory threshold. The impossibility of intact subjectivity under increasingly

1 Cf. Rolf Grimminger, "Aufklärung, Absolutismus und bürgerliche Individuen. Über den notwendigen Zusammenhang von Literatur, Gesellschaft und Staat in der Geschichte des 18. Jahrhunderts," in *Hansers Sozialgeschichte der deutschen Literatur*, vol. 3: *Deutsche Aufklärung bis zur Französischen Revolution 1680–1789*, ed. Rolf Grimminger (Munich/Vienna: Hanser, 1980), pp. 15–99; Iwan-Michelangelo D'Aprile and Winfried Siebers, *Das 18. Jahrhundert. Zeitalter der Aufklärung* (Berlin: Akademie Verlag, 2008); Doris Kolesch, *Theater der Emotionen. Ästhetik und Politik zur Zeit Ludwigs XIV* (Frankfurt/New York: Campus, 2006), pp. 237–255.
2 Walter Benjamin, "On Some Motifs in Baudelaire," in *Selected Writings, 1938–1940*, vol. 4 (Cambridge, Mass.: Harvard University Press, 2003), pp. 313–355.
3 Perhaps expressed most forcefully by Walter Benjamin in *One-Way Street* (1928) where he writes: "Criticism is a matter of correct distancing. It was at home in a world where perspectives and prospects counted and where it was still possible to adopt a standpoint. Now things press too closely on human society. The 'unclouded,' 'innocent' eye has become a lie, perhaps the entire naïve mode of expression sheer incompetence." *Selected Writings*, vol. 1 (Cambridge, Mass.: Harvard University Press, 1996), p. 476.
4 Sigmund Freud, "Introductory Lectures on Psychoanalysis," (1917) in *The Standard Edition of the Complete Psychological Works of Sigmund Freud*, vol. 16 (London: Hogarth Press, 1963), pp. 284–285.
5 Walter Benjamin, *The Arcades Project* (Cambridge, Mass.: Harvard University Press, 1999), p. 121.
6 Walter Benjamin, "The work of art in the age of its technological reproducibility," in: *Selected Writings 1935–1938*, vol. 3 (Cambridge, Mass.: Harvard University Press, 2002), p. 117.

abstract living conditions was becoming a certainty. In a rationalized working world—Taylorism, Fordism—the moderns were squeezed into automated processes, as the busy pace of city streets and the speed of assembly lines vied to outdo each other. Relief from the pressure of clocked working hours was provided by leisure activities in amusement parks and variety shows—which in fact reiterated the pressure to conform, playfully this time, by linking libido with fungibility. Every form of self-identity became ideology. The intellectuals detected a "revolt of the objects,"[3] illustrated by the grotesquerie of slapstick and presented as a fait accompli in Chaplin's *Modern Times*, where the superiority of machines is plain to see. For Freud, the ego was "not even master in its own house."[4] In a world of immanence, there seemed no longer to be any outside. "The stifled perspective," writes Benjamin, "is plush for the eyes."[5]

Plush is the feel-good factor, an addictive substance surreptitiously added to the products of the culture industry. This is where the Fourth Wall comes back into play, having secured its continued existence in the most reactionary way possible, as the cinema's silver screen—as long as the diegeses are hermetically sealed off. Looking directly into the camera is permitted only in the subjective mode of shot reverse shot—a convention dictated by the narrow-minded poetic rules of classical cinematography. What Benjamin identified in the 1930s as the essence of film, and more precisely of film montage, is only true of those forms of cinematic art that deliberately abstain from the creation of illusion:

> Our bars and city streets, our offices and furnished rooms, our railroad stations and our factories seemed to close relentlessly around us. Then came film and exploded this prison-world with the dynamite of the split second, so that now we can set off calmly on journeys of adventure among its far-flung debris.[6]

In terms of media ontology, the theory of montage as an explosive force is not tenable. While Sergei Eisenstein and especially Dziga Vertov can certainly vouch for it, it already becomes questionable in the case of D. W. Griffith. Eisenstein's dialectical montage, for all its conceptualizing tendency, at least addresses actual social contradictions, real contrasts. With his Cine-Eye concept, Vertov deploys the superiority of the technical apparatus over the human eye, so that the latter—as in the projection of *The Man With A Movie Camera* (1929)—is confronted with a multiple perspective previously seen only in Cubist painting. By contrast, Griffith's parallel montages can already be seen as early forms of the kind of suspense-building editing schemes subsequently developed by the Hollywood studio system into the epitome of the cinematic.

In the modern age, which makes the individual disappear, a medium of subject constitution—Diderot's Fourth Wall—gradually became a tool of

deception whose immersive power reached its full strength in mainstream cinema, the dominant medium of the twentieth century. This now long perfected and industrialized expropriation of experience, of personal meaning, has been under attack from advanced art ever since the days of Meyerhold and Brecht.

Antidotes

That the world is full of a "sense of possibility"[7] is demonstrated in a drastic way in Brecht's play *A Man's A Man* (1926): A man goes out to buy a fish, but he never comes home, ending up instead in the Foreign Legion. Brecht destroys the myth of a sovereign personality by showing how a human individual can be restructured if certain conditions occur. The fact that soldiers do not enter battle in a mood of collective enthusiasm, but must in fact be conscripted, had already been underlined by Karl Kraus.[8]

When a play's content insists that anything can happen at any time, then this assertion of contingency also has consequences for its staging, which can only be authentic if it involves the spectator in its play on unpredictability and denies him the illusion that the auditorium might offer any kind of security. "Discover the prevailing conditions"—this is the program of an art that reviles the Fourth Wall. It aims to create added value in terms of experience and knowledge, which always also means confrontation with one's own passivity. But it also means becoming aware of the conditions that constitute the framework for one's own perception and reflection.[9]

It is a matter of reestablishing distances that have been closed, and regaining and reopening views that have been obstructed, thus creating scope for play and action. And the arsenal of such aesthetic interventionism is made up of destructive, intrusive moves. Accordingly, Benjamin's allegorical figure of the destructive character "knows only one watchword: make room. And only one activity: clearing away."[10] Regarding the organi-

7 See Robert Musil, *The Man Without Qualities*, vol. 1 (London: Secker & Warburg, 1961), p. 11–13.

8 Karl Kraus, *Weltgericht I*, ed. Christian Wagenknecht (Frankfurt am Main: Suhrkamp, 1988), p. 238.

9 In his film *Gelegenheitsarbeit einer Sklavin* (1973) Alexander Kluge quotes the following dictum from Friedrich Engels, drawing the viewer's attention to the film's self-reflexive dimension: "Everything which sets men in motion must go through their minds; but what form it will take in the mind will depend very much upon the circumstances." Alexander Kluge, *Gelegenheitsarbeit einer Sklavin. Zur realistischen Methode* (Frankfurt am Main: Suhrkamp, 1975), p. 143.

10 Benjamin, "The Destructive Character," in *Selected Writings 1931–1934*, vol. 2 (Cambridge, Mass.: Harvard University Press, 2005), p. 541.

11 Bertolt Brecht, "The Modern Theatre is the Epic Theatre (Notes to the opera *Aufstieg und Fall der Stadt Mahagonny*)," in *Brecht on Theatre*, (New York: Hill and Wang, 1964), p. 37.

12 Walter Benjamin, *The Origin of German Tragic Drama* (London: Verso, 2003), p. 32.

13 Walter Benjamin, "What is epic theater?" in Selected Writings, 1938–1940. vol. 4 (Cambridge, Mass.: Harvard University Press, 2003), pp. 307, 304, 305.

cistic total artwork, critics demand "separation of the elements;"[11] concerning continuity of performance, they advocate "the art of interruption,"[12] and to break through the Fourth Wall, they call for "the filling in of the orchestra pit," "interruption of the action," and "making gestures quotable".[13]

If the issue is the emancipation and activation of the spectator, it is only logical for art to move outside the defined apparatuses of the theater and the cinema, migrating to spaces that permit more plural performances and more radical forms of participation. I would like to discuss two examples in more detail here:

Emptying out images
"I can't find the photograph," says Karl Roßmann. "Which photograph," asks Delamarche. "The one of my parents," Roßmann replies. Few pictures have stronger affective ties than a photograph of one's parents. It represents a regime of meaning. Its absence motivates Roßmann's search. In Danièle Huillet and Jean-Marie Straub's film *Klassenverhältnisse* (Class Relations, 1984) it also refers reflexively to the possibility of freeing the gaze from heteronomous bondage.

The part of Delamarche is played by Harun Farocki. It is not a scene from the actual film, but one of the rehearsals to which Farocki's own film is devoted. He just observes the way Straub and Huillet work, using the simplest means to precisely record the degree of attention and obsession with detail with which the two directors go about their task. The title of his film is correspondingly sober: *Jean-Marie Straub and Danièle Huillet at Work on Franz Kafka's "Amerika"* (1983).

Before moving onto the set, the dialogs are rehearsed at an apartment. People sit on the floor, drink beer, smoke, both relaxed and attentive, a Brechtian situation. Again and again, the accentuation of a single syllable is rehearsed, reviewed, and rejected. A repetitive approach to the material which nearly makes us forget that this process leads to a result: the finished film.

Straub/Huillet bring out the material value of language. The result is an artificial mode of speech which nonetheless never feels stilted or ornamental. Language is alienated from its communicative function, its conventional usage. The procedure is reductive, aiming—like Brecht's metaphor of buying brass—at the creation of raw materials, something that could be used to make many things, not just the one familiar thing. Few filmmakers have articulated such a radical rejection of the immersive potential of film as Straub and Huillet, or denatured its means so uncompromisingly. Instead, they construct spaces of possibility which demand more from viewers than mere perception, requiring them to make a contribution of their own. Meaning of their own. Such active interpretation is the objective of their reduced approach which aims to empty out not only language but, above all, images:

An image must stand up, an image is not something random. And an image, when it stands up, does not describe anything, it exists, in and of itself, it already has the character of a nightmare. All the more so if one does the opposite of what society does. That is: no inflation. One attempts the opposite of inflation: condensing everything, suggesting it, by showing the absolute minimum.[14]

Farocki's documentation, too, takes a minimalist approach, simply recording what takes place in front of the camera. His interest focuses on his subject, the question of how Straub/Huillet find their specific filmic form, how they stage language, how they build the individual tableaus out of which the sequential units of their films are composed—an approach to building up that is actually a breaking down, a thinning out of meaning, an emptying.[15] Farocki renders visible the living authorship behind the carefully composed images of the finished film, he reaches "behind the image"[16] by focusing on the communicative processes which accompanied their creation. While Straub and Huillet deal in their film with the laconic idiom of Kafka, the actual subjects of Farocki's film are the attitude and the means with which they approach this text material. If we return to the metaphor of the search for a picture, then Farocki's work involves the search for an image behind the images, although the latter did not yet exist at the time his footage was shot. And precisely because of this fact, the image he is searching for may contain a utopian not-yet, the model of a free space, a space free of meaning.

Hearing what's beyond the image
Unlike Karl Roßmann, American performance artist and photographer Allan Sekula does not have to search for the photograph of his parents.

14 "Wie will ich lustig lachen, wenn alles durcheinandergeht. Danièle Huillet und Jean-Marie Straub sprechen über ihren Film *Klassenverhältnisse*," in *Filmkritik*, issue 9–10 (1984), p. 273.
15 What Hans-Thies Lehmann has written about post-dramatic theater also largely applies to the films of Straub/Huillet with their affinity for the theater: "The theater of making sense and synthesis disappeared, and with it the possibility of any synthesizing appropriation. All that is possible are stuttering answers that remain 'works in progress,' partial viewpoints, no advice, certainly no instructions." Hans-Thies Lehmann, *Postdramatisches Theater* (Frankfurt am Main: Verlag der Autoren, 1999), p. 26.
16 The gesture of reaching behind the images is attributed by Georg Lukàcs to the practice of the critic and essayist. Lukàcs, *Die Seele und die Formen. Essays* (Neuwied/Berlin: Luchterhand, 1971), pp. 13–14.
17 Cf. *Allan Sekula. Performance under Working Conditions*, ed. Sabine Breitwieser (Vienna: Generali Foundation; Ostfildern: Hatje Cantz, 2003), pp. 92–163.
18 The definition of cinema given by Godard in his *Histoire(s) du Cinéma* (1996).
19 Bertolt Brecht, "The Three-Penny Trial, A Sociological Experiment," (1931) in *German Essays on Film* ed. Richard W. McCormick and Alison Guenther-Pal (New York/London: Continuum, 2004) p. 117
20 Alexander Kluge, *In Gefahr und größter Not bringt der Mittelweg den Tod. Texte zu Kino, Film, Politik*, ed. Christian Schulte (Berlin: Vorwerk 8, 1999), p. 134.

He took it himself and it stands at the center of his installation *Aerospace Folktales* (1973).[17] These tales are told on very different media levels: in photographs, as a soundtrack containing interviews with his father and mother, and in the form of a written commentary by the artist. The work revolves around his engineer father's dismissal from his job at Lockheed and the consequences of this dismissal for the family.

Sekula's sequence of photographs describes stages in a withdrawal. It begins with his father's workplace, the Lockheed aircraft works, which praises itself in an illustrated book from 1969, from which Sekula quotes, for its "services for human progress and national defense." Soon after, we see the father in the company's empty parking lot, then with his wife and daughter in front of the garage, then a full frame double portrait with his wife, and finally the sterile, deserted view of the outside of the house, the mowed lawn and the tidily clipped hedge. In a few images, Sekula describes a process of privation simply by narrowing the perspective.

This dramaturgy of constriction continues inside the house. The armchairs with their plastic covers, the model airplanes hanging from the ceiling, the carefully arranged family photographs with the father as the central figure—all these excerpts from everyday life appear as barometer of the bureaucratized world, like perfect realizations of the "tenant policies" shown in one photograph.

The isolated snapshots in the photographs are given spoken captions by the soundtrack: the son with the mother, the son with the father—two acousmatic voices that appear to have no location, arriving in the exhibition space from an undefined elsewhere. Unlike in the cinema, where the connection between sound and image is as fixed as the audience are to their seats, here the link between the photographs and the dialogs is determined by moving around the space—searching movements, perhaps, scanning the visual level for associative footholds, guided by what is heard. Searching for the integral image. For an image which not only imaginatively contracts its own before and after, but also acts as a magnet for particles of expression and meaning from other media sources. The integral image would be highly reflexive, a non-image. Or, as Jean-Luc Godard puts it: "A form that thinks."[18] To criticize the Fourth Wall of photography means enquiring after what is beyond the image, translating positive into negative, until, eventually, the Vietnam War appears in the margins of the family album. The pregnant moment as a dialectical image. "The situation thereby becomes so complicated," writes Brecht in *The Three-Penny Trial*, "that a simple 'representation of reality' says something about reality less than ever before. A photograph of the Krupp Works or of the A.E.G. yields nearly nothing about these institutions. Actual reality has slipped into the functional. The reification of human relations, such as the factory, no longer produces the latter. So there is in fact 'something to build up,' something 'artificial,' 'contrived'."[19]

More than four decades later, Alexander Kluge added to this, calling for "a whole aggregate of artificial objects."[20] The installation's multi-channel set-up is such an aggregate.

Sekula's written commentary, whose manner recalls the Brecht quotation, performs an ideological critique of the pictures and establishes connections that could not be conveyed by the hanging of the photographs. "but to a larger extent i am writing because of the limited representational range of the camera—one cannot photograph ideology—but one can make a photograph step back and say—look in that photograph there is ideology—between those two photographs there is ideology—there is such and such and such relates to such."[21] With his montage-like narration, Sekula tries to give at least some idea of the human relationships of which the pictures of the factory and the house reveal equally little. The installation is an intermedia formation dissolved in spatial parameters, a walk-in emblematic structure.

The way society's ideology has implanted itself in the private sphere of the family is perhaps nowhere more tangible than in the photographs showing a homemade bookcase, placed close to a crucifix, with its reputable contents. Grimm's Fairy Tales stand alongside the works of Joseph Conrad, Jonathan Swift, and Nathaniel Hawthorne. Taken together, they configure a canon of what is "worth knowing," a guarantee for the future of the children, whose father, as a wall text between the photographs tells us, used to give them a dollar for every book they read. In his commentary, Sekula reflects on the view of culture based on a fetishization of education that was shared by a social class which in spite of academic training was in danger of descending into economic precarity, making them all the more keen to amass symbolic capital: "the damn books never got opened much—but there they were—totems of high culture—constant gilt embossed reminders of our future as college educated citizens—my father built a middle class submarine because he was sailing in a blue-collar ocean—and he didn't want the sharks to eat his kids."[22]

Social distinctions recede into the background as soon as the events of the time force their way into the picture: "At some point in his career the engineer studied *the effects of nuclear weapons.*" And The Effects of Nuclear Weapons is the title of the book shown in the next photograph, right alongside Grimm's Fairy Tales, in horizontal format. We see several images of wounded bodies, a burning car, and a house destroyed by the blast. Pictures that deconstruct the ordered and supposedly secure petit-bourgeois cosmos, revealing it as an illusionary construct. Sekula unfolds his counter-narrative

21 Sekula, *Allan Sekula. Performance under Working Conditions*, p. 161.
22 Ibid., p. 160.
23 Kluge, *In Gefahr und größter Not*, p. 134.

"in reality's degrees of complexity."[23] His montage sequence confronts extreme close-ups with the greatest possible distance, the probable with the improbable. He diagnoses an end to certainties, both with regard to paternal authority and on the larger political scale.

Sekula's series of pictures can also be read as a variation on the following question: What is the relationship between the life of an individual and history in general? How do current events inscribe themselves into the life of a family? And in so doing, how do they shape individual biographies? Sekula's work is authentic in its enquiry into the impact of history and its disasters on the supposedly sheltered private spheres of the home and the family. His work is a document of this collision.

From the German by Nicholas Grindell

Susanne Knaller
The Paradox of Observation

The interrelation between Diderot's metaphor
of the Fourth Wall and contemporary autofictional forms

—————

I.

In his detailed response to the questions of Mademoiselle *** concerning
his *Letter on the Deaf and Dumb*, Denis Diderot describes the inadequacies
of the modern self-conscious subject as follows:

> Many times, with the intention of examining what was going on in my
> head, and of *surprising my mind in the act*, I cast myself into the deepest
> meditation, withdrawing into myself with all the application that I am
> capable of. But these efforts led to nothing. It seemed to me that one
> would need to be simultaneously both inside and outside oneself, while
> at the same time performing not only the role of observer but also that
> of the machine observed. But as with the eye, so too it is with the mind:
> it cannot see itself. [...] A monster with two heads attached to the same
> neck might perhaps teach us something novel. One must therefore wait
> until nature, which combines all and which, over the centuries, bears
> along the most extraordinary phenomena, shall give us a dicephalus
> who contemplates himself, and one of whose heads observes the other.[1]

This image of a two-headed person is preceded by the notion developed
in the modern episteme that self and world are based on a process
of self-observation from within and from without. In the naming and

representation of the world, one is both a representing element and that which is represented. "World" is the result of a differentiation between observer and observed, self and other, on the basis of a concept of reality. Participation (being in the world) and the concept of reality can thus only be grasped from higher-order levels of observation.

Diderot refers here to observation as a form of perception that grew in significance during the eighteenth century, and with it to a model of visuality exemplified by optical science and the figure of the "spectator" elaborated by the moral weeklies. In this focus on the observation paradigm, several factors come together. The first is the shift, set in motion by empiricism and aesthetics, from strictly rational models of knowledge towards models emphasizing questions of perception. This involved a discussion of Cartesian rationalism, which had had two major consequences for the western episteme: a) knowledge is based on a division between cognitive subjects and objects outside and independent of them, and b) due to the fact that truth is based on cognition, the real (in the sense of substance) is formed by *res extensa* (objects, matter) and by *res cogitans* (thought). As *res cogitans* provides the basis for truth, *res extensa* is only real (i.e., true) because of its being a representation, or the content, of *res cogitans*. Knowledge and truth are thus cognitive and conceptual. Only at this point does a modern concept of reality become possible: reality as an ontological, philosophical concept is the Other of the subject, which, to be true, must be grasped by the subject rationally and abstracted into cognitive meaning.

Eighteenth- and nineteenth-century theories of mimesis and realism address this constellation of participation, observation, and concept/form, as well as the debate over Descartes' modern concept of reality. Diderot's contribution to this discussion is marked by the fact that he deals in aesthetic and theoretical terms with the question of media (ignored by the rational model) and with the intersubjectivity by which concepts of reality are constituted. His definition of subjectivity includes a social element, and Diderot's interest in the dramatic and thematic possibilities of contemporary theater is thus not only a result of his literary ambitions, but can also be

1 Denis Diderot, "Additions à La lettre sur les sourds et muets," in *Oeuvres* 4:55. English translation quoted from Slavoj Žižek, ed., *Lacan: The Silent Partners* (London/New York: Verso, 2006), p. 30.

2 Denis Diderot, "On Dramatic Poetry" (1758), translated in B. H. Clark, *European Theories of the Drama* (New York: Crown Publishers, 1947), pp. 286–298.

3 See also the examples and discussion in Joachim Küpper, "Diderots Auseinandersetzung mit der klassischen Tragödie und die postklassische Ästhetik der Wirklichkeitsdarstellung," in *Ästhetik der Wirklichkeitsdarstellung und Evolution des Romans von der französischen Spätaufklärung bis zu Robbe-Grillet* (Stuttgart: Steiner, 1987), pp. 6–55.

4 An approach which is suggested, e.g. by Jürgen von Stackelberg, "Der Briefroman und seine Epoche. Briefroman und Empfindsamkeit," in *Romanische Zeitschrift für Literaturgeschichte*, no. 1 (1977), p. 298.

5 Küpper, *Ästhetik der Wirklichkeitsdarstellung*, p. 161.

attributed to his close correlating of philosophical, aesthetic, and social issues. This points to a second factor in the increased significance of the figure of the observer, namely the possibility, created by the premises of the Enlightenment, of an interest in the structures and functions of contemporary society. The individual always acts within a social and economic framework. Consequently, the moral weeklies declared the observation of society and its subjects as their primary concern. This had aesthetic consequences: a call for (auto)biographical narrativization and documentation of one's own life, portraying a morally self-assured, emotional, and intellectual human individual whose perceptions and actions are anthropologically and historically grounded. Diderot's response to these demands is the concept of the Fourth Wall, a reaction against the rigid court theater of the seventeenth and eighteenth centuries with its poetics of closed, single-perspective cohesion between the audience, the action on stage, and the structures of society. At the same time, his concept of theatrical space allows him to discuss the rational modes of self-observation from within and from without in a way that highlights observation itself as a theme rather than resolving the paradox of observation in mimetic coherence between subject and object. Diderot explains this ideal mode of communication between audience/observer and observed, commonly referred to as the Fourth Wall, as follows: "Whether you write or act, think no more of the audience than if it had never existed. Imagine a huge wall across the front of the stage, separating you from the audience, and behave exactly as if the curtain had never risen."[2]

This has often been understood by critics as postulating a theater of illusion.[3] But such a view overlooks important aesthetic and theoretical components, especially as Diderot enacted a meta-reflexive interplay of drama, dialog, commentary, and correspondence spread across various texts, and also engaged his figures on stage in a constellation of mutual observation, setting up the Fourth Wall inside the action on stage, so to speak. Thus, in the performative process of staged observation and in dialogs of commentary between genres, observation remains reflexively linked to conditions of media, space, and time. This is also why characterizing Diderot as precursor to the kind of realism developed in the nineteenth century is accurate only to a certain extent.[4] Firstly because his concept of reality prioritizes moral discourse over the kind of scientific and empirical aspects emphasized in the context of realism, and secondly because Diderot's concept of the Fourth Wall aims less at a realistic portrayal with illusionist effects than at a performative interrelation of observation and action. An important factor in nineteenth-century realism is the association of science and art, as occasioned by a concept of objectivity borrowed from the vocabulary of scientism: facilitated by an observing view of the world based on the rational concept of reality, there emerges an

"empiricist understanding of reality based on the registration of facts."[5]
By contrast, Diderot's concept of observation can be described as follows:

The relationship of gaze and gesture, of observation and bodily
expression, which according to the Fourth Wall exists between
audience and stage, recurs on the stage itself, where it becomes
observable as communication. [...] The people on Diderot's stage
appear as empirical human individuals in an empirical space
in the medium of their bodies as a means of expression; they appear
as 'observed observers' in dialog.[6]

II.

Between the poles of Diderot's self-reflective spaces of observation and
his enlightened mimesis of a "réel" in need of moral molding, the potential
unfolds for an analysis of those forms of contemporary art in which the
relationship of observation by self and other is dealt with in aesthetic terms,
as in documentary work and the closely related field of autofiction. This
latter, a concept introduced by Serge Doubrovsky, can be used to address
an inherent conflict within modern autobiography qua discourse on iden-
tity: the attempt at self-objectification via self-reflection and formation.
By referring to itself as a preexisting entity, the self is supposed to capture
itself as an intact whole. In this way, the autobiographical subject consti-
tutes itself via personal and historical events which, bundled in a narrative
context, add up to, and represent, a life. The result of the autobiographical
project is a formed, self-aware self unable to escape the risk of fictionaliza-
tion. In his novel *Le Livre brisé* (The Broken Book), Doubrovsky adapts
the Cartesian formula to define conventional autobiographical identity as
something that is only legitimated by media-ontological fixing: "Autobio-
graphy is not a literary genre, it is a metaphysical remedy. [...] a life as solid
as a rock, built on Cogito: *I write my life, therefore I have been*. Unshakeable.

6 Johannes Friedrich Lehmann, *Der Blick durch die Wand: zur Geschichte des Theater-
 zuschauers und des Visuellen bei Diderot und Lessing* (Freiburg: Rombach, 2000),
 p. 110. See also the major study by Doris Kolesch, *Theater der Emotionen: Ästhetik und
 Politik zur Zeit Ludwigs XIV* (Frankfurt/New York: Campus, 2006), pp. 237–255.

7 Serge Doubrovsky, *Le Livre brisé* (Paris: Grasset, 1989), p. 255, p. 257. "L'autobio-
 graphie n'est pas un genre littéraire, c'est un remède métaphysique. [...] enfin une vie
 solide comme du roc, bâtie sur du Cogito: *j'écris ma vie, donc j'ai été*. Inébranlable.
 [...] par écrit, notre vie prend sens. Nos actes sont légalisés, certifiés conformes.
 Seules, comme on sait, les écritures authentifient." (Engl. trans. NG)

8 Uwe Wirth, "Der Performanzbegriff im Spannungsfeld von Illokution, Iteration und Indexi-
 kalität," in Uwe Wirth, ed., *Performanz. Zwischen Sprachphilosophie und Kulturwissen-
 schaften* (Frankfurt am Main: Suhrkamp, 2002), pp. 10–11.

9 Jean-Jacques Rousseau, "Du contrat social", in *Œuvres complètes*, vol. 3, eds. Bernard
 Gagnebin and Marcel Raymond, (Paris: Gallimard, 1964), p. 381.

10 Denis Diderot, "Éloge de Richardson", in *Œuvres*, ed. André Billy (Paris: Gallimard 1951),
 pp. 1060–1061. Cf. Küpper, *Ästhetik der Wirklichkeitsdarstellung*, p. 13.

[...] Through writing our life acquires meaning. Our acts are legalized, certified as conforming. Only writings, as we know, authenticate."[7]

An autofictional approach does not, however, mean the binary pitting of representation against construction, preexistence against becoming-in-media. This is due to a performative structure that enables the semiotic process to appear alongside reflexive references to this process. Referentiality does not become obsolete here, nor does reality become amorphous material to be used at will. Rather, the simultaneity of description and the constitution of what is described replaces conditions of truth with conditions of accomplishment: "In contrast to the 'constative description' of states, which is either true or false, 'performative utterances' change conditions in the social world by the act of utterance—rather than describing facts, they create social facts."[8]

The potential of Diderot's metaphors lies not in any present-day topicality of his notions of art and reality (which cannot be attributed to an eighteenth-century author) but in his focus on the issue of observation, for which he devises performative forms intended to allow a simultaneity of participation and observation, self-reflexivity and reference, formation and action. In this way, the difference between fiction and reality remains intact and open to aesthetic treatment.

For the post-rational eighteenth century, this performativity leads to a play with factuality and fictionality, generality and individuality, which, ideally, leads to a moral and historical coherence of the real and the self. The best example of this is Rousseau, whose influence on eighteenth-century notions of the subject was near unmatched: his theoretical and literary projects represent a counter-model to institutionalized role play, while also postulating an individual subject ("existence physique et indépendante") that is expected to attain commonality ("existence partielle et morale").[9] Individually accented self-knowledge is indebted to a specific social structure, and in turn to that structure's particular concept of a generally defined nature. In this view, cognition is based on the communicative interrelation of self-reflection, observation, and transcendence. A good illustration of this relation is provided by the epistolary novel. In this genre, as in non-fictional correspondence, a self is modeled which, from a perspective of self-observation, can claim emotional and self-awareness. In contrast to classicist texts, the epistolary novel is governed by a dialogic or many-voiced constellation that is deployed against rigid social role assignment and emotional regulation. Diderot's emphatic praise for Richardson's *Pamela* is thus to be understood less as realist illusion theory *avant la lettre* than as a reference to the dramatic potential of dialogical epistolary novels and their documentary capacity with regard to modern society.[10]

Another aspect of *Pamela* which may have interested Diderot is the open relationship between factuality and fictionality. The constructed character of an exchange of letters did not stop readers at the time from

identifying with the protagonists, taking them for real people at the same time as using them as models for their own writing. Emotions and even identities can thus be fictionalized in personal letters.[11] Emotions of one's own are replaced by observation of emotions. "[...] formally speaking, then," writes Herder, "I no longer depict genuine emotions, but a perspective of them as seen by another."[12]

III.

These genre-specific properties of the epistolary novel are surely what inspired Diderot for his theory of drama: the interplay of dialogic structures on the receptive and discursive levels, and of self-observation and observation by others, permit an understanding of the individual as the result of intersubjective processes—as a social subject. Action within society is thus a performative interplay of self-image and role, of self-defined and attributed identities. The result is a playful constellation of identities devised between factuality and fictionality whose implications make Diderot's metaphor of the Fourth Wall applicable as an analytical tool for the description of current autofictional works which understand art as a seeking for clues in everyday life, an acting-out of behavioral patterns, a staging and documenting of one's own life and the lives of others. These approaches take account of the fact that when the I becomes a self, it has to be substantiated, made portrayable and exemplary. Identity has to be acquired.[13] In special forms of communication like confession and autobiography, Alois Hahn explains, this identity crystallizes as a fictitious unity of the social individual. At the same time, however, the self is also shaped by a variable, participatory social identity that is at odds with the biographical one. Consequently, in view of modern society, the notion of a unified (auto) biographical identity proves to be a fictitious construct:

11 Cf. Anette C. Anton, *Authentizität als Fiktion. Briefkultur im 18. und 19. Jahrhundert* (Stuttgart/Weimar: Metzler, 1995), p. 29.
12 Johann Gottfried Herder, "Von der Ode", in *Werke*, vol. 1, ed. Ulrich Gaier (Frankfurt am Main: Deutscher Klassiker Verlag, 1985), p. 68.
13 Niklas Luhmann, "Die gesellschaftliche Differenzierung und das Individuum", in *Soziologische Aufklärung*, vol. 6 (Opladen/Köln: Westdeutscher Verlag, 1995), p. 130.
14 Alois Hahn and Cornelia Bohn, "Das 'erlesene' Selbst und die Anderen," in Vittoria Borsò and Björn Goldammer, eds., *Moderne(n) der Jahrhundertwenden. Spuren der Moderne(n) in Kunst, Literatur und Philosophie auf dem Weg ins 21. Jahrhundert* (Baden-Baden: Nomos Verlagsgesellschaft, 2000), pp. 223–224.
15 Isabelle de Maison Rouge, ed., *Mythologies personnelles. L'art contemporain et l'intime* (Paris: Scala, 2004); Susanne Düchting, *Konzeptuelle Selbstbildnisse* (Essen: Klartext Verlag, 2001); Martina Weinhart, *Selbstbild ohne Selbst* (Berlin: Reimer, 2004); Barbara Steiner and Jun Yang, *Autobiography* (London: Thames & Hudson 2004). See also *art press*, No. 5 (2002), special issue *Fictions d'artistes, autobiographies, récits, supercheries*.
16 Christian Moser and Jürgen Nelles, eds., *AutoBioFiktion. Konstruierte Identitäten in Kunst, Literatur und Philosophie* (Bielefeld: Aisthesis Verlag, 2006), pp. 12–13.
17 Cf. Susanne Knaller, *Ein Wort aus der Fremde. Geschichte und Theorie des Begriffs Authentizität* (Heidelberg: Universitätsverlag Winter, 2007), p. 169.
18 Omar Calabrese, *Die Geschichte des Selbstporträts* (Munich: Hirmer Verlag, 2006), p. 24.

> The particular difficulty arising for the individual in this context is that it can no longer have itself discussed as a unified whole in any real situation. [...] Biographical identity as a discrete unit, both synchronic and diachronic, can thus only be discussed in special institutions such as confession or psychoanalysis, or in communications that lie beyond direct interaction, limited purely to writing, such as autobiographies [...].[14]

The modern subject is always a constructed, flexible result of a process of inclusion and exclusion with regard to specific roles, codes, and discourses, a result of one's own and external attributions. Current artistic strategies in addressing this interrelation between unified and plural identity are diverse and spread across different media: from autobiographical portrayals to fictitious assumptions of identity, from documentary recordings, from exhibitions of autobiographical material in the form of personal objects to decades-long projects of self-documentation.[15] An autofictional approach is not to be confused with a poetics of writing oneself or writing the self, underpinned by a notion of authenticity which acts as an existential and literary category linking the search for meaning, the formation of an integral identity, and artistic accomplishment. What Christian Moser calls subjective identity—the experience of the self as an individual person who remains identical through many different visual and textual identities over an extended period—is not what autofiction delivers.[16]

Instead, contemporary media combinations of image and text prompt discussions of the question of referentiality and authentication with regard to autobiography. In this way, art is probed for its autofictional potential: via the certifying instance of authors and artists and their self-images and self-portrayals, identity and form are dealt with in aesthetic and political terms.[17] Art-historically speaking, autofictional multimedia works share the emphasis on praxis, direct experience, and participation already seen in Conceptual, Pop, and Land Art, and in the activities of the Situationists. This opened art up to elements of trivialized day-to-day (media) life, everyday rituals of identity preservation, and programs for self-promotion, amplified by game-like structures that engaged recipients.

Another point of reference for autofictional forms can be found in early-modern and modern portraiture, with its long and prolific tradition going back to the fifteenth century, which, with the invention of photography in the nineteenth century, became a history of authenticity and art/image.[18] Since the second half of the twentieth century, participatory art has taken the issues of self-portraiture via the relation of artist and form on into procedures of certification and authentication requiring an ever-greater degree of complexity on account of media developments. A general mistrust of traditional models of identity and the self led—following Foucault, so to speak—to an increase in motifs of surveillance, control, and detective

investigation on the one hand, and on the other, to a search for new, non-normative forms of authenticity.

The most lasting impact on autobiographical art since the 1970s, which also justifies talk of an innovative generation of autobiographers, has been made by the ramifications of post-structuralist discussions of the concepts of author, artist, and narrator. In these theories, concepts of subject and self are linked to historically and culturally determined and modified procedures: subjects not only construct themselves, but are also constructed and trained for specific functions.[19] In spite of such ambivalent constructions, these theories engage ideas of the loss of something irretrievable (Lacan's "réel"), pre-modern ideals (Foucault's "techniques de soi"), and models of idealist constructivity (Lyotard's sublime), which ultimately uphold a form of self-determination within the (aesthetic) construction, if only as a vague, utopian backdrop.[20] By contrast, the discussion and production of autobiography can also attempt to take the debate beyond the polarization of wholeness versus fragment, identity versus dissolution, truthfulness versus construct by foregoing utopias of unity or sentimental discourses of loss altogether. At this point I would reject the notion that autobiography was once oriented entirely towards unity and coherence, a state of affairs from which the "new" performative forms of autobiography were then able to set themselves apart. Neither is the concept of performativity elaborated here meant to invoke that "return of the subject", much-cited in connection with the autobiography boom, which would like to distinguish itself from formerly unproblematic models of the self. Michael Renov writes:

> The 'return of the subject' is not, in these works, the occasion for a nostalgia for an unproblematic self-absorption. If what I am calling 'the new autobiography' has any claim to theoretical precision, it is due to this work's construction of subjectivity as a site of instability—flux, drift, perpetual revision—rather than coherence.[21]

Renov's contrasting of a poetics of conflict and discourses of unity overlooks the fact that conflictiveness has been part of the modern concept of

19 Michel Foucault, *Surveiller et punir* (Paris: Gallimard, 1975).
20 Knaller, *Ein Wort aus der Fremde*, p. 178.
21 Michael Renov, "The Subject in History: The New Autobiography in Film and Video", in *Afterimage*, No. 17 (1989), p. 5. See also Doris Grüter's comments on a rediscovery of the individual and a relativization of the self-referential aesthetic: Doris Grüter, *Autobiographie und Nouveau Roman. Ein Beitrag zur literarischen Diskussion der Postmoderne* (Münster: LIT Verlag, 1994), p. 318.
22 Knaller, *Ein Wort aus der Fremde*, p. 179.
23 On documentary and the question of realism, see Susanne Knaller, "Realismus und Dokumentarismus. Überlegungen zu einer aktuellen Realismustheorie," in Dirck Linck, Michael Lüthy, Brigitte Obermayr, Martin Vöhler, eds., *Realismus in den Künsten der Gegenwart* (Berlin: diaphanes, 2010, forthcoming).

the subject and subjectivity from the outset. The highly differentiated social systems of modernity call for a subject that responds flexibly to attributions of identity and is able to handle conflict. Art, philosophy, and anthropology were already facing this challenge in the eighteenth century. Rousseau, with his autobiographical endeavors spanning decades, is just one example of how autobiography supports his discourse of self-substantiation, while in the text itself the above-mentioned dilemmas are inscribed as irresolvable.[22]

IV.

Works using autobiographical, documentary techniques do not stop at demonstrating the constructed nature of reality and identity, however it may be generated or explained.[23] As a form, autobiography (like the documentary) presents itself as the selection, fragmentation, and montage of facts and circumstances: autobiography reaches back into "raw" reality in all its contingency. Like every performative form, autofiction includes a presentist, non-representational dimension which is open to artistic treatment. In this way, autobiography places both that which is document-ed and documentary procedures into one diegetic space, demonstrating the dependency on temporalization and spatialization processes and renounc-ing the unattainable utopia of a mimetically timeless social and biographical identity. This renunciation is also characteristic of Diderot's concept of the Fourth Wall. His dramatic, performative concept sets itself apart from both rational forms of representation (in classical literature and positivist realism) and presentist fantasies of immediacy (in Romanticism). Under-stood as an analytical metaphor, it permits the portrayal of various specific aesthetic approaches to the paradoxical basis of concepts of reality. Placed within a context of historical concepts of reality and the subject, it becomes apparent that the eighteenth century staged a playful approach to condi-tions of difference that can be taken as an example for the contemporary scene. Whether or not art wishes to join the moral discourse called for by Diderot must be decided case by case.

From the German by Nicholas Grindell

Bio- und Bibliografien der KünstlerInnen
Artists' Biographies and Bibliographies

Auswahl | Selection

Die in den Biografien vermerkten Publikationen werden in den Bibliografien nicht angeführt.
Publications listed in the biographies are not included in the bibliographies.

Harun Farocki

1944 Neutitschein/CZ – Berlin/D, Wien | Vienna/A

Einzelausstellungen | Solo Exhibitions
Harun Farocki. Museum Ludwig, Köln 2009–2010 (Publ.)
Harun Farocki. 22 Films 1968–2009. Tate Modern, London 2009
HF | RG. Harun Farocki / Rodney Graham. Jeu de Paume, Paris 2009 (Publ.)
Harun Farocki. Nebeneinander. MUMOK, Museum Moderner Kunst Stiftung Ludwig,
Wien | Vienna 2007 (Publ.)
Harun Farocki: Auge/Maschine I–III. Städtische Galerie Karlsruhe, Zentrum für Kunst
und Medientechnologie, Karlsruhe 2004
Harun Farocki: Eye/Machine III. Institute of Contemporary Arts, London 2003
Harun Farocki – Filme, Videos, Installationen 1969–2001. Westfälischer Kunstverein,
Münster. Kunstverein Frankfurt, Frankfurt am Main 2001

Gruppenausstellungen | Group Exhibitions
Changing Channels. MUMOK, Museum Moderner Kunst Stiftung Ludwig, Wien |
Vienna 2010 (Publ.)
ANIMISM. Extra City, Antwerpen. Museum van Hedendaagse Kunst Antwerpen,
Antwerpen | Antwerp. Kunsthalle Bern, Bern 2010 (Publ.)
Manifesta 7, Trentino 2008 (Publ.)
The Cinema Effect: Illusion, Reality, and the Moving Image. Part I: „Dreams".
Hirshhorn Museum, Washington 2008 (Publ.)
documenta 12, Kassel 2007 (Publ.)
Kino wie noch nie. Cinema like never before. Generali Foundation, Wien | Vienna.
Akademie der Künste, Berlin 2006/07 (Publ.)
Dinge, die wir nicht verstehen. Generali Foundation, Wien | Vienna 2000 (Publ.)
documenta X, Kassel 1997 (Publ.)

Bibliografie | Bibliography
www.farocki-film.de
Aurich, Rolf, und | and Kriest, Ulrich, Hg. | ed. *Der Ärger mit den Bildern. Die Filme
von Harun Farocki*. Konstanz: UVK-Medien, 1998.
Baumgärtel, Tilman. *Vom Guerillakino zum Essayfilm: Harun Farocki, Werkmonografie
eines Autorenfilmers*. Berlin: b_books, 2002.
Ehmann, Antje, und | and Eshun, Kodwo, Hg. | ed. *Harun Farocki. Against What?
Against Whom?* London: Raven Row, 2009.
Elsaesser, Thomas, Hg. | ed. *Harun Farocki: Working on the Sightlines*. Amsterdam:
Amsterdam University Press, 2004.
Theriault, Michèle, Hg.| ed. *Harun Farocki. One image doesn't take the place of the
previous one*. Montreal: ABC Art Books Canada, 2008.

Schriften des Künstlers | Writings by the artist
Farocki, Harun, und | and Silverman, Kaja. *Von Godard sprechen*. Berlin:
Verlag Vorwerk 8, 1998.
Gaensheimer, Susanne, Hg. | ed. *Harun Farocki. Nachdruck – Texte / Imprint – Writings*.
Berlin: Verlag Vorwerk 8. New York: Lukas und Sternberg, 2001.

1974 bis 1984 Redakteur und Autor der Zeitschrift *Filmkritik* | from 1974 to 1984
editor and writer for the magazine *Filmkritik*

Omer Fast

1972 Jerusalem/IL – Berlin/D

Einzelausstellungen | Solo Exhibitions
Omer Fast: Nostalgia. South London Gallery, London. Whitney Museum of American Art, New York. Berkeley Art Museum & Pacific Film Archive, Berkeley 2009–10
Omer Fast. Museum of Contemporary Art, Denver 2008–09
Omer Fast. Kunstverein Hannover, Hannover 2008–09

Omer Fast. The Casting. MUMOK, Museum Moderner Kunst Stiftung Ludwig, Wien | Vienna 2007–08 (Publ.)
Omer Fast: Godville. Midway Contemporary, Minneapolis 2005 (Publ.)
Omer Fast / Jeanne Faust. Ars Viva 03/04. Frankfurter Kunstverein, Frankfurt. Pinakothek der Moderne, München | Munich. Brandenburgischer Kunstverein, Potsdam 2004
Omer Fast. gb Agency, Paris 2002 (Publ.)

Gruppenausstellungen | Group Exhibitions
Actors & Extras. Argos Centre for Art and Media, Brüssel | Brussels 2009 (Publ.)
Made up! 5th Liverpool Biennial, Liverpool 2008 (Publ.)
Medium Religion. ZKM, Zentrum für Kunst und Medientechnologie, Karlsruhe 2008 (Publ.)
Manifesta 7, Trentino 2008 (Publ.)
The Cinema Effect: Illusion, Reality, and the Moving Image. Part II: Realisms. The Hirshhorn Museum, Washington DC 2008 (Publ.)
History will repeat itself. Strategien des Reenactment in der zeitgenössischen (Medien-)Kunst und Perfomance. Kunst-Werke, Berlin. Hartware Medien Kunstverein, Dortmund. Ujazdowski Castle, Warschau | Warsaw. Goethe-Institut, Hong Kong 2007–2008 (Booklet)
Reprocessing Reality. New Perspectives on Art and the Documentary. Château de Nyon, Nyon. PS1, New York 2006 (Publ.)
Life: Once More. Witte de With, Rotterdam 2005 (Publ.)

Bibliografie | Bibliography
Godfrey, Mark. „Making History", in: *Frieze*, Issue 97 (March 2006), 130–133.
Holert, Tom. „Attention Span", in: *Artforum International* XLVI, No. 6 (February 2008), 228–235.
Lebovici, Elisabeth. „From Homer to Omer Fast", in: *Afterall* (Spring 2009), 28–35.
Lütticken, Sven. „Gated History", in: *Texte Zur Kunst*, Heft 59 (September 2005), 190–194.
Muhle, Maria. „Omer Fast. When Images Lie…About the Fictionality of Documents", in: *Afterall* (Spring 2009), 36–44.
Schaschl, Sabine, Hg. | ed. *In Memory: Omer Fast*. Berlin: Green Box, 2010.
Tamir, Chen. „Omer Fast. New Magic Realism", in: *Flash Art*, Vol. XLI, No. 262 (October 2008), 114–117.

Michael Fliri

1978 Alto Adige/IT – Wien | Vienna/A

Einzelausstellungen | Solo Exhibitions
Michael Fliri. Getting too old to die young. Galleria Raffaella Cortese, Mailand | Milan 2008
Michael Fliri. Gravity. Eurac Project Room, Museion, Museum of modern and contemporary art Bolzano, Bozen | Bolzano 2007
Michael Fliri. Early one morning with time to waste. Galleria Enrico Fornello, Prato 2007
Michael Fliri. Nice and nicely done. Festival Transart praeludium, Goethe 2, Bozen | Bolzano 2006
Casting Decision Verification. Michael Fliri. Raum, Bologna 2005
I am always better on holiday. Michael Fliri. dispari & dispari project, Reggio Emilia 2005
…Hell…Well. Michael Fliri. Kunstrom, Bergen 2003

Gruppenausstellungen | Group Exhibitions
Languages and Experimentations. Young artists in a contemporary collection. MART, Museo di arte moderna e contemporanea di Trento e Rovereto, Rovereto 2010
Italian genius now – home sweet home. Kaohsiung Museum of Fine Arts, Taipei 2010
Wonder World. Expecting a Restless Future. Special Project for the 3rd Moscow Biennale

of Contemporary Arts, Ekaterina 2009 (Publ.)
Hopes and Doubts. Fondazione Merz, Turin. Dome City Centre, Beirut 2009 (Publ.)
New Entries! Museion, Museum of modern and contemporary art Bolzano, Bozen I
Bolzano 2009 (Publ.)
Emerging Talents. New Italian Art. Palazzo Strozzi, Florenz I Florence 2009 (Publ.)
The Rocky Mountain People Show. Galleria Civica, Parallel Event, Manifesta7, Trentino 2008
European Sovereign Art Prize. Somerset House, London 2008 (Publ.)

Bibliografie I Bibliography

Cavallucci, Fabio. „Michael Fliri. Come out and play with me. (Interview)", in: *Flash Art Italian Online Edition.* http://www.flashartonline.it (30.4.2010)
Cresci, Mario, Hg.I ed. *Future Images.* Turin: Federico Motta Editore, 2010.
Looking for the boarder. Ausst.-Kat. I Exh. cat. Mechelen: De Garage Culturcentrum Mechelen.
Grimberg: Culturcentrum Strombeek. Mailand I Milan: Fondazione Stelline, 2007
Paterni, Marinella, Hg. I ed. *Laboratorio Italia. Photography in Contemporary Art.* Monza:
Johan & Levi, 2010.
Pioselli, Alessandra. „Michael Fliri: Galleria Raffaella Cortese", in: *Artforum International* XLVII,
No. 2 (October 2008), 399.
Videoreport. Ausst.-Kat. I Exh. cat. Monfalcone: Galleria Comunale d'Arte Contemporanea
Monfalcone 2006

Andrea Geyer

1971 Freiburg/D – New York/USA

Einzelausstellungen I Solo Exhibitions
Andrea Geyer – Spiral Lands. Argos, Brüssel I Brussels 2010
Andrea Geyer I Sharon Hayes. Kunstmuseum St. Gallen, St. Gallen. Göteborgs Konsthall,
Göteborg 2009 (Publ.)
9 Scripts from a Nation at War. Mit I With Sharon Hayes, Ashley Hunt, Katya Sander,
David Thorne. Tate Modern, London 2008
Andrea Geyer. Spiral Lands/Chapter 2. Modern Mondays, MoMA, Musem of Modern Art,
New York 2008
Andrea Geyer. *Meaning is what hides the instability of one's position.* Mit I With Katya Sander.
Esbjerg Kunstmuseum, Esbjerg 2004 (Publ.)
Andrea Geyer. Parallax. Secession, Wien 2003 (Publ.)
Special Projects. Winter 2000. Mit I With Sharon Hayes. MoMA P.S.1 Contemporary Art Center,
New York 2000

Gruppenausstellungen I Group Exhibitions
The Greenroom. Reconsidering the Documentary and Contemporary Art. Annandale-
on-Hudson: CCS Bard Hessel Museum 2008–2009 (Publ.)
documenta 12, Kassel 2007 (Publ.)
Exil des Imaginären. Exile of the Imaginary. Generali Foundation, Wien I Vienna 2007 (Publ.)
Information / Transformation. Extra City, Antwerpen 2005
Die Regierung – Be what you want but stay where you are. Witte de With, Rotterdam 2005 (Publ.)
Die Regierung – Paradiesische Handlungsräume. Secession, Wien I Vienna 2005 (Publ.)
Die Regierung – How do we want to be governed? Miami Art Central, 2004 (Publ.)
The American Effect. Whitney Museum of American Art, New York 2003 (Publ.)
Manifesta 4, Frankfurt am Main 2002 (Publ.)

Bibliografie I Bibliography

www.andreageyer.info
Conrads, Martin und I and Gutmair, Ulrich. „Justify my Love: Andrea Geyer, Cecily Brown,
Dorit Margreiter, Stefan Ettlinger", in: *Texte zur Kunst*, Nr. 42 (2001), 102–108.
Leeb, Susanne, „Antiromantic Conceptualism: Über Spiral Lands / Chapter 1 by Andrea Geyer",
in: *Texte Zur Kunst*, Nr. 73 (März 2009).
Senzer, Christa. „Information Upon Request, Andrea Geyer", in: *Springerin*, Band 7, Heft 1/01
(2001).
„Working. A conversation between Andrea Geyer, Sharon Hayes, Ashley Hunt, Maryam Jafri,
Kara Lynch, Ulrike Müller, Valerie Tevere, David Thorne and Alex Villar", in: *artwurl.org*,
2004–2006. www.artwurl.org (30. 4. 2010).

Schriften der Künstlerin | Writings by the artist
Geyer, Andrea, und | and Berlo, Janet Catherine. *Spiral Lands / Chapter 1*. Köln | Cologne:
Galerie Thomas Zander. Wien | Vienna: Galerie Hohenlohe. London: Verlag Walther König, 2008.
Geyer, Andrea, „From the Notebook: Audrey Munson", in: *Starship*, Nr. 7 (2004), 58–73.

Marcello Maloberti

1966 Codogno – Mailand | Milan/IT, New York/USA

Einzelausstellungen | Solo Exhibitions
Die Schmetterlinge essen die Bananen (Le farfalle mangiano le banane). Marcello Maloberti.
Part of déjà vu 3° edizione, Raum, Bologna 2009
Raptus. Marcello Maloberti. GAMeC Galleria d'Arte Moderna e Contemporanea, Bergamo 2009
(Publ.)
Tagadà. Marcello Maloberti. Galleria Raffaella Cortese, Mailand | Milan. Galleria Francesco
Pantaleone, Palermo 2007
Marcello Maloberti. Galleria Raffaella Cortese, Mailand | Milan, 2004 (Publ.)
Marcello Maloberti. Kunstverein Ludwigsburg, Ludwigsburg. Galleria S.A.L.E.S., Rom |
Rome 2003 (Publ.)
Quaggiù. Marcello Maloberti. Spazio Aperto, Galleria d'Arte Moderna, Bologna 2002 (Publ.)

Gruppenausstellungen | Group Exhibitions
The Ants Sruggle on the Snow. Performa 2009, New York 2009
Peripheral vision and collective body. Museion, Museum of modern and contemporary art
Bolzano, Bozen | Bolzano 2008 (Publ.)
Light Lab. Cortocircuiti quotidiani. Museion, Museum of modern and contemporary art
Bolzano, Bozen | Bolzano 2005 (Publ.)
No Code. Contemporary Italian Art. Slovak National Gallery, Bratislava 2005 (Publ.)
Theorema. Collection Lambert, Avignon 2005 (Publ.)
Radiodays. de Appel arts centre, Amsterdam 2005
Peripheries become the center. Prague Biennale 1, Prag | Prague 2003 (Publ.)

Bibliografie | Bibliography
www.marcellomaloberti.com
Acrobazie#2 – Marcello Maloberti. Ausst-Kat. | Exh. Cat. San Colombano al Lambro:
Atelier Adriano e Michele, Centro Fatebenefratelli. Mailand | Milan: Galleria Raffaella
Cortese, 2006.
Casavecchia, Barbara. „L'imitatore di voci (Interview)", in: *Flash Art*, N. 275 (April–Mai 2009).
Fuori Campo. Marcello Maloberti. Ausst-Kat. | Exh. Cat. Trucazzano: Transmec Group, 2003.
Pioselli, Alessandra. „Marcello Maloberti. Galleria Raffaella Cortese", in: *Artforum International*
XLI, no.2 (October 2002).
Romeo, Filippo. „Marcello Maloberti: Galleria S.A.L.E.S.", in: *Artforum International* XLII, no.4
(December 2003).
Verzotti, Giorgio. „Marcello Maloberti: Galleria Raffaella Cortese", in: *Artforum International*
XLVI, n.4 (December 2007).

Aernout Mik

1962 Groningen/NL – Amsterdam/NL

Einzelausstellungen | Solo Exhibitions
Aernout Mik. Museum of Modern Art, New York 2009 (Publ.)
Aernout Mik: Shifting Shifting. Camden Arts Centre, London. Fruitmarket Gallery, Edinburgh.
Bergen Kunsthall, Bergen. Kunstverein Hannover, Hannover 2007 (Publ.)
Niederländischer Pavillon | Dutch Pavilion, La Biennale di Venezia, Venedig | Venice 2007 (Publ.)
Aernout Mik: Refraction. New Museum of Contemporary Art, New York. Museum of
Contemporary Art, Chicago. UCLA Hammer Museum, Los Angeles 2005–2006 (Publ.)
Aernout Mik. In Two Minds. Stedelijk Museum, Amsterdam. Les Abattoirs, Toulouse 2003
Aernout Mik: Primal Gestures, Minor Roles. Van Abbemuseum, Eindhoven 2000 (Publ.)
Niederländischer Pavillon | Dutch Pavilion, mit | with Willem Oorebeek, La Biennale di Venezia,
Venedig | Venice 1997 (Publ.)

Gruppenausstellungen | Group Exhibitions
Niet Normaal. Difference on Display. Beurs van Berlage, Amsterdam 2009–2010 (Publ.)
Actors & Extras. Argos Centre for Art and Media, Brüssel | Brussels 2009 (Publ.)
A Short History of Performance – Part IV. Whitechapel Art Gallery, London 2006

Irreducible. Contemporary Short Form Video. CCA Wattis Institute, San Francisco.
Miami Art Central, Miami 2005 (Publ.)
Território Livre. 26th São Paulo Biennial, São Paulo 2004 (Publ.)
*Dass die Körper sprechen, auch das wissen wir seit langem. That bodies speak has been
known for a long time.* Generali Foundation, Wien | Vienna 2004 (Publ.)
Poetic Justice. 8th Istanbul Biennial, Istanbul 2003 (Publ.)
Tableaux Vivants. Kunsthalle Wien, Wien | Vienna 2002 (Publ.)

Bibliografie | Bibliography
AC: Aernout Mik: Dispersion Room, Reversal Room. Köln | Cologne: Verlag der Buchhandlung
Walther König, 2004.
Aernout Mik: Dispersions. Ausst.-Kat. | Exh. cat. München | Munich: Haus der Kunst, 2004.
Aernout Mik: 3 Crowds. Ausst.-Kat. | Exh. cat. London: Institute of Contemporary Arts, 2000.
Birnbaum, Daniel. Aernout Mik: Elastic. How to (Mis)understand Aernout Mik in Twelve Steps.
Amsterdam: Koninklijke Nederlandse Akademie van Wetenschappen, 2002.
Hanging Around: Aernout Mik. Ausst.-Kat. | Exh. cat. Köln | Cologne: Museum Ludwig, 1999.
Inselmann, Andrea. *Aernout Mik: Reversal Room.* Ausst.-Kat. | Exh. cat. Ithaca: Herbert
F. Johnson Museum of Art, Cornell University, 2004.
Monk, Philip. *Aernout Mik: Reversal Room.* Ausst.-Kat. | Exh. cat. Ontario: The Power Plant
Contemporary Art Gallery, 2001.
Walsh, Anne. *Tender Habitat: Three Works by Aernout Mik.* Ausst.-Kat. | Exh. cat. Ann Arbor:
Jean Paul Slusser Gallery, University of Michigan, 2000.

Frédéric Moser & Philippe Schwinger

Zusammenarbeit seit | Collaboration since 1988
Frédéric Moser, 1966 Saint-Imier/CH – Berlin/D
Philippe Schwinger, 1961 Saint-Imier/CH – Berlin/D, Genf | Geneva/CH

Einzelausstellungen | Solo Exhibitions
Exposer – Frédéric Moser & Philippe Schwinger. Frac Provence-Alpes-Côte-d'Azur,
Marseille | Marseilles 2010
Frédéric Moser and Philippe Schwinger: Farewell letter to the Swiss Workers. KOW Issue 2,
Galerie Jocelyn Wolff, Paris 2009 (Publ.)
Frédéric Moser et Philippe Schwinger. Avant moi, le flou, après moi le déluge. Mamco,
Musée d'art moderne et contemporain, Genf | Geneva 2008
Frédéric Moser & Philippe Schwinger. Farewell Letter to the Swiss Workers. Kunsthaus Zürich,
Zürich | Zurich 2006
Território Livre. 26th São Paulo Biennial, Offizieller Beitrag der Schweiz | Swiss official
Contribution, São Paulo 2004 (Publ.)
Frédéric Moser & Philippe Schwinger. Dose miracle. Musée des beaux-arts, La Chaux-de-
Fonds 2000 (Publ.)
Frédéric Moser & Philippe Schwinger. Auf den Höhen. Kunstverein Schaffhausen,
Schaffhausen 1999 (Publ.)

Gruppenausstellungen | Group Exhibitions
A Generation. Petach Tikva Museum of Art, Petach Tikva 2010
*History will repeat itself. Strategien des Reenactment in der zeitgenössischen (Medien-)
Kunst und Perfomance.* Kunst-Werke, Berlin. Hartware MedienKunstVerein, Dortmund.
Ujazdowski Castle, Warschau | Warsaw. Goethe-Institut, Hong Kong 2007–2008 (Booklet)
Protections. Das ist keine Ausstellung. Kunsthaus Graz, 2006 (Publ.)
The 3rd Seoul International Media Art Biennale. Museum of Art, Seoul 2004 (Publ.)
So wie die Dinge liegen. Hartware MedienKunstVerein, Dortmund 2004 (Publ.)
Analog/ue – Dialog/ue. Plan, Modell und Bühne in der zeitgenössischen Kunst. Kunstmuseum
Solothurn, Solothurn. Musée jurassien des arts Moutier, Moutier 2001 (Publ.)
Internationaler Videokunstpreis 1997. ZKM, Zentrum für Kunst und Medientechnologie Karlsruhe,
Karlsruhe 1997 (Publ.)

Bibliografie | Bibliography
Frédéric Moser, Philippe Schwinger: Unexpected Rules. Bern: Swiss Federal Office of Culture.
Frankfurt am Main: Revolver Archiv für aktuelle Kunst, 2004.
Politi, Gea. „Moser & Schwinger: The Theater and its Double", in: *Flash Art International*,
Vol. XXXVIII, #242 (May–June 2005), 128–131.
Reust, Hans Rudolf. „Zimmer 319. Zu den Videoinstallationen von Frédéric Moser
und Philippe Schwinger", in: *Kunst-Bulletin* (September 2001), 26–31.
Schönwald, Cédric und | and Wecker, Frédéric. „Frédéric Moser et Philippe Schwinger.
Les versions des faits", in: *Art21*, numéro 17//printemps 2008 (mars 2008), 44–51.
Schulman, Clara. „Analyse/Fictions Politiques: Tout va bien, chez Philippe Schwinger
et Frédéric Moser", in: *Particules*, no 25 (juin–juillet–aôut 2009), 19.

Schriften der Künstler | Writings by the artists
Moser, Frédéric. „Affection riposte: über einige Treulosigkeiten", in: *Kunst und Medialität*.
Hg. | Ed. Gisela Febel, Jean-Baptiste Joly und | and Gerhart Schröder. Stuttgart: Akademie
Schloss Solitude, 2004, 109–121.

Wendelien van Oldenborgh

1962 Rotterdam/NL – Rotterdam/NL

Einzelausstellungen | Solo Exhibitions
The Past is Never Dead. Wendelien van Oldenborgh. A Space Gallery, Toronto 2010
Wendelien van Oldenborgh. Après la reprise, la prise. Wilfried Lentz, Rotterdam 2009 (Publ.)
Plug In #39. Wendelien van Oldenborgh Maurits Script. Van Abbemuseum, Eindhoven 2008–09
Wendelien van Oldenborgh. As Occasions. Tent, Rotterdam 2008 (Publ.)
*Lonely at the Top. sound effects #2. Lecture/Audience/Camera.... a work by Wendelien van
Oldenborgh*. MuHKA, Museum van Hedendaagse Kunst Antwerpen, Antwerpen | Antwerp 2008
Maurits Script. Wendelien van Oldenborgh. ApexArt, New York 2007 (screening)

Gruppenausstellungen | Group Exhibitions
Art and Politics. 29th Bienal de São Paulo, São Paulo 2010 (Publ.)
Museum Modules. Play Van Abbe – Part 2: Time Machines. Van Abbemuseum, Eindhoven 2010
What Keeps Mankind Alive? 11th International Istanbul Biennial, Istanbul 2009 (Publ.)
In Living Contact. 28th São Paulo Biennial, São Paulo 2008 (screening), (Publ.)
Be(com)ing Dutch. Van Abbemuseum, Eindhoven 2008 (Publ.)
Be What You Want But Stay Where You Are. Witte de With, Rotterdam 2005
heaven's gift. CAT project. MAK, Museum für Angewandte Kunst, Wien | Vienna 2002

Bibliografie | Bibliography
Bangma, Anke. „Historic Indeterminacy. The polyphonic work of Wendelien van Oldenborgh",
in: *Metropolis M*, Nr.4 (August/September 2008), 36–41.
Esche, Charles. „Best of 2009", in: *Artforum International* XLVIII, Nr. 4 (December 2009), 190.
Jurriëns, Edwin. „No False Echoes: Polyphony in Colonial and Post-Colonial Times", in:
IIAS Newsletter, #48 (Summer 2008), 21.

Schriften der Künstlerin | Writings by the artist
„Retouching Some Real with Some Real", in: *The Great Method. Casco Issues X*. Hg. | Ed.
Peio Aguirre and Emily Pethick. Rotterdam: Casco. Frankfurt am Main: Revolver Verlag, 2007.
„Staging Real Situations", in: *MaHKUzine Journal of Artistic Research*, #2 (Winter 2007), 26–30.
Oldenborgh, Wendelien van, Hg. | Ed. *Stadtluft*. Ausst.-Kat. | Exh. cat. Valence: art3. Frankfurt
am Main: Revolver Verlag, 2004.

Judy Radul

1962 Lillooet, British Columbia/CA – Vancouver/CA

Einzelausstellungen | Solo Exhibitions
Judy Radul: World Rehearsal Court. Morris and Helen Belkin Art Gallery, Vancouver 2009
Judy Radul. Catriona Jeffries Gallery, Vancouver 2007
Set: Room 302. Geoffrey Farmer, Judy Radul. Artspeak Gallery, Vancouver 2005 (Publ.)

Judy Radul. Vancouver Costume. Contemporary Art Gallery, Vancouver 2002
In Relation To Objects. Judy Radul. Institute of Contemporary Art, London 1999 (Performance)
To Shine. Judy Radul. Western Front Gallery, Vancouver 1991 (Publ.)

Gruppenausstellungen | Group Exhibitions
The Thing. All That is Solid Melts into Air. MuHKA, Museum van Hedendaagse Kunst Antwerpen Extra Muros, Cultural Centre, Mechelen, 2009 (Publ.)
Acting The Part: Photography As Theatre. Vancouver Art Gallery, Vancouver 2007 (Publ.)
Intertidal: Vancouver Art and Artists. MuKHA, Museum Van Hedendaagse Kunst Antwerpen, Antwerpen | Antwerp 2005 (Publ.)
Videodreams. Zwischen Cinematischem und Theatralischem. Kunsthaus Graz, Graz 2004 (Publ.)
Facing History. Presentation House Gallery, North Vancouver 2001 (Publ.)
Signs of Life. Melbourne International Biennial, The Ian Potter Museum of Art, The University of Melbourne, Melbourne 1999 (Publ.)

Bibliografie | Bibliography
Gaitán, Juan A. „Only People and Things", in: *Anthology of Exhibition Essays 2006/2007*. Vancouver: CJ Press, 2008, 71–79.
Speed, Mitch. „Judy Radul in Conversation with Mitch Speed", in: *Woo Magazine*, First Issue (Winter 09), 32–33.
Douzinas, Costas. „Rehearsals", ab Frühling 2010 verfügbar im Online-Katalog | available from spring 2010 in the online catalogue accompanying: *Judy Radul. World Rehearsal Court*, Vancouver: Morris and Helen Belkin Art Gallery. http://www.belkin.ubc.ca

Schriften der Künstlerin | Writings by the artist
„I come to Bury Ceasar: The Image of Theatre in the Imagination of Visual Art", in: *Art Lies*, #60 (Winter 2008).
„What was behind me now faces me. Performance, staging, and technology in the court of law", in: eurozine (2. 5. 2007). http://www.eurozine.com (28. 4. 2010)
„Just Try It: Thoughts on Art and Science Experiments", in: *Public: Experimentalism*, #25 (Toronto 2002), 92–105.
„You Don't Say: Voices From the Incongruous Outside", in: *One Fine Evening*. Vancouver: Western Front, 1997, 20–27.

Allan Sekula

1951 Erie/USA – Los Angeles/USA

Einzelausstellungen | Solo Exhibitions
Allan Sekula. MuHKA, Museum van Hedendaagse Kunst Antwerpen Extra Muros, FotoMuseum, Antwerp | Antwerpen 2010
Allan Sekula: Polonia and Other Fables. Ludwig Múzeum, Budapest 2010
Allan Sekula. Polonia and Other Fables. Zacheta National Gallery, Warschau | Warsaw 2009–2010 (Publ.)
Allan Sekula. Performance under Working Conditions. Generali Foundation, Wien 2003 (Publ.)
Allan Sekula. Dismal Science. Photo Works 1972–1996. University Galleries, Illinois State University, Normal 1996 (Publ.)
Allan Sekula. Fish Story. Witte de With, Center for Contemporary Art, Rotterdam 1995 (Publ.)
Allan Sekula. Photography Against the Grain. Folkwang Museum, Essen 1984 (Publ.)

Gruppenausstellungen | Group Exhibitions
The Universal Archive. The Condition of the Document and the Modern Photographic Utopia. MACBA, Museu d'Art Contemporani de Barcelona, Barcelona 2008–2009
Not Only Possible, But Also Necessary:Optimism in the Age of Global War. 10th Istanbul Biennial, Istanbul 2007 (Publ.)
documenta 12, Kassel 2007 (Publ.)
Die Regierung – How do we want to be governed? Miami Art Central, 2004 (Publ.)
documenta 11, Kassel 2002 (Publ.)
Positions. Attitudes. Actions. Social and Political Commitment in Photography. Foto Biennale Rotterdam, Museum Boijmans Van Beuningen, Rotterdam 2000 (Publ.)
Art and Ideology. New Museum of Contemporary Art, New York 1984 (Publ.)
Autobiographical Fantasies. Los Angeles Institute of Contemporary Art, Los Angeles 1976 (Publ.)

Bibliografie | Bibliography
Allan Sekula: Dead Letter Office. Rotterdam: Netherlands Foto Instituut, 1997.
Bennet, Derek. „Allan Sekula. Photography against the Grain", in: *European Photography*.
Vol. 7, No. 1 (1986), 50–52.
Geography Lesson: Canadian Notes. Vancouver: Vancouver Art Gallery. Cambridge:
MIT Press, 1997.
Kester, Grant H. „Toward a New Social Documentary", in: *Afterimage*, Vol. 14, No. 8
(March 1987), 10–14.
Römer, Stefan. „Sekula Tours", in: *Texte zur Kunst*, Nr. 41 (März 2001), 194–196.
TITANIC's Wake. Lissabon: Centro Cultural de Belem, 2001.
Tuer, Dot. „Columbus Re-Sighted. An Analysis of Photographic Practices in a New World
of Post-Modernism", in: *Thirteen Essays on Photography*. Ottawa: Canadian Museum
of Contemporary Photography, 1991, 180–194.

Ian Wallace

1943 Shoreham/GB – Vancouver/CA

Einzelausstellungen | Solo Exhibitions
Ian Wallace. A Literature of Images. Kunsthalle Zürich, Zürich. Witte de With, Rotterdam.
Kunstverein Düsseldorf, Düsseldorf 2008/09 (Publ.)
Ian Wallace. Yvon Lambert, New York 2008
Clayoquot Protest. Ian Wallace. Sprengel Museum, Hannover 1998 (Publ.)
Ian Wallace. Catriona Jeffries Gallery, Vancouver 1995
Ian Wallace: The Idea of the University. Fine Arts Gallery, University of British Columbia,
Vancouver, 1990
Ian Wallace. Selected Works 1970–1987. Vancouver Art Gallery, Vancouver 1988 (Publ.)
Ian Wallace. Vancouver Art Gallery, Vancouver 1979 (Publ.)

Gruppenausstellungen | Group Exhibitions
101 Collection: Route 1. R for Replicant. CCA Wattis Institute for Contemporary Arts,
San Francisco 2010
*Un Coup de dés. Bild gewordene Schrift. Ein ABC der nachdenklichen Sprache. Writing Turned
Image. An Alphabet of Pensive Language*. Generali Foundation, Wien | Vienna 2008 (Publ.)
Studio Models. National Gallery of Canada, Ottawa 2007
Intertidal: Vancouver Art and Artists. MuKHA, Museum Van Hedendaagse Kunst Antwerpen,
Antwerpen | Antwerp 2005 (Publ.)
Concrete Language. CAG Contemporary Art Gallery, Vancouver 2006
The Studio. The Hugh Lane Museum of Modern Art, Dublin 2006 (Publ.)
A Notion of Conflict. Stedeljik Museum, Amsterdam 1995 (Publ.)
Vancouver 1965–1975: Contexts and Influences. Vancouver Art Gallery, Vancouver 1995

Bibliografie | Bibliography
Ian Wallace. In the Studio. Ausst.-Kat. | Exh. cat. Vancouver: Charles H. Scott Gallery, 2005.
Ian Wallace: Masculin / Feminin. Ausst.-Kat. | Exh. cat. Montreal: Leonard and Bina Ellen
Gallery, 1999.
Madill, Shirley J.R., Hg. | ed. *Private/Public: Art and Social Discourse*. Winnipeg: The Winnipeg
Art Gallery, 1993.
Watson, Scott. „Ian Wallace's Poverty", in: *Frame of Mind. Viewpoints on Photography in
Contemporary Canadian Art*. Hg. | ed. Daina Augaitis. Banff: Banff Centre for the Arts, 1993.

Schriften des Künstlers | Writings by the artist
„The Monochromes of 1967 to 1968 and After", in: *Anthology of Exhibition Essays 2006/2007*.
Vancouver: CJ Press, 2008, 82–93.
„Photoconceptualism in Vancouver", in: *Thirteen essays on Contemporary Canadian
Photography*, Hg. | ed. Martha Langford, Ottawa: Canadian Museum of Contemporary
Photography, 1991.
„Canada: Anyone, Anywhere, Anything", in: *The International Transavantgarde*, Hg. | ed.
Achille Bonito Oliva, Mailand | Milan: Giancarlo Politi, 1983.
„Literature, Transparent and Opaque", in: *Concrete Poetry*. Ausst.-Kat. | Exh. cat. Vancouver:
Fine Arts Gallery, University of British Columbia, 1969.

Biografien der AutorInnen
Authors' Biographies

Susanne Knaller

Professorin für Romanistik und Allgemeine und Vergleichende Literaturwissenschaft am Institut für Romanistik der Universität Graz. Forschungsschwerpunkte: Ästhetische Theorien (18. bis 20. Jahrhundert), Theorien der Allegorie, Geschichte und Theorie des Begriffs Authentizität, Realitätskonzepte in der Moderne. Zahlreiche Publikationen, u. a.: *Zeitgenössische Allegorien. Literatur, Kunst, Theorie* (2003); *Authentizität. Diskussion eines ästhetischen Begriffs* (2006), hg. mit Harro Müller; *Ein Wort aus der Fremde. Geschichte und Theorie des Begriffs Authentizität* (2007); *Realitätskonstruktionen in der zeitgenössischen Kultur. Beiträge zu Literatur, Kunst, Fotografie, Film und zum Alltagsleben* (2008), Hg.; *Wirklichkeitskonzepte der Moderne in Literatur, Kunst, Film und Fotografie*, Anthologie und Datenbank in Arbeit.

Professor of Romance Philology and Comparative Literature at the University of Graz, Austria. Main research interests: aesthetic theories (18th to 20th century), theories of allegory, history and definition of the notion of authenticity, conceptions of reality in modernity. Various publications, including: *Zeitgenössische Allegorien. Literatur, Kunst, Theorie* (2003); *Authentizität. Diskussion eines ästhetischen Begriffs* (2006), ed. together with Harro Müller; *Ein Wort aus der Fremde. Geschichte und Theorie des Begriffs Authentizität* (2007); *Realitätskonstruktionen in der zeitgenössischen Kultur. Beiträge zu Literatur, Kunst, Fotografie, Film und zum Alltagsleben* (2008), ed.; *Wirklichkeitskonzepte der Moderne in Literatur, Kunst, Film und Fotografie*, anthology and data base (work in progress).

Ilse Lafer

Seit 2008 Assistenz-Kuratorin der Generali Foundation, Wien. Mitarbeit an zahlreichen Ausstellungen, Projekten im öffentlichen Raum und Publikationen, u. a.: *Raymond Pettibon. Whatever it is you're looking for you won't find it here* (2006/07); *Die Toten. Hans-Peter Feldmann. RAF, APO, Baader-Meinhof: 1967–1993* (2007); *Chen Zhen. Der Körper als Landschaft* (2007); *Julius Popp. Bit Fall* (2007); *Under Pain of Death* (2008); *Syberg/Clever. Die Nacht. Ein Monolog* (2008); *Western Motel. Edward Hopper und die zeitgenössische Kunst* (2008); *Ree Morton. Werke 1971–1977* (2008/09); *Die Moderne als Ruine. Eine Archäologie der Gegenwart* (2009).

Assistant Curator at the Generali Foundation, Vienna since 2008. Contributions to various exhibitions, projects in public space, and publications, including: *Raymond Pettibon. Whatever it is you're looking for you won't find it here* (2006/07); *Die Toten. Hans-Peter Feldmann. RAF, APO, Baader-Meinhof: 1967–1993* (2007); *Chen Zhen. The Body as Landscape* (2007); *Julius Popp. Bit Fall* (2007); *Under Pain of Death* (2008); *Syberberg/Clever. Die Nacht. Ein Monolog* (2008); *Western Motel. Edward Hopper and Contemporary Art* (2008); *Ree Morton. Works 1971–1977* (2008/09); *Modernism as a Ruin. An Archaeology of the Present* (2009).

Christian Schulte

Kulturwissenschaftler. Professor am Institut für Theater-, Film- und Medienwissenschaft der Universität Wien. Unterrichtete an den Universitäten Osnabrück, Bremen, Berlin (FU) und Potsdam; arbeitete als freier Journalist für Presse und Hörfunk, als Redakteur bei der DCTP/ Development Company for Television Program und als Medienwissenschaftler am ZKM, Zentrum für Kunst und Medientechnologie Karlsruhe. Zahlreiche Publikationen, u. a.: *Kluges Fernsehen. Alexander Kluges Kulturmagazine* (2002), hg. mit Winfried Siebers; *Ursprung ist das Ziel. Walter Benjamin über Karl Kraus* (2003); *Der Text ist der Coyote. Heiner Müller Bestandsaufnahme*, (2004), hg. mit Brigitte Maria Mayer; *Walter Benjamins Medientheorie* (2005); *Vlado Kristl. Die Zerstörung der Systeme* (2010).

Cultural studies scholar. Professor at the Institute for Theater, Film and Media studies, University of Vienna. Taught at the universities of Osnabrück, Bremen, Berlin (FU) and Potsdam; has worked as a freelance journalist for press and radio, as an editor at the DCTP/Development Company for Television Program and as media scholar at the ZKM, Center for Art and Media Karlsruhe. Numerous publications, including: *Kluges Fernsehen. Alexander Kluges Kulturmagazine* (2002), ed. with Winfried Siebers; *Ursprung ist das Ziel. Walter Benjamin über Karl Kraus* (2003); *Der Text ist der Coyote. Heiner Müller Bestandsaufnahme*, (2004), ed. with Brigitte Maria Mayer; *Walter Benjamins Medientheorie* (2005); *Vlado Kristl. Die Zerstörung der Systeme* (2010).

Werkliste
List of Works

Harun Farocki

Jean-Marie Straub und Danièle Huillet bei der Arbeit an einem Film
nach Franz Kafkas Roman „Amerika", 1983
Film, 16mm, Farbe, Ton, transferiert auf Video, 25 min |
Film, 16mm, color, sound, transferred to video, 25 min
Sammlung Generali Foundation, Wien | Vienna
Abb. S. | Fig. pp. 104, 105

Immersion, 2009
Videoinstallation, 2 Videos, Farbe, Ton, 20 min, Loop |
Video installation, 2 videos, color, sound, 20 min, loop
Sammlung Generali Foundation, Wien | Vienna
Abb. S. | Fig. pp. 108, 109

Omer Fast

A Tank Translated, 2002
Videoinstallation, 4 Einkanal-Videos auf 4 Monitoren, Farbe, Ton, 3 bis 7 min |
Video installation, 4 single-channel videos on 4 monitors, color, sound, 3 to 7 min
Edition: 6 + 1 AP
Courtesy Arratia, Beer, Berlin; gb agency, Paris; Postmasters, New York
Abb. S. | Fig. p. 73

Godville, 2005
Zweikanal-Videoprojektion, Farbe, Ton, 40 min |
Two-channel video projection, color, sound, 40 min
Edition: 6 + 1 AP
Courtesy Arratia, Beer, Berlin; gb agency, Paris; Postmasters, New York
Abb. S. | Fig. p. 75

Michael Fliri

Give Doubt the Benefit of the Doubt, 2010
Performance in 3 Teilen: Maskenbild, Falltest, Kunstblut, ca. 50 min |
Performance in 3 parts: Make-up, drop test, fake blood, approx. 50 min
Spezial-Make-up | Special make up: Jade FX Workshop
Auftragswerk | Comissioned Work
Courtesy Michael Fliri und | and Galleria Raffaella Cortese, Mailand | Milan
Abb. S. | Fig. p. 117

Give Doubt the Benefit of the Doubt, 2010
Video im Kontext der gleichnamigen Performance, Farbe, Ton |
Video in the context of the performance of the same title, video, color, sound
Auftragswerk | Comissioned Work
Courtesy Michael Fliri und | and Galleria Raffaella Cortese, Mailand | Milan

Andrea Geyer

Reference Over Time, 2004
Videoinstallation, Video, s/w, Ton, 16 min, Tisch, Stuhl, Wandschild, 5 s/w Fotografien,
je 10,2 × 13,6 cm, auf Karton, zusammen gerahmt 41 × 51,1 cm |
Video installation, video, b & w, sound, 16 min, table, chair, label, 5 b & w photographs,
10.2 × 13.6 cm each, on cardboard, framed together 41 × 51.1 cm
Sammlung Generali Foundation, Wien | Vienna
Abb. S. | Fig. p. 79

Marcello Maloberti

Die Schmetterlinge essen die Bananen, 2010
Performance, 2 lebende Skulpturen, Zypresse auf Tischplatte, Radio,
Bilder ausschneidender Junge, Flaschen in Matrosenanzügen, ausrangierter Kühlschrank,
15 Perfomer mit 15 Porzellantigern |
Performance, 2 living sculptures, cypress on table top, radio, boy cutting out pictures,
bottles in sailor suits, discarded fridge, 15 performers with 15 porcelain tigers
Auftragswerk | Comissioned Work
Courtesy Marcello Maloberti und | and Galleria Raffaella Cortese Mailand | Milano
Abb. S. | Fig. p. 121

Die Schmetterlinge essen die Bananen, 2010
Video im Kontext der gleichnamigen Performance (15 Perfomer mit 15 Porzellantigern),
Farbe, Ton, ca. 4 min |
Video in the context of the performance of the same title (15 performers with
15 porcelain tigers), color, sound, approx. 4 min
Auftragswerk | Comissioned Work
Courtesy Marcello Maloberti und | and Galleria Raffaella Cortese Mailand | Milano

Aernout Mik

Convergencies, 2007/2010
Videoinstallation, 2 Projektionstafeln mit integriertem Ton, digitales Video auf DVD,
Farbe, Ton, 40 min, Loop |
Video installation, 2 projection boards with integrated sound, digital video on DVD,
color, sound, 40 min, loop
Edition: 4 + 2 AP
Courtesy carlier | gebauer, Berlin
Abb. S. | Fig. pp. 69–71

Frédéric Moser & Philippe Schwinger

Farewell Letter to the Swiss Workers, 2006–2009
Videoinstallation: *Alles wird wieder gut*, 2006, digitales Video, 16/9, 19 min 55 sec,
Farbe, Ton; *Donnerstag*, 2006, digitales Video, 16/9, 12 min 33 sec, Farbe, Ton;
La 7ème cité, 2009, Digitaldruck, 5000 Poster, je 70 × 100 cm; Strohballen |
Video installation: *Alles wird wieder gut*, 2006, digital video, 16/9, 19 min 55 sec, color,
sound; *Donnerstag*, 2006, digital video, 16/9, 12 min 33 sec, color, sound;
La 7ème cité, 2009, digital print, 5000 posters, 70 × 100 cm each; bales of straw
Courtesy Frédéric Moser & Philippe Schwinger, KOCH OBERHUBER WOLFF, Berlin
und | and Galerie Jocelyn Wolff, Paris
Abb. S. | Fig. pp. 92, 93, 95

Wendelien van Oldenborgh

No False Echoes, 2008
Videoinstallation, Farbe, Ton, 30 min, Niederländisch und Englisch (mit englischen
Untertiteln), 2 freistehende, einander gegenüberliegende Paraventwände mit integriertem
Ton; Paraventwand I: integrierter Monitor, Videoprojektion (Untertitel), Paravantwand II:
Videoprojektion |
Video installation, color, sound, 30 min, Dutch and English (with English
subtitles), 2 free standing opposite partition walls with integrated sound, partition wall I:
built-in monitor, video projection (subtitles), partition wall II: video projection
Mit | With Salah Edin, Edwin Jurriëns, Wim Noordhoek, Baukje Prins, Joss Wibisono
Edition: 2 + 1 AP
Courtesy Wilfried Lentz, Rotterdam
Abb. S. | Fig. pp. 88, 85

The Basis For A Song, 2005
Diainstallation, 3 Projektoren, Farbdias von Videostills, Ton, Niederländisch und Englisch
(mit englischen Untertiteln), 24 min, Loop |
Slide installation, 3 projectors, color slides from video stills, sound, Dutch and English
(with English subtitles), 24 min, loop
Mit | With Milford Kendall, Romeo Gambier
Edition: 2 + 1 AP
Courtesy Wilfried Lentz, Rotterdam
Abb. S. | Fig. pp. 88, 89

Judy Radul

World Rehearsal Court, 2009
Siebenkanal-Videoinstallation, 4 h, 4 Live-Kameras mit Vorsteuerung, Kamera-
Choreographie-Playback-System, computergesteuerter Kamerawagen, Kameraschienen,
Monitore, gefundene und angefertigte Objekte, Plexiglas, Möbel |
Seven-channel video installation, 4 h, 4 servo-controlled live cameras, camera
choreography playback system, computer-controlled dolly, tracks, monitors, found and
built objects, plexiglass, furniture
Courtesy Morris and Helen Belkin Art Gallery und | and Catriona Jeffries Gallery, Vancouver
Abb. S. | Fig. pp. 61, 63

Allan Sekula

Aerospace Folktales, 1973
Foto-Audio Installation, 51 s/w Fotografien (Abzüge auf Barytpapier, 1984),
in 23 Rahmen, gerahmt je 55,9 × 71,5 cm, 3 rote Regiestühle, 6 Fächerpalmen,
3 simultane, nicht synchronisierte Tonaufnahmen (Gesamtdauer 17, 21 und 23 min) |
Photo-audioinstallation, 51 b & w photographs (prints on Baryta paper, 1984),
in 23 frames, framed 55.9 × 71.5 cm each, 3 red canvas director's chairs, 6 potted fan palms,
3 simultaneous, non-sychronized sound, (total duration 17 min, 21 min and 23 min)
Edition 1/2
Sammlung Generali Foundation, Wien | Vienna
Abb. S. | Fig. pp. 98–100

Ian Wallace

Poverty, 1980
Film, 16mm, kolorierter s/w Film, transferiert auf Video, 6 min, Loop |
Film, 16mm, colored b & w film, transferred to video, 6 min, loop
Courtesy Catriona Jeffries Gallery, Vancouver
Abb. S. | Fig. p. 111

Poverty, 1980
8 Blaupausen (Diazotypien) und Xerox-Drucke auf Tonpapier, je 55,9 × 76,2 cm,
Gesamtabmessungen 55,9 × 609,6 cm, Plexiglas | 8 blue prints (diazotypes) and xerox
prints on color construction paper, 55.9 × 76.2 cm each, total measurements
55.9 × 609.6 cm, plexiglass
Collection of the Vancouver Art Gallery, Promised Gift of Rick Erickson
Abb. S. | Fig. pp. 114, 115

Impressum
Colophon

Hinter der Vierten Wand. Fiktive Leben – Gelebte Fiktionen
Behind the Forth Wall. Fictitious Lives – Lived Fictions

Ausstellung I Exhibition

2. Juni – 15. August I June 2 – August 15, 2010
Generali Foundation, Wien I Vienna

Kuratorin I Curator: Ilse Lafer
Projektassistentin I Project Assistant: Katharina Menches

Kuratorin I Curator Performances: Sabine Folie
Assistenz-Kuratorin I Assistant Curator: Georgia Holz

Presse, Marketing, Printmedien I Press, marketing, print production: Barbara Mahlknecht
Ausstellungsdesign, -technik und -aufbau I Exhibition design and technical installations:
Thomas Ehringer (Leitung I Head) in Zusammenarbeit mit I in collaboration with
Daniel Bemberger, Michal Estrada, Dietmar Hochhauser, Markus Strohschneider,
Martin Strohschneider, Christian Rasser
Audiovisuelle Medien I Audiovisual engineering: Dietmar Ebenhofer, Peter Kulev
Front office: Dario Punales mit I assisted by Antonia Aigner, Stephanie Lang,
Elisabeth Hochwarter, David Wiltschek, Magdalena Winkler, Johannes Yezbek
Kunstvermittlungsprogramm I Art education program: Verena Gamper, Johanna Lettmayer,
Rolf Wienkötter
Grafische Gestaltung der PR-Medien I Graphic design of PR media: Martha Stutteregger
Ausstellungsfotografie I Exhibition photography: Markus Wörgötter
Dokumentation der Performance von I Documentation of the performance by Michael Fliri:
Tizza Covi, Rainer Frimmel
Dokumentation der Performance von I Documentation of the performance by Marcello Maloberti:
Natascha Unkart

Unterstützt von I Supported by

Canada Council for the Arts
Social Sciences and Humanities Research Council of Canada

Publikation I Publication

Herausgegeben von I Edited by Ilse Lafer
Verlegt von I Published by Sabine Folie
für I for

Generali Foundation
Wiedner Hauptstraße 15
1040 Wien, Austria
Telefon +43 1 504 98 80
Telefax +43 1 504 98 83
foundation@generali.at
http://foundation.generali.at

Verlag für moderne Kunst Nürnberg
Luitpoldstraße 5
D-90402 Nürnberg
Telefon +49 (0) 911 240 21 14
Telefax +49 (0) 911 240 21 19
verlag@moderne-kunst.org
www.vfmk.de

Vertrieb I Distribution UK
Cornerhouse Publications
70 Oxford Street
Manchester M1 5 NH, UK
Tel. +44-161-200 15 03
Fax +44-161-200 15 04
publications@cornerhouse.org
http://www.cornerhouse.org

Außerhalb Europas I Outside Europe
D.A.P. Distributed Art Publishers, Inc.
155 Sixth Avenue, 2nd Floor
New York, NY 10013, USA
Tel. +1-212-627 19 99
Fax +1-212-627 94 84
www.artbook.com

Generali Foundation, Wien I Vienna
ISBN 978-3-901107-60-3
Verlag für moderne Kunst Nürnberg
ISBN 978-3-86984-115-1

Konzept I Concept: Ilse Lafer
Publikationsmanagement I Publication managment: Ilse Lafer und I and Katharina Menches
Textredaktion I Text editing: Ilse Lafer und I and Katharina Menches
Bio- und Bibliografien, Werkliste I Biographies and bibliographies, list of works:
Katharina Menches
Bildredaktion I Photo editing: Ilse Lafer und I and Katharina Menches
AutorInnen der Kurztexte I Authors of short texts: Sabine Folie, Georgia Holz,
Katharina Menches, Rolf Wienkötter
Übersetzungen I Translations: Nicholas Grindell (Essays), Gerrit Jackson
Deutsches Lektorat I German proofreading: Wolfgang Astelbauer (Essays),
Anna Drechsel-Burkhard
Englisches Lektorat I English proofreading: Michael Strand
Grafische Gestaltung I Graphic design: Martha Stutteregger
Digitale Bildbearbeitung I Digital imaging: Markus Wörgötter
Druckerei I Printed by: Holzhausen Druck GmbH, Wien I Vienna
Papier I Paper: Munken Polar 150g
Schriften I Typefaces: Mercury, Neue Helvetica
Gesamtherstellung I Production: Generali Foundation

Printed in the EU